ELECTRONIC FLASH
By Jim Cornfield

Cover photograph by Jim Cornfield. Cover design by Al Isaacs.

(For technical information on how the cover shot was made, please see page 134.)

BOOK DIVISION

Erwin M. Rosen
Executive Editor

Al Hall
Editor

Dick Fischer
Art Director

Chriss Ohliger Jay
Managing Editor

Jim Norris
Managing Editor

George Fukuda
Assistant Art Director

Kathleen Zawrotney
Editorial Assistant

The essence of photography is capturing on film the light reflected from a subject and producing an image that reveals the photographer's technical skill and artistic sensitivity. Since "light" is the key element in the mysterious process of creating this image, the control of light is perhaps the major challenge in making a photograph.

The use of electronic flash, in the hands of a novice or a professional, can add new dimensions of graphic impact to any photograph. Whether the aim is to complement natural or available light, or to exercise unbounded imagination in a special lighting effect, electronic flash offers a controlled source of illumination that can add heightened emotional appeal to your recording of a fleeting moment in time.

This book will tell you what electronic flash is—from the simplest hand-held or camera-mounted unit to the most expensive and elaborate studio equipment. We will show you how it works and how to use it for a variety of desired effects. Electronic flash can help you compensate for the inadequacy or chicanery of natural light and can also enable you to improvise lighting applications that nature never thought of—all the while adding image magic to a process that is oversimplified as "just point and shoot."

From the *camera obscura's* dependence on sunlight to the frightening "pouff!" of magnesium powder to the convenient mini-brilliance of flashcubes . . . this is the ancestry of state-of-the-art electronic flash equipment and techniques. The "brilliance" of this space-age technology stands ready to shed new light on your picture-taking.

Electronic Flash is one of a continuing series of self-help books for photographers from Petersen Publishing Company. Others are available at photo dealers and bookstores.

ELECTRONIC FLASH

Vol. 3—Petersen's Photographic Library

By Jim Cornfield and the editors of PhotoGraphic Magazine. Copyright© 1980 by Petersen Publishing Co., 8490 Sunset Blvd., Los Angeles, CA 90069. Phone (213) 657-5100. All rights reserved. No part of this book may be reproduced without written permission from the publisher. Photographs Copyright© 1980 by Jim Cornfield. All rights reserved. Printed in U.S.A.

Library of Congress Catalog Card Number 80-81779

ISBN 0-8227-4041-9

PHOTOGRAPHIC MAGAZINE

Paul R. Farber/Publisher
Karen Geller-Shinn/Editor
Jim Creason/Art Director
Mike Stensvold/Technical Editor
Markene Kruse-Smith/Senior Editor
Bill Hurter/Feature Editor

Rod Long/Associate Editor
Franklin D. Cameron/Managing Editor
Peggy Sealfon/East Coast Editor
Allison Eve Kuhns/Assistant Art Director
Charles Marah/Far East Correspondent
Natalie Carroll/Administrative Assistant

PETERSEN PUBLISHING COMPANY

R.E. Petersen/Chairman of the Board
F.R. Waingrow/President
Robert E. Brown/Sr. Vice President
Dick Day/Sr. Vice President
Jim P. Walsh/Sr. Vice President, National Advertising Director
Robert MacLeod/Vice President, Publisher
Thomas J. Siatos/Vice President, Publisher
Philip E. Trimbach/Vice President, Finance
William Porter/Vice President, Circulation Director
James J. Krenek/Vice President, Manufacturing
Leo D. LaRew/Treasurer/Assistant Secretary

Dick Watson/Controller
Lou Abbott/Director, Production
John Carrington/Director, Book Sales and Marketing
Maria Cox/Director, Data Processing
Bob D'Olivo/Director, Photography
Lawrence Freeman/Director, Subscription Sales
Nigel P. Heaton/Director, Circulation Administration and Systems
Al Isaacs/Director, Graphics
Carol Johnson/Director, Advertising Administration
Don McGlathery/Director, Research
Jack Thompson/Assistant Director, Circulation

Electronic Flash

Introduction

Electronic flash is one of modern technology's most sophisticated contributions to the art of photography. Among the significant advancements of this technology—electronic shutters, precision light metering, space-age materials—the special area of photography that comprises the production of artificial light has surely profited the most. The real beneficiary, of course, is the modern photographer—professional or amateur—who now has at his fingertips a dazzling repertoire of lightweight, portable, reliable and easy-to-use electronic flash gear.

Even the most modest and least expensive flash equipment on the market today is eminently superior to what was considered "top of the line" a few years ago. For that reason, before beginning this book, the reader should be aware that it is neither a buyer's guide to electronic flash equipment nor a compendium of money-saving shortcuts. The brand name on your strobe unit and its price tag are the least important factors in the quality of the flash pictures you produce, and only your specific creative needs and budgetary restrictions can accurately dictate the type of equipment you should own. The following chapters will help you determine what those requirements are, but for solid buying tips, you should refer to your camera dealer and those consumer guides that periodically appear in *PhotoGraphic* magazine. Suffice it to say, the flash units you will see in this book are considered topnotch, both in quality and in price. They appear here simply because they are the equipment I use in my own work. I endorse them highly, but again, your own choice must be based on an evaluation of your special requirements, and not purely on the personal preferences of someone else.

Anyway, so much for what this book does *not* contain. What it *does* contain is, I feel, a comprehensive guide for either developing or improving your technique with electronic flash. Whether your past experience with strobe has consisted of simply using it to produce light in a location where there was none, or you have already begun to explore more creative uses, what follows will certainly add to your inventory of flash techniques. And if, in the end, you find that your photographic results are better, or at least easier to achieve, the book will have done its job.

—*Jim Cornfield*

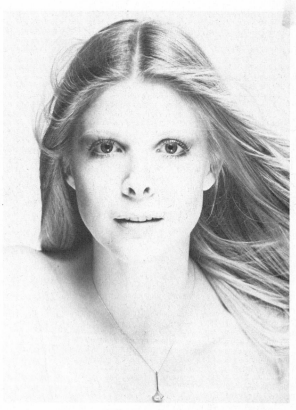

The quick, clean light of electronic flash has made it indispensable for fashion and glamour photography. Its ability to stop the subtlest nuance of expression and the briefest sweep of a garment or wisp of a model's hair makes strobe one of the photographer's most useful creative tools.

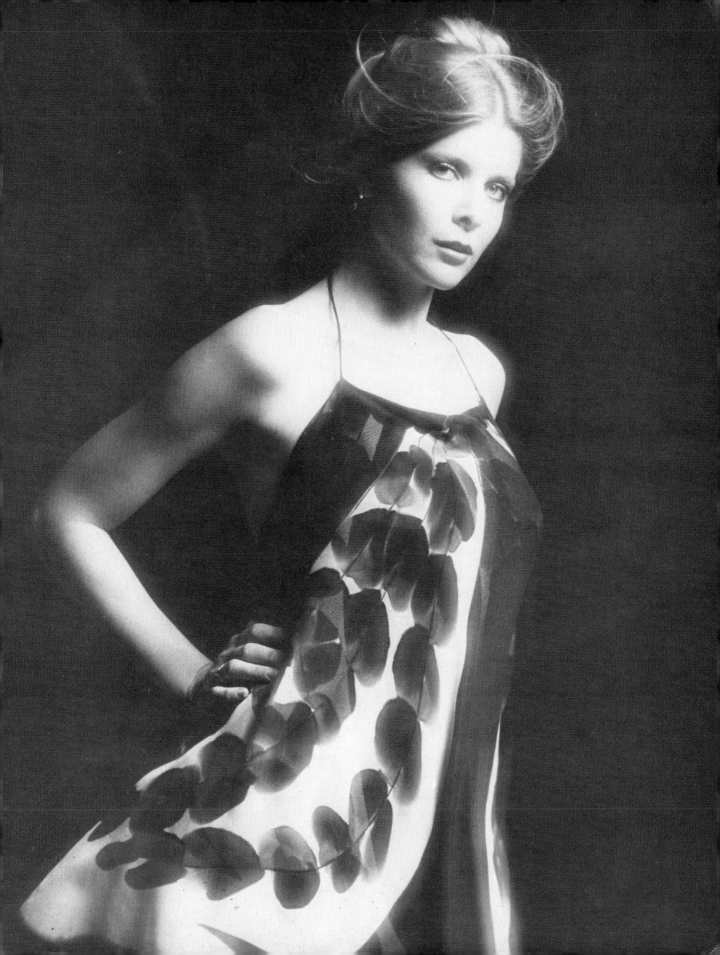

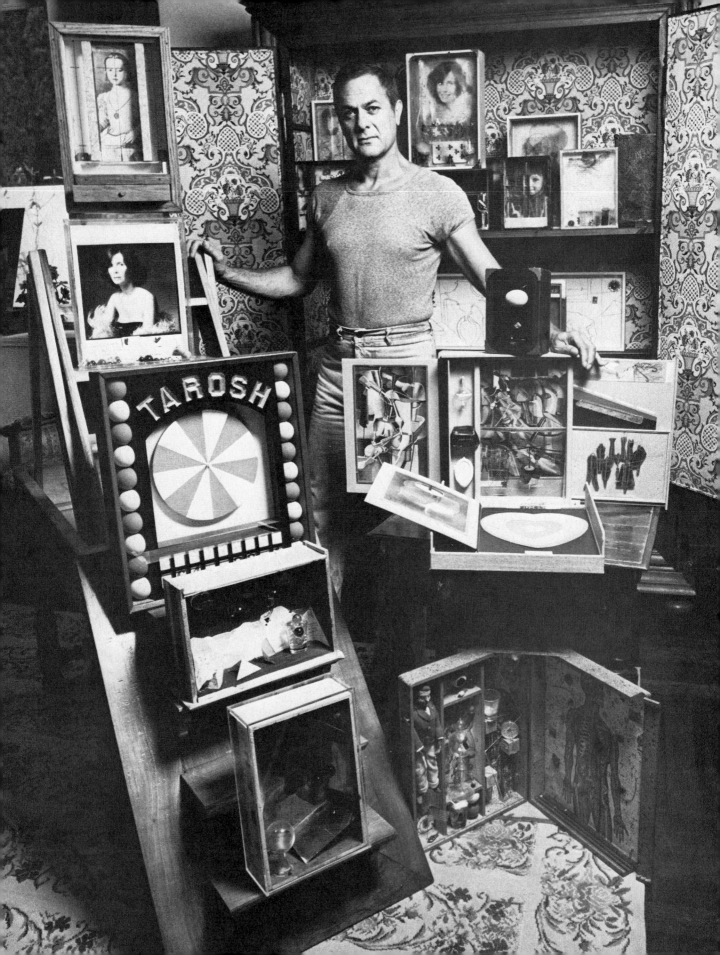

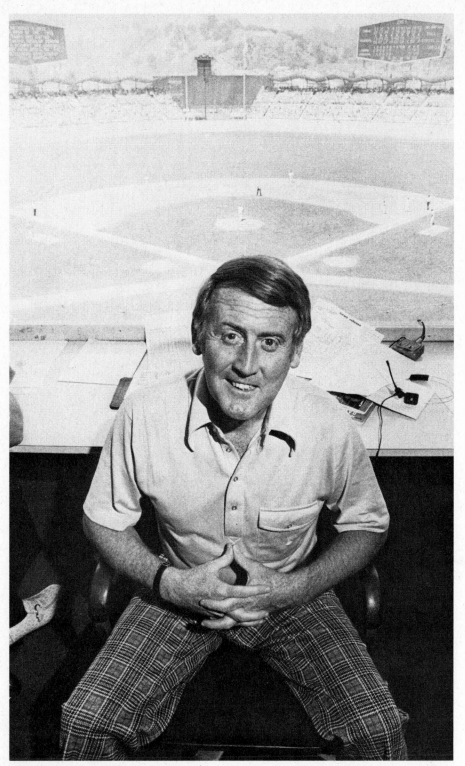

The portability of electronic flash units is considered a major asset to the photographer who works a great deal on location. Its compatibility with lightweight accessories gives it total versatility in the most awkward location situations. For example, it can provide the illusion of window light in an actor's living room and is compact enough to fit in the cramped broadcasting booth of a sports announcer.

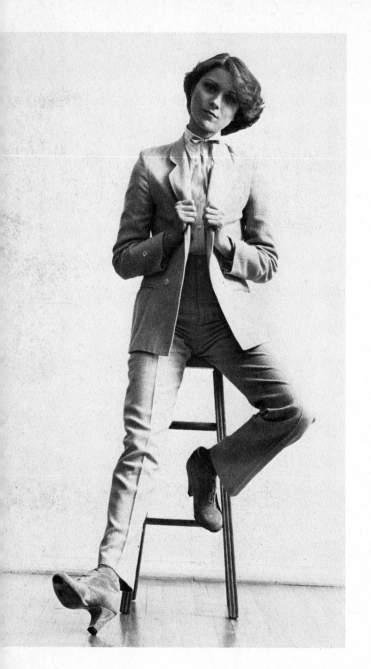

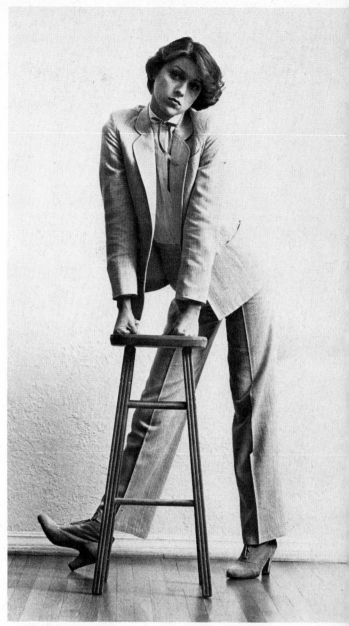

The easygoing style of modern fashion photography requires a tool like electronic flash to isolate the total range of looks that a good model can create with her repertoire of poses and expressions.

A Unique Form of Light

In 1888, a handbill advertising the services of a fashionable English portrait studio extolled the virtues of electric light. "My electric light installation," gushed the ad copy, "is perhaps the most powerful in London! Photographs superior to daylight pictures can now be taken in any weather at any time." The poster ended with a line of caution: "Many photographers advertise photographs taken by electric light, but nine out of ten do not possess an electric light. Owing to its costliness, they use an inferior and nasty substitute, *viz.* a pyrotechnic powder which gives off poisonos (*sic*) fumes."

Although that ad does not represent the true antecedent of modern photographic lighting technology, it does prefigure a basic concern of today's photographers—that artificial lighting is a very special breed of stuff. The fact that it is held in equal measure of awe and terror by beginning photographers belies the fact that artificial lighting is one of photography's most versatile tools.

Of all the ways in which a photographer can dramatize the subjects he records on film—among all of his great arsenal of artistic capabilities—the act of creating his own light is uniquely significant. Light is the essence of photography, and the art of lighting is—for many of us—the essence of what being a photographer is all about.

Of all the light-producing implements that photographers have used over the last century or so, electronic flash represents the zenith of technological achievement. Design-wise, it is the foster child of space-age electronics—a miniaturized, microcircuited, compact source of enormous energy. Aesthetically, it provides the cleanest, most natural lighting quality available for still photographers without daylight. And, from the standpoint of convenience and economics, it is the simplest, most durable and least expensive form of artificial light a photographer can use. But to really appreciate the unique advantages electronic flash holds over other modes of lighting, you must first examine the alternatives.

Incandescent Lighting

As the aforementioned handbill demonstrates, the familiar incandescent bulb was being used by photographers before it actually found its way into the homes and business establishments of astonished Victorians who first witnessed the dawn of mass electrical power around the turn of the century. A lot more improved lighting methods have grown up since then, but the incandescent "photoflood" lamp is still with us, and for good reason: The technology, the hardware and accessories for lighting photographic subjects with incandescent illumination are no more mysterious, and not much more expensive, than common household lighting fixtures. Suffice it to say, though the drawbacks of incandescent photography are legion, particularly to the serious photographer, it's nevertheless important for anyone to understand.

Thanks to the economy of the hardware involved and the arch simplicity of its garden-variety circuitry, incandescent or "photoflood" lighting is an ideal tool for the beginning studio photographer. First of all, it provides a *continuous* source of illumination so that, unlike flash bulbs or electronic flash, the photoflood allows the photographer the capability of easily monitoring effects of his lighting on the surface—the planes and the curves—of his subjects. But to properly understand why photofloods are not as useful to serious, more experienced photographers, you should first understand how this illumination works.

An incandescent lamp is simply a vacuum-sealed glass tube housing a thin tungsten filament that completes a circuit when the lamp is switched on. The loop formed by the tungsten filament usually connects to its current source by means of a familiar threaded base. Like their household counterparts, photoflood lamps are operated by passing current through the filament, causing the filament to produce enormous heat close to the melting point of the tungsten. At this temperature, the phenomenon of incandescence—light emission—occurs. Unlike the light bulbs that you're familiar with around your home, the photoflood bulb emits far more intense light energy, which gives it a shorter life expectancy than its household cousins. Depending on the amount of power output a photoflood is designed to provide, that life expectancy can be anywhere from three to ten hours, which, on

the surface, makes photoflood appear to be ideal for a photographer whose work indoors is only occasional. But total "life expectancy" doesn't include the duration of a photoflood lamp's usefulness, and *that* begins to deteriorate long before the bulb has completely given up.

As the filament "incandesces," the high temperatures involved cause small amounts of the tungsten surface to evaporate and collect as dark soot on the inner surface of the glass housing. This builds up a thin, ashy layer that quickly begins to reduce the amount of light energy that can be transmitted through the wall of the bulb. The formation of this layer begins very early in the life of a photoflood

The lowly incandescent bulb is the most basic lighting tool available to the photographer. Its low cost and garden-variety circuitry make it the ideal starter implement for the novice, but high heat production and short bulb life make it impractical for more serious applications. Light production occurs when current passing through coiled tungsten filament creates high temperatures necessary for the filament to glow, or "incandesce."

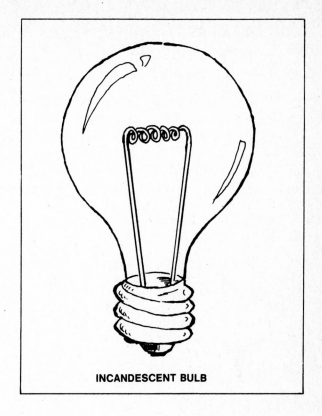

INCANDESCENT BULB

Photographic film emulsions do not necessarily "see" colors as the human eye sees them. Therefore, a convenient system is needed for classifying the idiosyncracies of a film's "color vision" in order to be able to render natural colors in a photograph. This system is based on what we refer to as the "color temperature" of a light source. Depending on the relative proportion of short and long wavelengths emitted by any given light source, the color temperature value of that light source distinguishes it dramatically from other forms of illumination. The inventor of this system was a British scientist, Lord Kelvin, from whom we derive the increments for measuring color temperature—"degrees Kelvin."

Some typical color temperature values are shown in this chart.

Take special note that the lower color temperature values, for example 3200°K.-3400°K. (for tungsten-halogen and incandescent sources) represent light that tends toward the redder end of the visual spectrum. In contrast, the higher temperature values, such as 6000°K.-8000°K. (for daylight) are characterized by greater proportions of wavelengths toward the blue end of the spectrum.

COLOR TEMPERATURE COMPARISONS
THE VISIBLE SPECTRUM

COLOR TEMP. DEGREES K	LIGHT SOURCE	
10,000° K	CLEAR BLUE SKY	
8000° K	OVERCAST SKY	ELECTRONIC FLASH
7000° K	LIGHTLY OVERCAST SKY	
6000° K	SUN AND CLEAR SKY	
5500° K	BLUE FLASHBULBS	
5400° K	NOON SUNLIGHT	
3800° K	CLEAR FLASHBULBS	
3400° K	INCANDESCENT	
3200° K	TUNGSTEN-HALOGEN	

SHORTER ← WAVELENGTHS → LONGER
BLUER ← COLOR AS SEEN BY THE EYE → REDDER

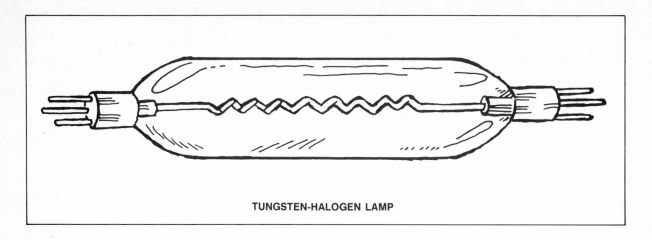

TUNGSTEN-HALOGEN LAMP

lamp, and affects more than just the degree of the bulb's output. The color of the light produced is also altered dramatically.

Since photoflood illumination has a relatively "cool" color temperature of 3400°K. (as opposed to about 6000°K. for daylight; see Color Temperature illustration on page 11, its utility for color photography is extremely limited anyway (with only one color film emulsion available that is balanced for use with incandescent lamps). As the color changes brought on by the internal evaporation continue, of course, the lamp rapidly changes color, making it practically useless for anything but black-and-white photography almost as soon as you've put it to work in your studio. So, in spite of the relative economy of photoflood lighting equipment, the optimum efficiency of that equipment can only be ensured by constantly replacing your photoflood lamps long before their life expectancy has run out.

In addition, the comparatively low light output of photoflood bulbs requires inordinate heat production, making high illumination levels very impractical as well as uncomfortable for people working in the studio.

Nevertheless, photoflood illumination does have its place in modern photographic technique, especially for a photographer just beginning to experiment with artificial lighting. What frequently makes the notion of more sophisticated forms of artificial lighting, particularly electronic flash, so intimidating is the fear that the effects that the photographer seeks by positioning his light source will not necessarily be recorded the same way on film. The relative simplicity and economy of photofloods thus make incandescent lighting an ideal tool for experimenting with artificial lighting techniques. As one famous photographer

Greatly increased light output and longer bulb life make tungsten-halogen lighting superior to conventional incandescent light. The phenomenon of incandescence occurs within the vacuum-sealed environment containing halogen gas. Metallic ash leaving the surface of the filament is prevented from accumulating on the tube's inner surface by its reaction with gas molecules. The tungsten-halogen compound thus produced returns to the filament surface where the metal is redeposited, extending bulb life and duration of color temperature stability. Extremely high operating temperatures and the need for AC power source are this system's major drawbacks.

observed, photography itself is really nothing more or less than "understanding the world in terms of light." What better tool to crystallize that understanding than a piece of hardware that's no more difficult to operate than a common desk lamp?

Tungsten-Halogen

If it were possible to increase the light output capability of standard photoflood bulbs by very large magnitudes, there would be no need for an alternative form of incandescent illumination. But the high filament temperatures required to accomplish this cannot be accommodated by the simple design of incandescent bulbs.

Here is where we turn to a phenomenon known as the tungsten-halogen cycle, which has been a feature of continuous photographic illumination since the early 1960's. This cycle provides the principle by which incandescence can be harnessed to produce significantly increased light output, as well as dramatically extend the life of the individual unit. As in incandescent light sources, tungsten-

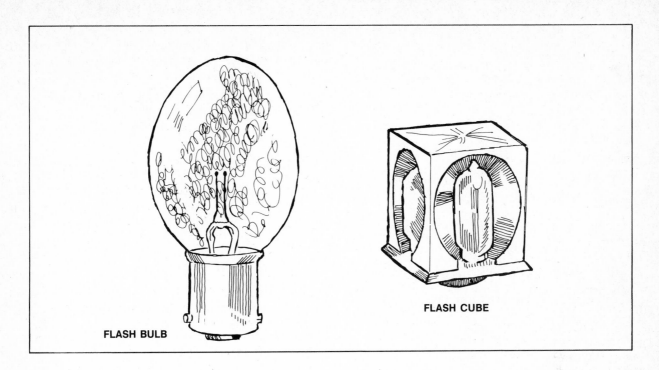

FLASH BULB

FLASH CUBE

The familiar flash bulb creates light through combustion of a coiled zirconium wire inside the housing. A weak supply of electrical current produces ignition, and the oxygen-rich internal environment supports combustion. The obvious inconvenience of the flash bulb has been partially overridden by the availability of multi-bulb flashcubes and flashbars, which are manufactured principally for use with amateur "snapshot" cameras.

halogen illumination is produced by the heating of a tungsten filament in a sealed environment. But here the similarity ends. Rather than the filament being enveloped in a vacuum-sealed glass housing, the tungsten-halogen filament is enclosed by a narrow tube of quartz, filled under pressure with a halogen gas, usually iodine. For this reason, tungsten-halogen light sources are often referred to as quartz-iodine, a forgivable misnomer which overlooks the frequent use of other similar materials to accomplish the same end.

The mechanism of the tungsten-halogen cycle is simple: Between the temperatures of 250°C.-800°C., metallic ash that leaves the surface of the heated filament will combine with iodine gas to form gaseous tungsten iodide. At the much higher filament temperature of about 1200°C. this compound will divide again into its components: metallic tungsten and gaseous iodine. Therefore, as a tungsten-halogen filament is heated, tungsten ash which evaporates from the filament's surface can be made to combine with the gas, preventing the ash from collecting on the inside surface of the housing, as it does in the environment of a photoflood bulb. This reaction provides the reason for the familiar tubular shape of tungsten-halogen bulbs. The shape maintains enough proximity between halogen gas and the heated filament to ensure a temperature range in which the gas can combine efficiently with the tungsten ash. As this substance is formed, it migrates back to the surface of the filament where it decomposes, redeposits tungsten on the filament and returns the halogen to the gaseous environment.

The most significant result of this cycle is the prevention of changes in the total light output of the tube, since deposits on the inner wall are minimized. Also minimized, of course, are the commensurate changes in color temperature that are so severely limiting with incandescent lamps. As we saw, these changes result not only from the color of the ashy deposits, but also from the slow degradation of the tungsten filament. As such a filament is degraded, its light output is decreased, causing its color temperature to shift toward the redder end of the spectrum. In short, the tungsten-halogen system increases the useful life of the individual unit by maintaining *stable color temperature and stable output.* A typical photoflood bulb of 500 watts

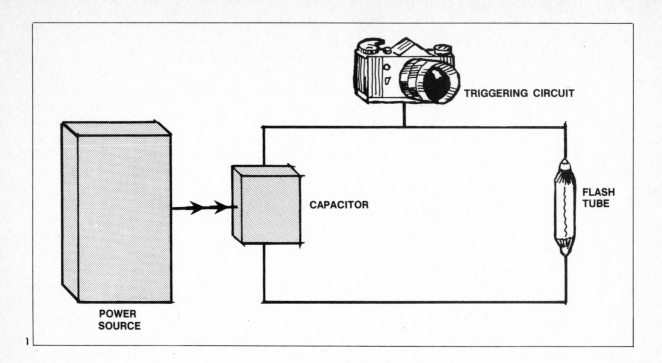

TRIGGERING CIRCUIT

CAPACITOR

FLASH TUBE

POWER SOURCE

1

power might have an average life of six hours compared to the 15-hour average life of a tungsten-halogen tube with *twice* the wattage!

Tungsten-halogen light sources are probably the most common and certainly the most useful continuous light producers available today for photographic purposes. They are especially popular among motion-picture makers who—obviously—require continuous lighting, and there is a much broader range of color film emulsions balanced for the 3200°K. color temperature of tungsten-halogen lighting. But while this particular mode of light production provides considerably higher output than incandescent sources, it does bear a significant liability: Those extreme internal temperatures, required to sustain the constant cycle of chemical breakdown and reconstitution on the filament surface, make tungsten-halogen lamps extremely uncomfortable and relatively dangerous to work with.

That tired Hollywood reference to working "under hot lights" is all too accurate, as anyone who has ever touched the surface of a tungsten-halogen unit while it's on can explain, usually in very terse language. Still, even though the hardware and accessories required for tungsten-halogen lighting are usually more expensive than incandescent equipment, this ingenious mode of light production is considerably more efficient and more versatile than the photoflood system.

This highly simplified series of diagrams shows the sequence of events involved in firing an electronic flash unit: (1) The power source (batteries or AC current) provides energy for the capacitor which stores it until (2) the camera's shutter release activates the triggering circuit, which instantaneously causes gas within the tube to ionize, making it electrically conductive. This completes the circuit, allowing energy to surge from the capacitor and discharge across the electrodes in the tube, producing a light pulse. (3) The flash unit cannot be fired again at full output until the capacitor has returned to its full energy load capability, as indicated by the "ready light."

Photoflash

Despite the fact that photoflash lamps, or "flash bulbs," have fallen into disuse among most serious photographers, they still represent the oldest mode of artificial lighting in photography. Like its noisy, dangerous predecessor, "flash powder," the modern photoflash bulb operates on the simple principle of high-speed combustion to produce a brief, powerful pulse of light.

Photographers during the last century had to create this combustion by igniting large quantities of explosive powder in long, uncovered troughs held perilously above their heads. Owing to the relatively slow speed of the early film emulsions, this technique for augmenting existing illumination enjoyed fairly widespread

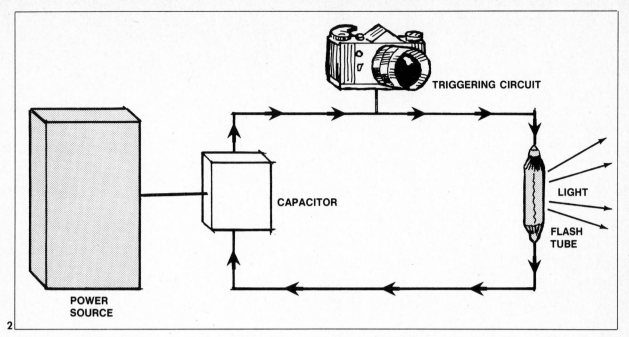

TRIGGERING CIRCUIT

CAPACITOR

LIGHT

FLASH TUBE

POWER SOURCE

2

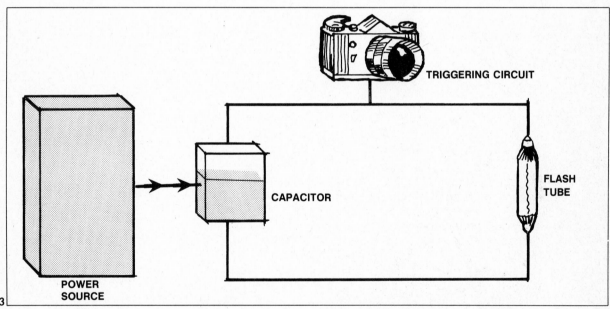

TRIGGERING CIRCUIT

CAPACITOR

FLASH TUBE

POWER SOURCE

3

popularity, and even became something of a science. The powder, for example, could be measured out according to the film speed and aperture which the photographer wanted to use for his exposure. And there were fairly detailed charts available to make this possible. Nonetheless, the flash powder technique was still a primitive one with only a fine margin of error to distinguish lighting a picture from blowing up a bridge. The powder was ignited by a fuse and, with any luck, the camera lens was opened just before combustion. Needless to say, flash powder was extremely dangerous and difficult to use (particularly in a high wind), but there's no doubting its significant role as the ancestor of modern photographic lighting.

In principle, the modern flash bulb is not too far removed from flash powder, with some obvious and important modifications. Today the same combustion takes place within a sealed glass housing which contains a long

coiled filament of a highly combustible material such as zirconium. Sealed in the oxygen-rich atmosphere of the flash bulb, the filament is precisely measured to burn for a specified duration of mere fractions of a second, at a specified brightness level. A synchronizing circuit in the camera shutter supplies a weak electronic impulse that heats a tiny filament in the base of the bulb. As the heat builds up, it ignites a bit of explosive primer, which, in turn, ignites the filament. The sudden oxidation of the filament produces the light.

Probably the most obvious advantage of flash bulbs, and the reason why they were so popular among professional photographers for so many years, is the plain fact of their portability. Unlike incandescent and tungsten-halogen lighting, they require no fixed power source and, because they are small and extremely lightweight, hundreds can be transported easily in a camera bag. In addition, since flash bulbs are strictly *intermittent* (as opposed to *continuous*) light producers, they can be manufactured to create very high illumination levels, without demanding a con-

The popularity of electronic flash is partially owed to the economy and compactness of modest little units like this one, powered by low-voltage penlight batteries or rechargeable nickel-cadmium batteries.

stant drain from some electrical power source. And, finally, they have the added advantage of a lighting duration fast enough to "freeze" the action of a subject.

Among the more obvious disadvantages of flash bulbs is the fact that the combustion required to produce adequate illumination for a photograph is not completely instantaneous. There is an appreciable delay between the moment when electricity is introduced to the bulb from the camera shutter contacts and the eventual production of peak illumination.

In addition, flash bulbs are expensive, since each bulb is capable of producing only a single flash. For the occasional shooter, of course, they still offer a pretty convenient option for artificial lighting, and the introduction of multibulb "flashcubes" and "flashbars" has taken much of the hassle out of flash-bulb photography. Nevertheless, from the standpoint of truly serious photography, the photoflash lamp can only be characterized as an interim step in the evolution of a much more powerful and efficient means of light production: the electronic flash unit.

Electronic Flash

The idea for a strictly electrical, high-speed artificial light source actually predates the widespread use of flash powder. In 1851, William Henry Fox Talbot, the noted photographic pioneer, received a patent for such a device, which professed to "stop" action on film by illumination from an open-air spark. It was not until nearly a century later, however, that the principle emerged in a practical form. In 1931, Dr. Harold E. Edgerton developed his famous high-speed "stroboscopic" light source for use in conducting motion studies at the Massachusetts Institute of Technology.

Unlike the photoflash lamp, which was already a well-entrenched lighting tool, the stroboscope was capable of generating rapid repeating light pulses, and it became the prototype for the modern electronic flash.

As set down by that original design in Dr. Edgerton's laboratory, the basic principle behind the operation of today's electronic flash units (which also go under the excusable but slightly imprecise diminutive, "strobe units") is the instantaneous production of light energy that occurs when a powerful electrical charge is allowed to pass between two electrodes. The power source for this process is either standard AC electrical current or, in the case of portable flash units, one or more batteries.

The power source supplies energy to a high-voltage storage capacitor, where it accumulates until it is allowed to pass between two electrodes located in the flashtube. The sealed glass tube is filled with an inert gas—xenon—and connected to the unit's circuit at either end of its length. Between the tube and the storage capacitor is a small triggering circuit, which can be completed by the closing together of two metal contacts that are activated by the camera's shutter release. When this occurs, stored electrical energy surges to the flashtube and rapidly ionizes the molecules of xenon. In this state, the gas becomes electrically conductive, effectively completing the circuit and allowing the remainder of the energy in the capacitor to rush between the two electrodes, producing a brilliant flash of light as it does so.

Once the accumulated energy has been drained from the capacitor, the voltage quickly drops and the gas returns to its molecular, nonconductive state. With the circuit thus reopened, the capacitor again begins to store energy from the power source, until the triggering circuit reactivates the process for the next flash.

Far different from the relatively sluggish sequence of a flash bulb, an electronic flash pulse occurs without delay, as soon as the contacts in the camera activate the triggering circuit. Depending on the power of the unit, the total duration of the flash burst will occupy between 1/200 and 1/10,000 second, and it is the extraordinary speed of this process that imputes to strobe its reputation for acute action-stopping ability. But speed is only one of the legion advantages to which modern electronic flash units lay claim. Let's have a look at some others.

Daylight Color Temperature

Like no other type of artificial light source (with the exception of certain special makes of flash bulb), the color temperature of light produced by a strobe unit is between 5500°K. and 7000°K., roughly equivalent to the color temperature of daylight. This means that strobe can be used with any color film emulsion balanced for daylight—which includes the vast majority of color films available today—and can also be used in combination with sunlight illumination.

Power/Size Ratio

The astonishing advances that have been made recently in the technology of miniature electronic components have brought modern strobe units to represent incredibly powerful

The ingenious circuitry of automatic strobe units allows them to regulate their own light output to produce perfectly exposed pictures. Light reflected back from a subject is instantaneously measured by the photocell, which diverts current away from the flashtube. Excess energy is discharged internally by the unit's "quench tube."

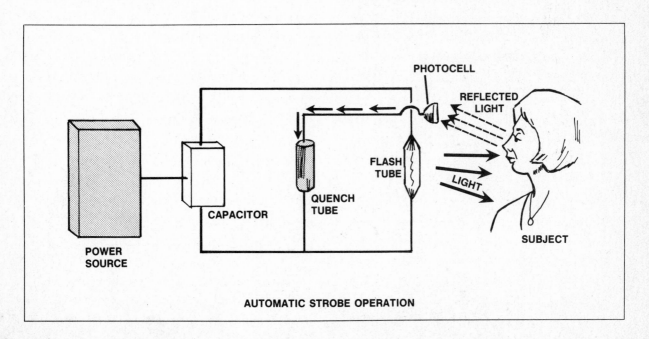

AUTOMATIC STROBE OPERATION

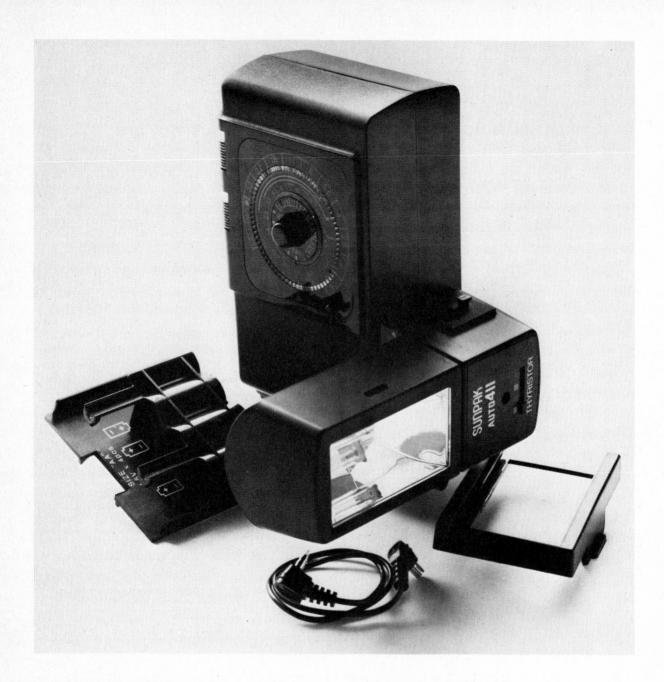

light sources for their size. An inexpensive, portable strobe unit, powered by tiny batteries, can produce light output equivalent to that of a tungsten-halogen light source that is 20 times its size and weight. And the strobe unit does not require a fixed source of power!

User Comfort

Because the duration of an electronic flash unit's light output is extremely brief, neither the photographer nor his subject need suffer from the heat that accompanies other kinds of

Modern automatic portable strobe units like this one are now available with ''thyristor'' circuitry, which shortens the recycle time and saves energy. Such units are often manufactured with a full line of accessories and can operate on either low-voltage batteries or AC current.

High-powered professional electronic flash units usually require a large power pack to be separate from the flashtube. Such units operated exclusively on AC current and are designed for use in studios or for serious location work.

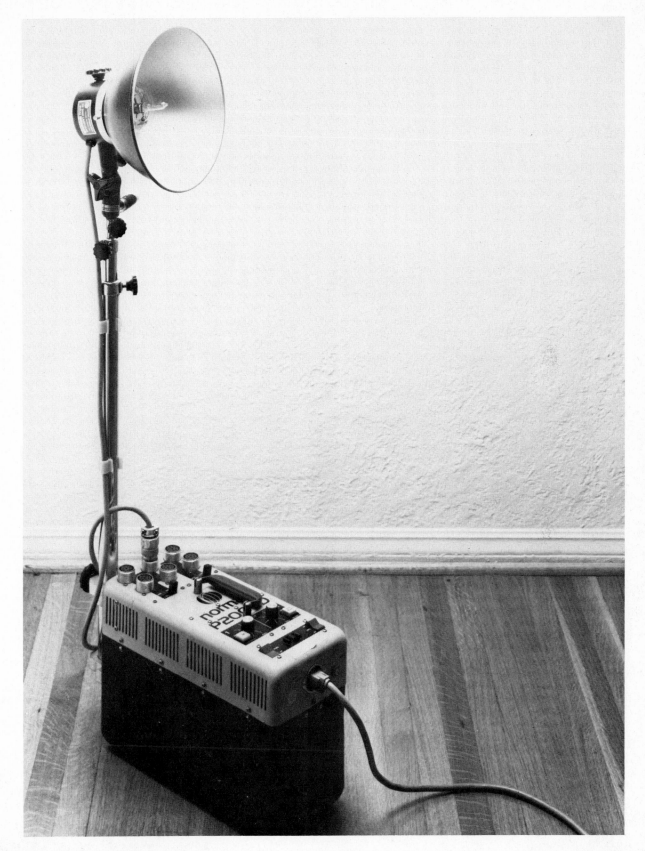

Electronic flash's short duration makes it great for catching fleeting expressions.

(Left) Electronic flash won't "melt" your models as hot incandescent lamps may, nor will it make subjects squint as bright continuous light sources do.

light sources. This is not only beneficial to live models and portrait subjects, but is an extreme asset for photographing perishable or heat-sensitive inanimate objects as well. In addition, this brief light duration permits a subject to pose for your camera in the relative ease of natural, ambient room light, rather than under the unfamiliar glare of photofloods or tungsten-halogen bulbs.

Economy and Convenience

Like photoflash bulbs, electronic flash offers the advantage of portability. Many strobe units on the market today are barely larger than a pack of cigarettes. But unlike flash-bulb illumination, strobe is relatively inexpensive. While a standard "flash gun" for use with bulbs might cost less than the initial investment for a strobe unit of equivalent power, the strobe is capable of thousands of flashes with a periodic change of batteries. Flash bulbs, on the other hand, must be continually replaced—a

fact which, in the long run, makes electronic flash a far less costly alternative. And this economy extends into the realm of the large nonportable strobe units designed for use in the studio. With many such units, a single flashtube can deliver 50,000 flashes, and more, before it must be replaced, while a continuous light source of equivalent power would require several bulb changes in the course of that many exposures.

Basic Types of Electronic Flash

The current family of electronic flash equipment falls neatly into three categories, distinguished mainly by the different power source which each utilizes.

The first category comprises the smallest portable strobe units, which are ordinarily powered by low-voltage alkaline or nickel-cadmium batteries. While these units are by far the least expensive to own and operate, they offer comparatively weak light output, and are therefore a little handicapped as far as versatility is concerned. The newer models are usually good for about 200 flashes on a set of batteries, which can become restricting if you shoot a lot of flash pictures. Nevertheless, to a serious photographer, they can be extremely useful for shots that involve several strobe units fired simultaneously. This application will become more apparent in a later chapter.

From the dual standpoint of cost and performance, the larger, more powerful electronic flash unit represents the paradigm of convenience and versatility. Strobes in this category usually feature rechargeable self-contained power sources—dry-cell batteries or nickel-cadmium cells—and nearly always offer the alternative of operation with AC current as well. At least one such unit on the market today can be used with AC current or, portably, with a nonrechargeable 510-volt dry-cell battery that is carried externally from the unit itself. Strobes of this type, which required the extra bulk of a "battery pack" when used remote from an AC power source, compensate for their relative inconvenience by producing comparatively high levels of light output.

Within both of the above categories, there is now another classification for portable strobe units, which is distinguished by a truly remarkable convenience feature—automatic operation.

What "automatic" refers to in this case is precise control over light output in a given exposure situation. You'll be reading a good

deal more about the problems and procedures involved in producing correctly exposed pictures with electronic flash. But for now, suffice it to say that automatic strobe units simplify the problem of calculating flash exposures by an ingenious mechanism that allows the strobe to regulate its own light output according to the level of illumination required for a certain photograph. The backbone of that mechanism is a photocell that measures the amount of strobe light reflected back from a subject.

Having first been programmed by the photographer according to the film speed and lens aperture he has selected for a shot, the photocell "knows" when the subject has received sufficient illumination for a proper exposure. Astoundingly enough, this determination is made within the sparest fraction of a flash burst—which we've already seen is itself extremely brief. At this point, a secondary circuit is activated, which draws away any electrical energy that is still on its way to the flashtube, effectively cutting short the total duration of the flashtube's pulse of light. This is accomplished by means of a secondary flashtube—the "quench tube"—located within the strobe unit. This tube functions very much like the primary tube, except that it does not produce any usable light. Instead, when the xenon gas inside the quench tube becomes conductive, it merely diverts the remaining energy from the capacitor, and prevents it from reaching the flashtube and prolonging the burst of light. In effect, the quench tube becomes a "dumping ground" for the capacitor's surplus voltage.

Many of the recent automatic strobes on the market feature an even more exotic mechanism for regulating flash duration. The energy-saving "thyristor circuit" also prevents surplus voltage from reaching the flashtube, but, unlike the quench system, it prevents this energy from leaving the capacitor at all. By activating a switch on command from the photocell, the thyristor circuit quickly cuts off movement of electrical energy from the capacitor, conserving the remaining power and shortening the interval during which the photographer must wait for the capacitor to become fully charged again.

Whether or not you consider the relatively effortless techniques of working with automatic strobes to be consistent with your own creative needs, you've got to admit that they represent compelling testimony to the sophis-

Since electronic flash is present only when you trigger it, subject feels more relaxed and natural than with continuous incandescent lighting.

tication of electronic flash technology.

Our third major category of strobe units is less distinctive for exotic circuitry than it is for sheer power. The heavy, AC-power studio flash units used by many professional photographers are geared toward satisfying one primary requirement—consistently high levels of light output. In competitive career fields like portraiture, industrial photography and commercial illustration for advertising and magazines, the professional must be equipped to handle any situation a client might propose. And, while his routine assignments may rarely require using his strobe unit's maximum out-

put, the working photographer knows that he must have the potential of high illumination levels to accommodate those special assignments where such levels are vital. For obvious reasons, AC current is preferable to batteries as the power source for creating intense light output with an electronic flash. Its already high voltage level can be quickly transformed into the higher voltages needed, not only for increased illumination levels, but also to expedite the recharging of a unit's capacitors.

Confined as they are by the need to operate near power outlets, strobe units in the studio category are designed less for portability and convenience and more for features that allow the photographer precise control over not just power, but critical factors that affect lighting "quality" as well. Since techniques for varying light direction, angle of illumination, or output ratios among several units used simultaneously all affect the "quality" of light, studio strobes are frequently equipped with a wide variety of accessories. Such accessories can include things like "modeling lights" to aid in previewing the effect of a flash burst on the way in which a subject will be recorded on film. In addition, most studio strobes are compatible with a variety of metallic and fabric reflectors, as well as provisions for "fine tuning" light output in small, precise increments. There are even features like audible buzzers to signal full capacitor recharging, and remote triggering devices permanently built into such strobe units to anticipate even the most unusual applications.

For reasons I listed earlier in this chapter, electronic flash can add a whole extra dimension to your photography, no matter what kind of unit you own. If you think of photography as a language, you can also think of your strobe unit as a significant addition to your vocabulary. But, first, you've got to know the meanings of the "words," which is what the next chapter is all about.

The Practical Basics

If you've ever watched a nighttime football game on television you've probably noticed a puzzling phenomenon that occurs in the grandstands, usually during halftime. From out of the darkened sea of humanity in the upper reaches of the stadium will occasionally come sporadic pinpoint bursts of light. It's not rifle fire or people lighting cigarettes; those are electronic flash units going off, hundreds of them sometimes, if the game is an important one—hundreds of people shooting pictures of activity on the field a great distance away using tiny, battery-powered strobe units that, with any luck, could illuminate the heads of spectators four or five rows in front of them.

When these photographers get their pictures back from the lab, one wonders if they are ever distressed by the fact that the Homecoming Queen is invisible and all they've gotten for their efforts is the backsides of some fellow football fans. Perhaps not, but nevertheless, they provide us with model examples of photography's most classic problem: the tendency of the photographer to overrate the capabilities of his equipment. This most often results from ignorance of the basic principles that make pictures happen in the first place.

As this applies to electronic flash, those optimistic snapshooting spectators at the football game are apparently oblivious to the basic axioms that govern the use of any kind of artificial lighting equipment, strobe or otherwise. These axioms are not necessarily complicated or difficult to master, and for this reason, you shouldn't expect to develop any sort of skills with flash until you've assimilated some very fundamental notions: the Inverse Square Law, the rule of F, the relationship between distance and aperture, guide numbers and synchronization.

The Inverse Square Law

The Inverse Square Law is the basic tenet that governs the correct application of *any* type of artificial light source—incandescent, tungsten-halogen or electronic flash. It's especially critical to electronic flash, since it is the Inverse Square Law on which all calculations for rating the output of strobe units are based, and it also provides the basis for the system by which correct flash exposures are determined.

In its standard textbook form, the Inverse Square Law states: "At a point on a surface receiving radiation from a point source, the irradiance (or illuminance) diminishes as the square of the distance from the source is increased." (From the *Dictionary of Contemporary Photography,* Morgan & Morgan, 1974, by Leslie Stroebel and Hollis Todd.) Among physicists, the Law is expressed as an equation: $D = I/d^2$, but among photographers it need not be so complicated.

Put simply, the Inverse Square Law describes what happens to the amount of light on a subject when the distance between the subject and the light source is altered. Ac-

THE INVERSE SQUARE LAW

The inverse square law is the basis for our understanding of the relationship between distance and illumination level. As such, it is also basic to flash exposure calculations. The law states that the intensity of light decreases as the square of the distance between light source and subject increases. The law is explained in detail in the text, and though it doesn't have to be memorized, understanding the principle behind it is fundamental to understanding photographic lighting.

THE RELATIONSHIP BETWEEN LIGHT-SOURCE-TO-SUBJECT DISTANCE AND CORRECT EXPOSURE

This table shows the inverse square law at work in a practical photographic application. As the light source is moved away from the subject, the amount of light falling on that subject diminishes by 1/distance². Our sample here assumes a light source and film combination which would yield a properly exposed picture with the light source placed eight feet from the subject and the lens aperture set at f/8. The photos at the top of the chart show how the values of the shot would be altered by changing the light source distance without commensurate adjustments of aperture. Note that when the distance is reduced by half—from eight feet to four feet—the picture becomes overexposed by four times, or two f-stops. The converse is true as the distance is increased. The row of lens apertures shows the various f-stop adjustments required for each change in distance.

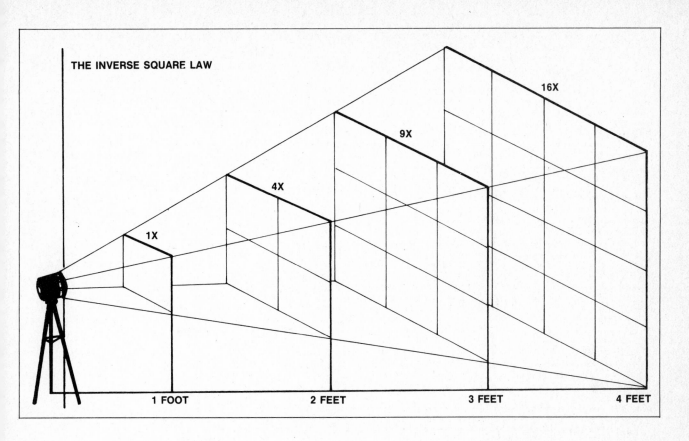

THE INVERSE SQUARE LAW

1X — 1 FOOT
4X — 2 FEET
9X — 3 FEET
16X — 4 FEET

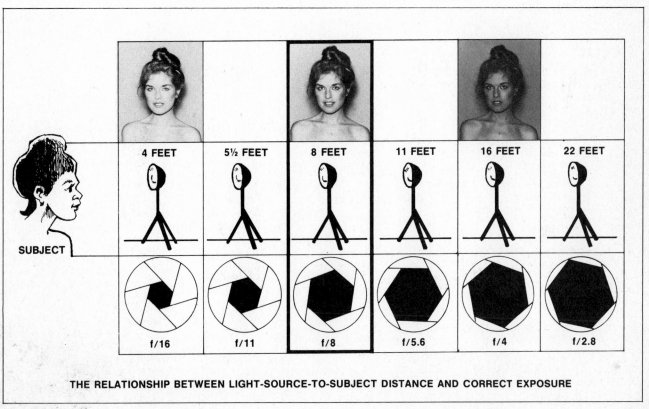

SUBJECT

| 4 FEET | 5½ FEET | 8 FEET | 11 FEET | 16 FEET | 22 FEET |
| f/16 | f/11 | f/8 | f/5.6 | f/4 | f/2.8 |

THE RELATIONSHIP BETWEEN LIGHT-SOURCE-TO-SUBJECT DISTANCE AND CORRECT EXPOSURE

cording to the Law, when you change the distance of the light from one position to a second position, the squared ratio of those distances will describe the change in illumination on the subject. So, doubling the distance between a light source and a subject would reduce the light reaching that subject to ¼ of the original illumination.

Let's assume, for instance, you have a light source placed one foot from a subject, and you double that distance by moving your source back to two feet from the subject. The Law states that you're not simply cutting the illumination level in half, as you might suspect. You're reducing the intensity of the light on the subject by four times (two squared = four). If you now increase the subject-to-light-source distance to three feet, you've decreased the illumination level to 1/9 its original intensity (three squared = nine).

The accompanying diagram should make the Inverse Square Law a little clearer to you. Examine it carefully, since the relationship between distance and illumination level that the Law describes is an all-important consideration for mastering the technique of electronic flash photography. But even if you don't care to bother with the Law, at least bear this much of it in mind: As the light is moved away from or closer to the subject, the illumination level changes very quickly. So, to make a correctly exposed photo, you have to know how to compensate for changes in light level. The tool that we use to make that compensation represents our next important fundamental—one that you're probably a little familiar with already.

An abbreviated version of the simple exposure test by which an electronic flash unit's true guide number can be established. A series of shots is made on Kodachrome 25 film, with the flash unit positioned 10 feet from the subject. Kodachrome is chosen for its narrow latitude of errors in processing. The resulting transparencies are carefully inspected to find the "best" exposure. In this case, that is the picture made at f/8. Multiplying that f-stop by the distance—10 feet—establishes a true guide number of 80 for this particular flash unit. This guide number is accurate for the unit only when it is used in the configuration chosen for the test. The addition of diffusers over the flashtube or the use of umbrella reflectors have a significant effect on the unit's illumination capability. Guide-number tests should be made for every configuration you might use set up your strobe unit.

The Rule of F

F-numbers, as you know, indicate the amount of light transmitted by a lens, and provide the photographer with a convenient system for selecting apertures. Another function of the f-number is to express the relationship between the size of the opening made by the lens's iris and the focal length of the lens itself. On modern lenses, f-numbers appear on the aperture ring as a series of "stops," and, as you also know, when you adjust the aperture setting from one stop to the next larger stop (for example from f/8 to f/5.6, remembering that as the numbers decrease the size of the aperture increases), you are *doubling* the amount of light coming through the lens. Conversely, if you change the aperture to the next smaller stop (say, f/8 to f/11), you thereby cut the amount of transmitted light in half. If you start with a given f-stop and adjust the aperture two stops larger (say, f/8 to f/4), you've now increased the amount of transmitted light by four times. Two stops in the other direction (f/8 to f/16), of course, would do just the opposite: decrease the amount of transmitted light to ¼ the amount coming through the lens at the original setting.

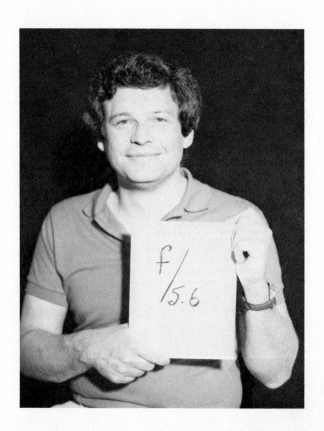

Like the Inverse Square Law, the rules that govern our system for calculating lens openings have a critical bearing on the correct use of flash equipment. We can see just how critical by bringing all the rules together for a moment.

Distance vs. Aperture

Although there are many criteria for defining what constitutes "a properly exposed photograph," let's for our purposes here assume this simple definition: *"a picture in which the necessary amount of light strikes the subject to allow the camera and lens to record a satisfactory image of the subject on film."*

We have just seen two important ways by which the process of making a correctly exposed picture with a flash unit can be affected. From the Inverse Square Law we can calculate the effect of the distance between the flash and the subject, and our knowledge of f-stops tells what happens when we adjust the aperture setting on the lens. In other words, the way in which a subject illuminated by electronic flash will be recorded on film is a function of both *flash-to-subject distance* and *aperture.* The relationship is illustrated by the chart on page 25.

Let's assume that a correct exposure of our subject would be obtained with the flash unit placed eight feet away from his position and the lens aperture set at f/8. (Don't worry right now about how we made that determination. That will be discussed shortly.) The chart indicates to what degree our picture would now be under- or overexposed by altering the distance between flash and subject. Let's assume, for example, that we double the flash-to-subject distance from 8 to 16 feet. The Inverse Square Law tells us that by so doing we have decreased the amount of light on the subject to ¼ of its intensity at the original distance. Since each f-stop transmits only ½ the amount of light as its next larger neighbor, we can see that doubling the distance is the equivalent of stopping down two f-stops. The photos within the chart show the degree to which these changes affect the picture itself. In other words, our picture would now be two stops underexposed. If, on the other hand, we moved the flash unit to four feet from the subject, cutting the distance in half, that would be equivalent to *overexposing* by two f-stops. In short, changes in flash-to-subject distance can be translated directly into changes in f-numbers.

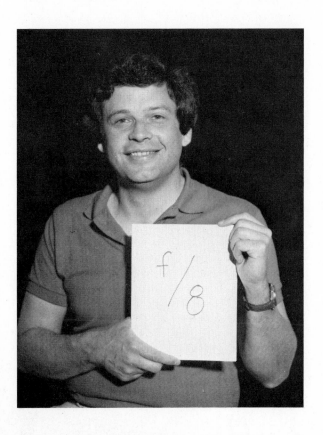

The Guide Number

With the understanding you now have of the way in which distance correlates with f-numbers, you are ready to examine this relationship from the standpoint of maintaining constant exposure when the subject-to-flash distance changes. Refer again to the chart on page 25 (Inverse Square Law). Suppose that the so-called correct exposure called for a distance of eight feet and aperture of f/8 and we doubled the flash-to-subject distance. We already know what the effect would be on our picture—two stops underexposure. As the chart shows, we can compensate for that change in distances by opening the aperture two stops. Remember that by doubling the distance we had reduced illumination on the subject by a factor of four. So, to keep the amount of light striking the film constant, we must therefore quadruple the amount transmitted by the lens. As we've observed, that requires a two-stop increase.

You probably already know that the process of exposure calculations with electronic flash doesn't require you to continually refer back

Featured on most portable electronic flash units is a calculator dial like this one to aid in exposure computations. The dial also provides a quick reference for optional distance-aperture combinations in a given shooting situation. Don't forget that the calculator is designed according to the manufacturer's guide number and should be recalibrated for the unit's true guide number.

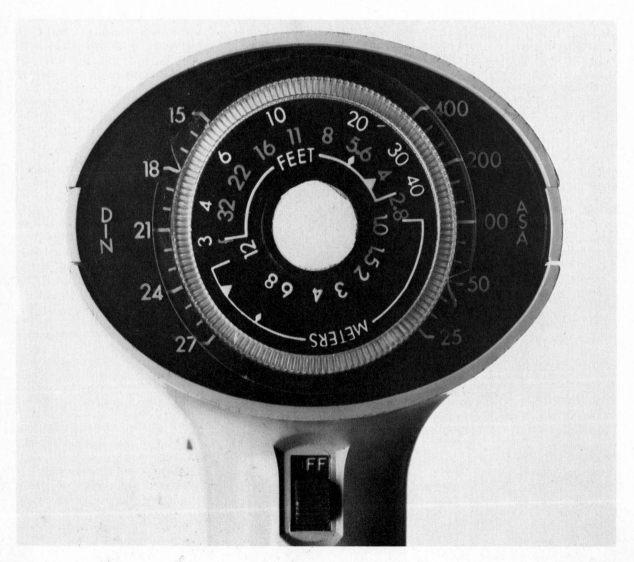

to charts like ours every time you take a picture. The information that is illustrated by this chart, however, is crucial to arriving at one very important number; that's the number you actually use for exposure calculation with your electronic flash unit. It's commonly known as the *guide number* and is simply an expression of a flash unit's output based on the distance/f-stop relationship we've just been discussing.

If you multiply each f-number on the scale by its corresponding footage value (for instance f/4 X 16 feet, f/8 X 8 feet, f/11 X 5½ feet, f/16 X 4 feet), you'll find that the result is roughly the same for every f-stop-distance combination on the scale—somewhere around 64. That figure would represent the guide number for the flash unit we used in our example. It is a constant that expresses the relationship between distance and f-stop for that particular strobe unit, and it is determined, just as we did, by the formula:

Distance (for correct exposure) X f-stop (for correct exposure) = Guide Number

Guide numbers are assigned to electronic flash units by their manufacturers. Supposedly, the manufacturers base their guide numbers on exhaustive product tests to determine what set of distance/aperture combinations produce correct exposures with their particular flash unit.

Remember, however, the "correct exposure" is a highly variable criterion subject to the obvious factor of film speed and many less obvious factors like latitude in development times and printing, or simply the subjective evaluation of the person conducting the guide number tests. Therefore, to minimize these variables, the guide numbers provided by flash manufacturers are nearly always based on tests made using Kodak Kodachrome 25 film. Since Kodachrome is a transparency-type emulsion, rather than one that produces a negative, and since it is processed under very rigid standardized conditions, it's a brutally honed indicator of whether or not the film has been properly exposed. No manipulation in processing time or printing techniques is possible. That's why, when we speak of a strobe unit's assigned guide number, we usually refer to it as the "Kodachrome guide number."

Exposure calculation based on an electronic flash unit's guide number is, obviously, quite simple. In any given shooting situation, you simply determine the distance between your strobe unit and the subject, then rearrange the above equation to find the unknown quantity, which will be your correct aperture setting:

f-stop = Guide Number ÷ Distance (flash-to-subject)

Thus, if a flash unit has a Kodachrome guide number of 80 and you're shooting a picture on Kodachrome with the flash unit positioned 10 feet from your subject, you would set your lens for an aperture of f/8:

f/8 = 80/10 ft.

In the same way, if your flash-to-subject distance was 20 feet, you would choose f/4 for correct exposure (f/4 = 80/20), and so on.

Needless to say, when you know a strobe unit's Kodachrome guide number, you can make accurate exposure calculations for any other type of film, merely by adjusting the guide number to the speed of the film you're using. A film with an ASA rating of 50, for example, is "one stop" faster than Kodachrome, which has a rated speed of ASA 25. This means that correct exposure for the new film will require one stop less light than Kodachrome. In the above situation with the flash placed 10 feet from the subject, that would mean stopping your lens down to f/11. Going back to our first formula then, you can now determine the correct guide number for your strobe unit when used with the new film: f/11 X 10 feet = 110, so 110 is the guide number for use with the faster film, and as we've seen, it will be accurate for any flash-to-subject distance you choose.

Determining True Guide Numbers

The determination of correct exposure settings is one obvious point of guide numbers. For reasons that are fairly apparent by now, the guide number is also a convenient expression of a strobe unit's relative power. If you refer to our guide number formula, it's clear that the higher the guide number, the more power that unit produces and the more effectively it can operate at smaller apertures. For this reason, the guide numbers by which manufacturers rate their products are sometimes exaggerated in order to make their units more competitive with those of other manufacturers.

In addition, even the most comprehensive field testing to determine the correct guide number for a strobe unit has inherent liabilities. Not the least of these is the basic impracticality of testing every unit that comes off the assembly line, and the true guide number for a "representative unit" of any particular model might not be accurate for all other units of the same model. Nor do manufacturer's tests take into account the broad variety of variables that can affect a strobe's performance—variables like working frequently with subject matter that is very dark or very light.

So, no matter what guide number has been assigned to your unit at the factory, it always behooves you to conduct your own tests under the shooting situations you encounter most, in order to establish the truest possible guide number for the flash unit you use. The procedure for accomplishing this is fairly straightforward:

Set up your camera and strobe unit in an area typical in size and reflectivity to the type of location you work in most often. On a series of white cards—large enough to be readable—inscribe f-numbers that correspond to the widest range of f-stops you want, depending on the relative power of your unit. For academic purposes, you might number the cards starting with the largest aperture on your lens, say f/2.5 or f/1.7, and mark them sequentially up to the smallest aperture possible with that lens, probably f/22 or f/32.

Now place a typical subject in front of the camera, position your strobe unit 10 feet from the subject, and on Kodachrome shoot a series of exposures, each at a different f-stop, with the appropriate card placed close to the subject so that it will show in the finished picture. If you like, you can also include such control devices as a 10-step gray scale or color patches for critical evaluation later on. But by far, the simplest criterion for evaluating correct exposure is normal human skin tone, so, if possible, use a person as your subject.

After the film has been processed, examine it carefully for the one frame that shows the best exposure according to whatever your personal criteria for "best" might be. Now, take the f-number that appears on the card in that particular frame, multiply it by the distance—10 feet—according to our first equation, and you have the true guide number for your flash unit. If, for example, the best exposure was made at f/8, your working guide

number for that unit would be 80 (f/8 X 10 feet = 80), even if the manufacturer rates that unit at 110.

It should go without saying that even the guide number you yourself assign to your strobe unit is not necessarily valid for every shooting situation you encounter. Rooms with very reflective wall surfaces, for example, can alter the results of your exposure calculation with your guide number, as can any other special circumstance that affects the light from your strobe unit differently than the conditions under which you made your tests. Also bear in mind that the guide number is only accurate for the strobe when it's used in the same conformation as it was during the test. If, for instance, you change the reflector on the flash head, or add accessories like diffusing material to the head, some exposure compensation will be necessary. If you use such accessories a lot, it's wise to make a separate series of guide number tests for each different conformation.

Alternative Methods for Determining Exposure

To aid you in making fast exposure calculations based on your unit's guide number, many units feature some sort of built-in calculator located on the top or rear of the flash head. These calculators typically feature a movable scale like the one illustrated on page 28, whereby you can align all of the correct distance-aperture combinations simply by setting the scale for the ASA rating of the film you are using. Then, directly opposite the flash-to-subject distance (on the distance scale) will be the proper f-stop to use (on the f-stop scale). You can quickly determine your correct exposure setting in this way with no mental arithmetic required.

Bear in mind, of course, that the built-in calculator has been calibrated according to the *manufacturer's guide number*. If your guide number tests differ from his, you'll have to recalibrate the calculator to accommodate the unit's true guide number. For example, if your best test exposure is one stop over what

Most conventional exposure meters are incapable of reading the brief light pulse produced by electronic flash. Specially designed flash exposure meters like this one are required instead. Many feature a sync cord connector that allows the photographer to stand at some distance away from the flash unit and then manually trigger it for an exposure reading.

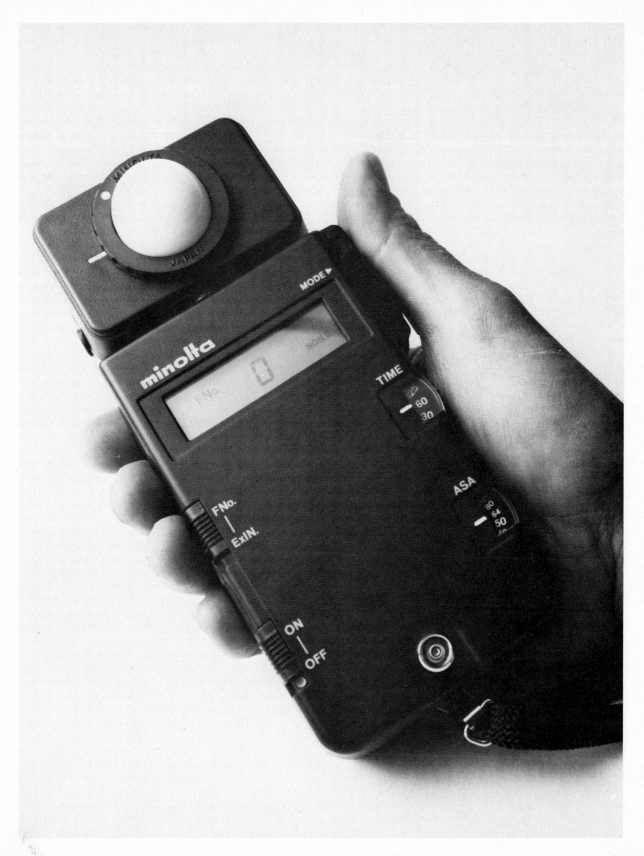

the manufacturer's guide number suggests it should be at 10 feet, simply remark the ASA indicator on the calculator dial so that it can be set consistently for speeds one stop slower than the true ASA ratings of your film.

If you're puzzled at this point about how you can accurately measure the flash-to-subject distances required by both the guide number method and the calculator method of determining exposure, be assured that there's no mystery involved at all. Nearly every good adjustable camera lens has a footage scale clearly marked on the focusing ring of the lens barrel. If you're using a strobe unit that's mounted on the camera, you have only to focus on your subject, then refer to the footage scale for the correct distance. Flash-to-subject distance and camera-to-subject distance are, in this case, identical. If, on the other hand, your strobe unit is mounted off-camera (the techniques for which are discussed later on), the easiest method for measuring off the flash-to-subject distance is to step to the flash position, focus on your subject, and, again, refer to the lens' footage scale. You'll probably have to refocus when you return to your shooting position.

One of the great advantages of using your unit's built-in exposure calculator is that, beyond providing you with the correct aperture for the flash-to-subject distance you've

The all-important distance computation involved in determining correct exposure with electronic flash is simply accomplished using the footage scale printed on your camera's lens barrel. This same method can be used with flash off-camera as well. Move to the position of the flash unit, focus on your subject to determine the distance, return to the original camera position, refocus and shoot.

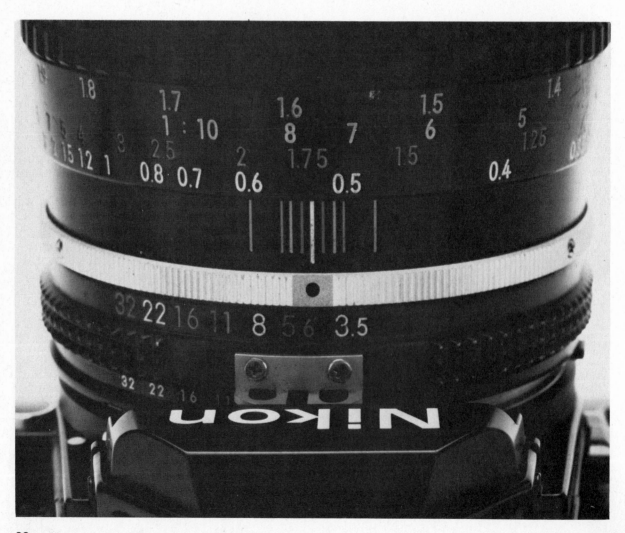

chosen, it also gives you an instant reading of what your optional distance/aperture combinations are. Suppose that you place your strobe 10 feet from the subject and calculate the correct f-stop for that distance as f/11. If you're shooting, say, a portrait, f/11 might not be the f-stop you really want to use. Perhaps there's some distracting detail behind the subject which you'd like to throw out of focus, and at f/11 your lens provides too much depth of field to do so. An aperture of f/5.6, however, will shorten your depth of field to provide a more pleasing portrait, so you merely scan the calculator dial for the distance that corresponds to f/5.6 (in this case, that

Most modern cameras have two separate synchronization terminals—one (FP) for use with flash bulbs, and the other (X) to provide zero-delay firing of electronic flash by the camera shutter.

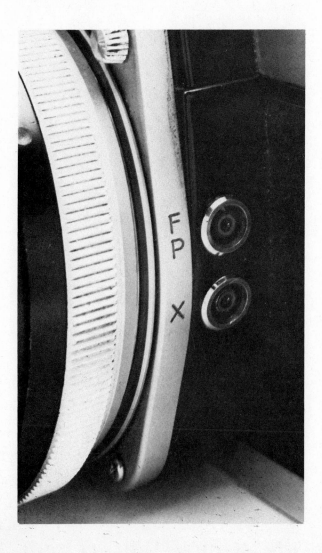

distance would be 20 feet) and reposition your strobe unit accordingly.

If you use your strobe unit frequently under similar types of shooting conditions, either the guide number method or the built-in calculator is perfectly adequate for determining correct flash exposure. If, on the other hand, you find yourself working in environments that vary a great deal in size or reflectivity, a far better means of ensuring accurate exposures is to use a flash exposure meter.

Because of the instantaneous light emission characteristic of electronic flash, conventional exposure meters are incapable of "reading" the amount of light produced in such short duration. Several manufacturers, however, offer special exposure meters constructed to catch and record the burst of an electronic flashtube. Naturally, in order to make an exposure reading with such a meter, you must manually fire the flash before actually making your exposure. Since most good flash meters are the "incident" type, a correct reading must be obtained by holding the meter near the subject position and having an assistant trigger your strobe manually. Several flash exposure meters fortunately feature extension cords that plug into the strobe's synchronization terminal, allowing the operator to fire the flash remotely, while holding the meter near the subject. Even that, however, entails considerably more effort than the more basic methods for exposure determination, and, needless to say, flash meters are not very useful in those candid "grab shot" situations.

Automatic Flash Exposure Control

As we mentioned earlier, one type of strobe unit requires no exposure calculation on the part of the photographer. With the automatic electronic flash this calculation is a *fait accompli*.

There's no question that these automatic units are of great value for many types of picture-taking situations—particularly those obvious moments when a candid shot opportunity might be lost while the photographer is busily occupied juggling f-numbers and distances around in his head. However, you have to accept the fact that most of the automatic units on the market are limited in their effective distance and aperture ranges. This can represent an important handicap to a serious photographer who requires maximum versatility in a strobe unit. Fortunately, the majority of top-quality electronic flash units featuring au-

tomatic operation also offer manual operation as well, making such a unit a very good investment for the photographer who might occasionally make use of the automatic mode. And, thanks to some recent dramatic developments in the design of automatic strobe units, some of the more patent liabilities have been successfully eliminated.

One such liability was the limitation of the automatic flash in bounced lighting setups (which will be discussed in a later chapter). Since early models of auto units usually featured a sensor attached to the flash head, correct automatic exposure was impossible when the head was directed away from the subject toward a reflective surface. Most current units, however, now allow the sensor and the flash head to be directed independently, so that, even in the bounced mode, the sensor still reads only that light reflected from the subject—as it must to properly control exposure. No doubt other advances in the technology of auto electronic flash will someday make it an all-round tool for all strobe applications. But meanwhile, the complete versatility for exposure control needed by the serious photographer is still the exclusive province of the manually operated strobe.

Two other exotic flash exposure control devices deserve at least passing mention here. One is the *guide number lens*. This type of lens can be useful to a photographer who uses on-camera strobe a great deal, especially if he works over a wide range of distances from his subjects. The guide number lens is designed so that, as the photographer focuses on his subject, the aperture is simultaneously adjusted for correct flash exposure, depending on the guide number he has preselected on the lens barrel. Like the automatic strobe unit, the guide number lens is most advantageous for candid, quickly changing shooting situations, in which exposure calculations are difficult.

Dedicated Flash

A second and very recent innovation is Dedicated Flash, which provides automatic flash exposure control for use in conjunction with automatic cameras.

Synchronization

You may have noticed that during the foregoing discussion of exposure with electronic flash we have made no reference to one special function of a camera that photographers usually think of in terms of exposure control. That function is the camera's shutter speed.

For conventional shooting situations, obviously, the shutter speed works hand in hand with aperture to determine the amount of light that will strike the film plane during an exposure. In electronic flash photography, however, shutter speed is, with a couple of major exceptions, a matter of little consequence. Here's why:

As we saw in the previous chapter, the actual duration of the discharge from an electronic flash tube is very brief, between 1/200 second and 1/10,000 second, depending on the type of strobe unit. Since shutter speed controls the *duration* over which a single frame of film is exposed to light, there has to be a way of reconciling shutter speed duration with the duration of the flash burst. With the extraordinary speed of most flash discharges it should be obvious that altering shutter speed will have very little effect on the amount of time the film is exposed, so long as the shutter remains open long enough for the film to "see" the entire burst of light. This is why when talking about exposure times with electronic flash we refer to the "duration of

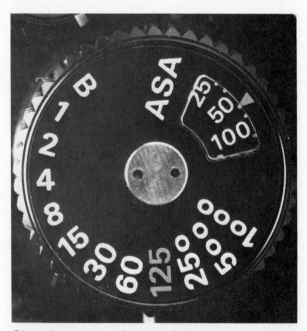

Since focal-plane shutters of the majority of cameras on the market today will not synchronize with electronic flash at very high shutter speeds, the maximum allowable sync speed is usually indicated on the shutter speed dial (here it is indicated as 1/125 second).

the flash'' rather than the actual shutter speed at which the camera was set. Needless to say, this applies only to those situations in which the strobe unit provides the sole illumination. Shutter speed obviously takes on major significance when the electronic flash is ''mixed'' with daylight or some other continuous light source. We'll discuss that later.

Although shutter speed is not an important tool for exposure control with electronic flash, it can nevertheless become an arch villain if its role is not completely understood. To see why that's true, let's first review a couple more fundamentals.

Most modern cameras have two separate settings for the terminal to which a flash sync cord can be connected. These are often simply two separate terminals, one marked either ''M'' or ''FP'' and the other marked ''X.'' The FP or M terminal, as your camera instruction manual points out, is for use with conventional flash bulbs, which usually take around 1/50 to 1/60 second to reach maximum light output after they have been fired. The M or FP terminal mechanically ensures that the bulb will be ignited before the shutter opens, giving the light a ''head start'' so it will reach its maximum level when the shutter is fully opened.

The X terminal, on the other hand, is designed to accommodate the instantaneous burst of an electronic flashtube, which reaches its maximum brilliance immediately on firing. The X (or ''zero delay'') terminal insures that the shutter will actually begin to open *before* the flashtube fires, so that it will be fully open when the illumination level is at its peak. In the case of leaf or ''between-the-lens'' shutters, which open in a radial fashion like the lens iris, the peak level of illumination will, with almost all strobe units, occur when the shutter is at its maximum opening, no matter what the shutter speed happens to be. However, on cameras that feature focal-plane shutters, like the popular single-lens reflex models most of us use, the story can be quite different.

The focal-plane shutter, as you know, works on a special principle whereby light reaches the film through an opening between two moving curtains. It is the width of this opening, and not the speed of the curtains as they travel across the film plane, that actually regulates the shutter speed, and vice versa. Most modern focal-plane shutters cannot synchronize with the burst of a flashtube at speeds faster than 1/60 second. It is only at slower shutter speeds that the curtains are ever separated enough for a single instant to allow the flash burst to expose the entire area of a single frame all at once. You can usually see very graphically the results of improper synchronization with a focal-plane shutter. The hard line that cuts off part of your frame in an improperly synchronized strobe shot is simply the shadow of the shutter curtain, which was not opened wide enough to allow the whole frame complete exposure to the instantaneous burst of light from the flashtube.

Most camera manufacturers indicate the maximum sync speed for their focal-plane shutters by printing it in red on the shutter-speed selector dial. In most of the indoor applications for which strobe is commonly used, this particular limitation of focal-plane shutters is of minor import—providing you ensure that your shutter-speed selector is set at a proper sync speed before you attempt to shoot flash pictures. Where it can become a nuisance is in those situations where your strobe is used to supplement existing, continuous lighting, and we'll examine that application in detail in the chapter on using flash outdoors.

When too fast a shutter speed is used with a focal-plane shutter, the result will look like this. In such a situation, the shutter curtain has moved too slowly to escape the instantaneous burst of the flash unit. The hard edge that appears in the photo is actually the curtain's shadow.

Light in a Box:
How to Select an Electronic Flash Unit

For reasons that should be fairly apparent by now, electronic flash is a very versatile tool for artificial lighting. In its most sophisticated incarnations it incorporates design features that represent the virtual zenith of modern electronic engineering technology. Some of the circuitry and computerized components of contemporary strobe units are as remarkable as anything you'll find aboard a space capsule. Even unassuming economical battery-powered units, in spite of relatively low output and limited utility, can still produce illumination levels that were unheard of just a few years ago.

If you've visited a camera store lately, you don't have to be told that the manufacturers of this splendid photographic tool are nothing less than prolific. With the great number and variety of portable flash units on the market, it's easy to be confused about how to select the unit that's best suited to your needs as a photographer. The shortest path out of that confusion is to take a long look at your priorities before you hand any hard-earned cash across the counter at your local camera store.

There's a relatively common phenomenon among photographers, particularly novices, whereby, not long after making the initial investment in a camera, some internal injunction begins to well up in the mind of the camera-owner to buy something. The first of these gratuitous purchases is often a telephoto lens—usually of a ponderous and impractical focal length that would do justice to a U-2 spy plane. It doesn't take long after the onset of this mania for a flash unit to suddenly become a priority acquisition.

Now, we should issue a candid reminder here that cameras make fine photographs in most cases *without* artificial light. The assumption is that you already know that and that you have already achieved some degree of mastery of the simple basics of making photographs by available light. If not, let's face it, you probably don't need an electronic flash unit just yet. If, on the other hand, you are ready to begin experimenting with electronic flash, you doubtless meet one or both of the following requirements: (1) You have already encountered, or expect to encounter, shooting situations in which there is no light available to make a picture without the introduction of artificial illumination; or (2) you want to make photographs in situations where the available illumination does not satisfy the aesthetic outcome you have in mind for your final image. In short, you need an electronic flash unit when you want to achieve unlimited control over the lighting conditions in your pictures.

What to Look For

Once you have decided that you properly fit the above criteria, you've now got to deal with the problem of selecting a flash unit from among a dizzying variety of special features. Needless to say, the makers of flash equipment, like all manufacturers, practically stand on their heads to convince you that one line of strobes is better than everyone else's. But the only valid criteria for selecting the unit you need are those which, by and large, apply to all strobes on the market today. They are as follows:

1) *Power:* There are actually two ways to describe the power of electronic flash. The first of these is expressed in "watt-seconds" and refers to the internal power of the unit; that is, the amount of energy that the capacitors are capable of storing and releasing to the flashtube. Theoretically, the light output of a strobe tube depends on the amount of stored electronic energy the capacitors can hold. So, the higher the watt-second rating for any given electronic flash unit, the more powerful would be its output of illumination. Unfortunately, this relationship can be mislead-

GUIDE NUMBERS FOR ELECTRONIC FLASH UNIT

BCPS RATING	350	500	700	1000	1400	2000	2800	4000
GUIDE NUMBER (WITH KODACHROME 25)	20	24	30	35	40	50	60	70

BCPS ratings of electronic flash units provide an accurate basis for comparing the effective light output of different units. This chart illustrates the correspondence between BCPS rating and guide number.

ing. Factors such as the quality of the flash-tube itself, the size and type of the reflector used with the tube, and the duration of the flash discharge are all capable of conspiring to mitigate slightly the direct correspondence between internal power and measurable output. For this reason, many manufacturers also choose to rate their units in terms of external or *output* power. The standard increment for measuring output power is the *beam candle power second (BCPS),* sometimes referred to as *effective candle power second (ECPS).* Since BCPS ratings are determined solely by measuring flash burst power, they comprise a far more accurate yardstick for comparing different strobe units. In practical use, as you saw earlier, the photographer's best criterion for evaluating power output is the strobe

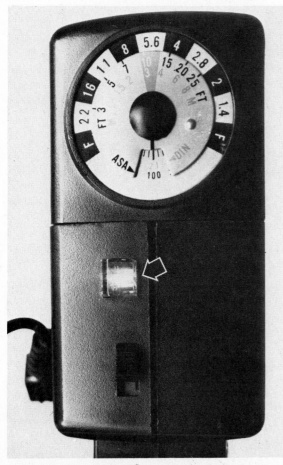

Recycle time is a major criterion for evaluating an electronic flash unit. Nearly every strobe manufactured today features a small neon ready light (arrow) and frequently an audible signal as well, to indicate that the capacitors have returned to full charge.

unit's guide number. The chart on page 36 shows some approximate Kodachrome (ASA 25) guide numbers you can expect in units with different BCPS ratings.

2) *Recycle Time:* You'll remember from our earlier discussion of the principles of electronic flash operation that every time a flashtube is discharged, electricity is drained from the capacitors, and the unit cannot be fired again at maximum output until the capacitors have stored up their full load of power again. The time required to reach full capacity between flashes is referred to as "recycle time," and it is another criterion for judging the quality of a portable electronic flash. Some units, especially those with very low power output, have extremely brief recycling times. As you move up the power spectrum, these times tend to get progressively longer. Some older, nonportable studio strobe units require seven or eight seconds to reach full charge after each flash, and, not long ago, even longer recycling times were considered par for the course with *portable* units as well.

Once again, however, modern science has come to the rescue with circuitry that allows relatively powerful portable flash units to recycle very quickly. Many of the newer units in the automatic category feature special devices called "thyristors," which conserve unused energy by preventing the capacitor from dumping reserve power when the flashtube has discharged at less than full power. (The principle of automatic flash, you'll recall, is to adjust the duration of the flash burst according to the flash-to-subject distance.) In any case, recycling time can be an important criterion for choosing a strobe unit, especially if you must make repeated exposures quickly.

Despite what the literature that accompanies your prospective flash might indicate, it's always wise to test the unit yourself by timing the interval between flashes. This can be done simply by observing the "ready light" with which nearly all strobes are equipped. The light will be extinguished when the flash is discharged and then will glow again when the capacitors have returned to their full charge. Bear in mind, however, that most ready lights come on at slightly less than full charge, which means that you're liable to encounter trouble by making an exposure the very instant the ready light glows. It's wise to allow a couple of seconds of lag time after the ready light comes on, just to "top off" the capacitors. Obviously, when you make an ex-

posure before the unit is completely re-charged, your picture will be underexposed.

A good way to ensure the accuracy of the ready light on your own unit is simply to shoot a series of shots, timing each for progressively longer lag times after your ready light begins to glow. If a picture made as soon as the light says full charge appears one stop underexposed, it means that your ready light comes on when the capacitors have only reached 50 percent of their load. And that means it's time to have a chat with the dealer who sold you the flash unit!

3) *Angle of Illumination:* Most portable strobes come equipped with some kind of metallized reflector which is positioned just behind the flashtube. This reflector is intended to create a uniform spread of illumination from the flashtube over an angle that, for most conventional strobes, is slightly broader than the angle of view covered by a ''normal'' lens. But simply because a strobe unit provides the requisite angle of illumination (ideally between 50 and 80 degrees horizontally and from 30 to 60 degrees vertically) doesn't guarantee that the illumination will be even across that entire angle. A central ''hot spot'' in the beam of a strobe unit is a typical symptom of a less-than-efficient reflector, and though it's difficult to detect with the naked eye, it can have a noticeable effect on the quality of your flash-pictures.

A good way to test your unit for hot spots is to photograph a blank, medium-toned wall, and examine the negatives for density gradations. If the negative appears denser in the center than it is at the edges, your strobe is not providing uniform lighting. Frequently, this problem is easily solved by placing a layer of some thin, translucent material over the face of the flash head. This will not only diffuse the light and eliminate the hot spot, but it will also reduce the illumination level slightly.

If you're partial to wide-angle lenses, of course, you'll also have to find some means for increasing the beam angle of your unit. Most portable strobes on the market today come equipped with an accessory that will accomplish this, but these ''wide-angle attachments'' also tend to cut down the unit's light output.

4) *Weight, Convenience, Price:* Your level of seriousness, as well as the frequency of the shooting you do, combine to bear significantly on the criteria discussed above. Weight, for example, along with size, is an obvious factor

if you travel a lot or if your photographs entail a lot of climbing or hiking forays into remote places. A very small or lightweight strobe unit, of course, may not provide you with sufficient power. So, at some point in the process of selecting the strobe unit that's right for you, you'll have to make compromises.

Similarly, if you're committed to owning a strobe unit with a self-contained power source rather than a more powerful but less convenient external battery pack, you'll have to lower your requirements for power output and quick recycling. The number of flashes your unit is capable of per set of batteries or per each recharging can also become a critical factor if you find yourself shooting a lot of pictures during each session. By the same token, the span of time required to fully recharge your unit's batteries can loom as a profound criterion if you require constant and ready access to a strobe unit that's always ready to go.

Needless to say, any number of convenience features, along with a considerable amount of power, go right down the drain if price is a very important consideration. Actually, the way you can optimally establish and balance your criteria for choosing a strobe unit is by consulting with your camera dealer as well as keeping up with the various flash-related articles which appear regularly in photographic magazines, and, particularly, by honestly assessing the kind of results you expect from your photography.

What's Available: A Survey of Electronic Flash Types

1) *Pocket-Size Manual Electronic Flash:* Here is, by far, the most economical type of strobe unit and certainly the most popular among photographers whose needs for electronic flash are infrequent. Unlike the great mass of portable electronic flash units on the market today, the small manual unit has no automatic features, and thus correct exposure requires calculations—either based on the guide number or using the calculator dial. Units in this category can usually be expected to sell for under $30.

Beyond the obvious economic advantages of the manual units, is the added bonus that power is usually provided by one or two AA alkaline batteries. It's not unusual for one set of batteries to provide 100 or more flashes, and, of course, the batteries are small, inexpensive, and available at any corner drugstore. Compact size is another really major

1. *Pocket-Size Manual Electronic Flash* 2. *Pocket-Size Automatic Electronic Flash*

benefit with this type of flash unit. Since very little sophisticated circuitry is involved in its operation, the unit is usually not much larger than a pack of cigarettes and rarely weighs more than just a few ounces.

Though they lack the glamorous features of their "pricier" cousins, compact manual units usually have similar convenience features such as an "open-flash" button for manual firing of the unit and a ready light or audible signal that tells you when the unit has fully recycled for firing.

Unfortunately, the small manual strobe's convenient and economic design obviates its usefulness for more sophisticated applications. The slow recycling time, for instance, which is often up around 10 seconds, makes it fairly useless for rapid exposures and capturing spontaneous action. Thanks to the small flashtube and relatively modest power source, the light output of units in this classification might to a serious photographer seem nothing short of pathetic. The unit illustrated above, for instance, claims a guide number of 22 with Kodachrome 25 film. That means a photograph of a subject 10 feet away would require an aperture setting of about f/2 for a proper exposure with this particular unit. Additionally, owing to the miniscule size of the metal reflector, uniform light coverage over the entire breadth and height of a subject is less than efficient. Needless to say, the wide range of accessories available for serious

flash photography are, by and large, not compatible with the little compact manual unit. Nonetheless, there's no questioning the value of this type of strobe in a variety of simple shooting situations.

2) *Pocket-Size Automatic Electronic Flash:* Despite the fact that the notion of automatic electronic flash units is often held in a certain degree of disdain by serious photographers, there's no doubt that automatic operation is a major boon to snap-shooters who want to get the most from their equipment with the smallest possible investment of technical knowledge. To this end, most manufacturers of portable flash equipment now market pocket-size units that ensure correct exposure automatically. Here again, owing to its relative simplicity, the pocket-size auto-strobe is the least expensive member of the automatic family, its popularity even beginning to eclipse that of the pocket-size manual strobe. Price range for this particular category of unit generally falls in the affordable area between $30 and $60.

The first and obvious advantage of most pocket-size autos is that they are actually two types of strobe unit in one, with a feature for overriding automatic operation when the photographer wants the flexibility of making manual adjustments in the light output. The power requirement of such a unit, of course, is somewhat higher, but can usually be filled with the same low-priced AA alkaline batteries used in the nonautomatic pocket-size. The

unit above, for example, requires four AA batteries, and its manufacturer asserts that each set of batteries is good for 275 flashes. Like its tiny manual brethren, minimal size and weight are important considerations in the design of this unit. Though generally somewhat larger than the pocket-size manual, weight is usually around twice that of the simpler unit. But this is still an almost negligible consideration in view of the portability and versatility of this little strobe.

Beyond just making exposure a very simple matter, automatic units in this category often have extra convenience features such as the capability of operating directly from an AC current supply or using tiny AA nickel-cadmium batteries that can be recharged. Power, of course, in terms of light output is again fairly modest. The unit shown here has a guide number of only 40 with Kodachrome 25. But compared to its manual counterpart, a much faster recycling time, from two to five seconds depending on the type of power source. The photo-electric cell required for automatic operation (see page 39) on these less expensive auto-strobes is usually placed adjacent to the small reflector. In many ways this is a limitation, as we'll see a little later on.

Strobes in this category, however, usually feature a certain amount of flexibility and convenience (beyond automatic exposure) that their manual counterparts often lack. The above unit, for example, connects to the camera circuitry via a "hot-shoe" connector incorporated into the clip mechanism that mounts it to the camera body, thus eliminating the need for a connector cord. At the base of

3. Battery Pack Manual Flash

most pocket-size automatic strobes there is usually, in addition, some kind of hinge mechanism for allowing the reflector to be oriented vertically or horizontally, depending on the need of the photographer. Again, the sacrifices in picture quality entailed by conserving size and weight in these pocket-size units are considerable. They are still versatile tools for use in simple photographic applications.

3) *Battery Pack Manual:* Despite their voluminous claims of automated versatility, power output and portability, few of the currently manufactured portable strobe units are really capable of providing the serious photographer with what is still a major priority in electronic flash photographs: power.

In spite of the cornucopia of high-speed films available today, the key to really high-quality pictures, the kind you see in magazines and advertisements—in short, the kind professional photographers take—is still the use of slow, high-accutance fine-grain film emulsions. And, to make successful pictures combining these types of films and electronic flash requires high levels of illumination.

Flash units in this category are designed to provide just that. Short of the extreme light output of their larger AC-operated studio counterparts, no portable strobe can approach the power capabilities of units that allow the user to carry with him the type of meaty external power source pictured.

In the case of this particular unit, and other examples of its type, that power supply consists of a large, rechargeable nickel-cadmium battery which allows the unit to boast an internal power of 200 watt-seconds.

Naturally, the limitations on portability and convenience with such a design are extreme for the photographer who must "travel light." And, it's probably obvious that a person with a limited budget for portable flash equipment will probably seek another option since units in this category customarily run around $500.

To those for whom the trade-offs involved are worthwhile, the battery-pack-style manual electronic flash unit can produce light outputs upwards of 4000 BCPS, with much higher outputs possible depending on the conformation in which the flashtube is used. The more modern versions of this type of strobe unit can provide up to 200 flashes at full power with recycle times of less than three seconds between flashes. Recharging time has also been brought to a minimum in many cases. The unit above, for example, requires only 90

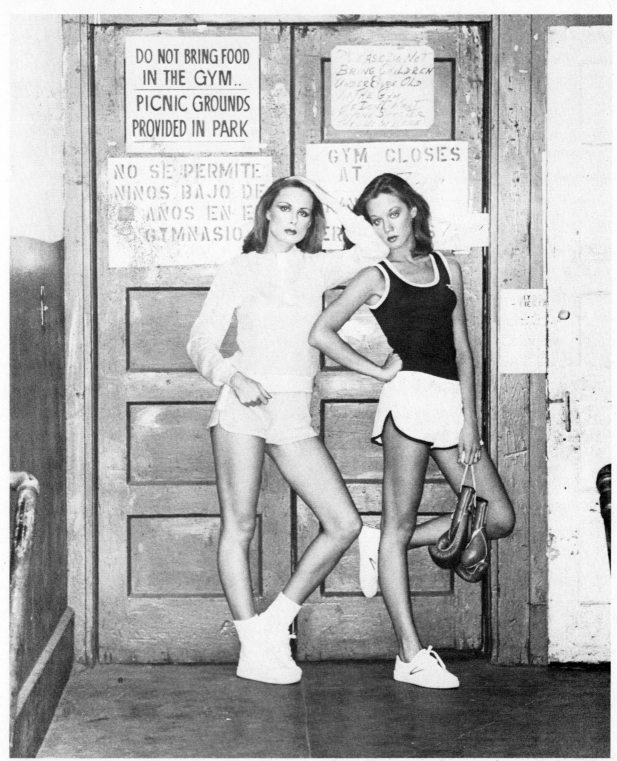

DO NOT BRING FOOD IN THE GYM.. PICNIC GROUNDS PROVIDED IN PARK

NO SE PERMITE NIÑOS BAJO DE AÑOS EN E GIMNASIO

GYM CLOSES AT

Ring flash is a highly specialized tool developed primarily for technical applications. Since the light-source-to-subject axis corresponds exactly with the lens-to-subject axis, shadows fall directly behind the subject where they cannot obscure or alter subject detail. This fashion shot illustrates the use of ring flash's very special characteristics for creating an exotic, rather than realistic, effect. The more conventional applications of ring flash include medical and biological specimen photography.

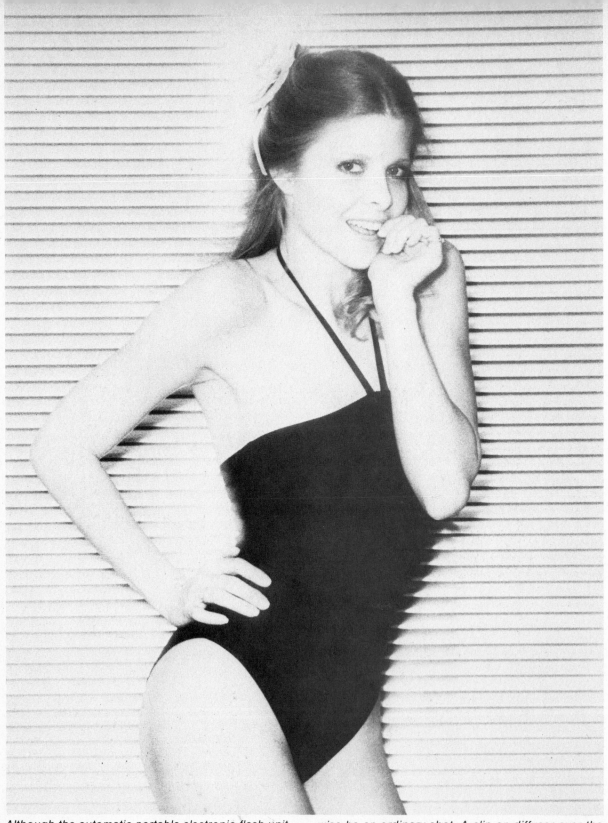

Although the automatic portable electronic flash unit is especially suited for use in candid, "snapshot" situations, it can be the perfect tool for more stylized pictures as well. In this fashion illustration, it adds a playful element of spontaneity to what might otherwise be an ordinary shot. A clip-on diffuser over the flash head minimizes the harshness of direct illumination across the background. Fully accessorized auto strobe systems give versatility without sacrificing the convenience of a lightweight, portable unit.

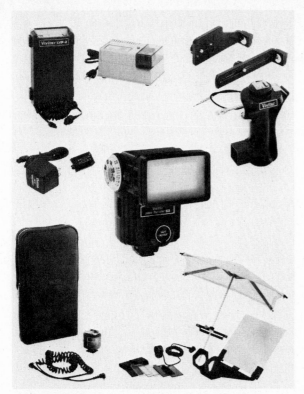

4. Portable Automatic System Electronic Flash

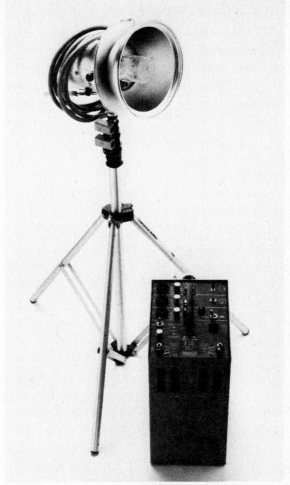

5. Studio Grade Electronic Flash

minutes for full recharge. And needless to say, because such a unit has many professional applications, there is usually a full line of accessories that allow the flash head to be used in a number of different conformations.

To summarize, the battery pack manual strobe unit represents the closest thing to "studio" power currently available in a portable flash unit.

4) *Portable Automatic System Electronic Flash:* The impulse for the development of this family of strobe unit was undoubtedly the desire of strobe manufacturers to counter claims that automatic flash units lack versatility. What this category embodies is fundamentally the "top-of-the-line" in automatic electronic flash. The foundation of automatic system type flash units is the automatic thyristorized strobe we saw on page 18, with the thyristor circuitry providing extended battery-life.

Unlike more modest auto-strobes, this type of unit generally provides appreciably more power output (in the case of the two units illustrated above, Kodachrome 25 guide numbers of around 50.) But the real hallmark of strobes in this classification is their extreme versatility. Unlike simpler automatic units, for

example, the light sensor is not permanently fixed adjacent to the flashtube. That means it can be placed at a position remote from the strobe unit—a feature whose advantages will be more apparent later on. This type of unit also features a much broader range of power control settings, which simpler units lack.

Accessories, however, comprise the real key to the versatility of systems auto-strobes. Beyond the fact that the reflector-head/flashtube of such units can usually be repositioned at any angle a photographer might want, it can also be augmented by a variety of clip-on gadgetry for altering the reflector's illumination angle, as well as the color and the quality of the light. There are neutral density filters as well as filters for color correction, colored filters for special effects, diffusers for softening, and lenses for creating wide-angle or narrow-angle illumination. Some units also feature

small "bounceboards" that can soften the lighting effects of the strobe unit without major sacrifice in light output.

Within the total range of portable strobe units currently available, the systems auto-strobe offers the most ideal compromise between portability and overall usefulness to the photographer. The importance of the versatility such a wealth of accessories provides will be clearer later on when we examine actual techniques for manipulating and controlling electronic flash illumination.

5) *Studio Grade Electronic Flash:* An important assumption is necessary before looking at this category of electronic flash unit; that assumption is that neither price nor portability are major considerations. Units like the one shown here are, as we've mentioned earlier, designed principally to produce the extraordinary levels of illumination required in many professional photographic applications.

Since such applications rarely entail a need for extreme portability, compactness or economy, manufacturers of such equipment are given tremendous license in designing units for maximum light output. The typical studio grade electronic flash rarely combines power source and flashtube in a single housing. More often, the system, like the example here, consists of two basic components: (1) a large "power pack" that contains basic circuitry and capacitors and operates off AC electrical current, and (2) a separate lamphead, attached to the power pack via a length of cord and containing the flashtube, usually surrounded by a metal reflector, and a "modeling light," or "pilot light." The modeling light is a feature unique to studio strobe units. It usually consists of a tungsten-halogen lamp situated adjacent to the flashtube, allowing the photographer to preview with continuous light the effect that a strobe burst will have on his subject. Modeling lights of sufficient output to perform this function are only practical with high-powered units that can be plugged into an electrical main. The tungsten-halogen lamp used in conjunction with a low-output strobe unit would obviously overwhelm that unit's light output at the larger apertures required for strobe units in the "weaker" category.

Thanks to their size, and significant power capabilities, studio strobe units are thus designed in most cases for shooting high-quality photographs at the small apertures that produce great depth of field and extremely clear images with slow, fine-grained film. Compared to even the grandest portable units, the power levels attainable with typical studio flash equipment are therefore extreme.

A power pack like the one shown above is a typical example of strobe units that fall in the useful range for most studio work, with internal power ratings of anywhere from 600 to 2400 watt-seconds. To give you an idea of the kind of illumination such a unit produces, a 2400 watt-second power pack, used in conjunction with a single lamphead whose light is bounced into a white umbrella, has an effective guide number of about 110, with film of ASA 25.

Since photographic requirements in the studio frequently require precise control and manipulation of light, studio grade power packs are usually capable of being used in conjunction with several lampheads simultaneously. When operated in such configurations, the total available power from the pack is split between the lampheads. Many such units offer systems for dividing this power up with great precision and may also feature similar functions for controlling the output of the modeling lights as well. In this way, the modern studio strobe unit represents the ultimate tool for total control of lighting effects.

Since high levels of power output comprise the keystone of studio strobe lighting, units such as these allow the photographer another great measure of control: the ability to use indirect light on a subject. Bear in mind that all basic guide numbers of portable strobe units are determined for light that is direct from flash tube to subject. As we'll see later, whenever the light is "bounced" or "diffused"—used indirectly—a major deficit is incurred in the illumination level. Studio units are meant, in part, to render this deficit negligible. Owing to the wide spectrum of applications for which units in this category are manufactured, even the least impressive of them can usually be totally accessorized to achieve almost any lighting effect a photographer could want. On the most basic level, such accessories consist of: specialized hardware for positioning lampheads, and attachments for diffusing and bouncing light and for narrowing or widening illumination angle. On another level, of course, are accessories that simply augment power output. In the case of the unit shown here, for example, several power packs and/or lampheads can be com-

Lighting for a serious environmental portrait, like this one of a well-known Las Vegas businessman, should properly be done with a powerful studio flash unit. Such a unit offers the output and versatility for creating attractive subject illumination as well as accenting elements of the subject's surrounding. Limitations of time and room to work, unfortunately, can become serious obstacles to using bulky power packs and lightstands on location. The next-best option is the powerful battery-pack manual flash unit. The extra illumination level provided by the large dry-cell battery affords advantages that are simply beyond the capabilities of conventional self-contained portable units. Smaller apertures, for example, allow the depth of field that emphasizes the foreground and background critical to the success of environmental portraiture.

45

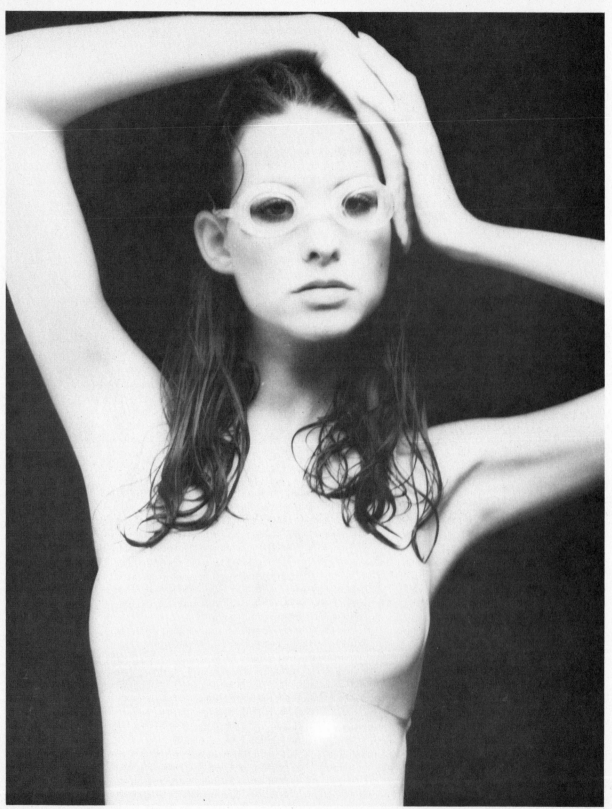

The controllable lighting magic of electronic flash—available from equipment of various types—provides a photographer with an illumination source that can bring fresh creativity and heightened impact to his work.

6a. Ring Flash

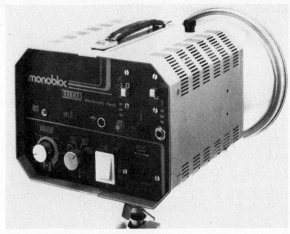

6b. High-Speed Flash

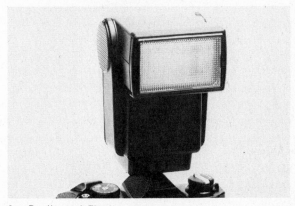

6c. Dedicated Flash

bined as a single extremely powerful light source.

Studio strobe units are obviously a lot more expensive than their portable cousins. A photographer with any desire for serious studio work using electronic flash can easily find himself spending many thousands of dollars, with around $500 to $700 being the minimum investment for equipment in this category.

6) *Specialty Equipment:*

(a) Ring-Flash: This highly specialized piece of equipment was originally developed for technical applications requiring completely frontal, shadowless lighting. Its principle is simply to surround the lens with a direct light source in such a way that when an exposure is made, all of the shadows will fall behind the subject. One of the common applications of ring-flash is specimen photography for medicine and biology. There is even one close-up medical lens manufactured with a ring-flash unit already built-in. Within recent years, ring-flash has come into vogue for creating rather exotic fashion and glamour photographs—a technique that we will look at a little later on.

(b) High-Speed Flash: This category of special-effects equipment invokes the origins of electronic flash—Dr. Edgerton's high-speed stroboscope. Although most conventional flash equipment is now capable of recycling quite rapidly, it still requires specialized units like the one shown here to produce the kind of high-speed recycling required for multiple-image photographs of moving objects and people. While this particular unit can provide up to five flash bursts per second, there are similar units available that can create even faster sequences—including one remarkable piece of equipment that can actually be synchronized with the rapidly moving shutter of motion-picture cameras.

(c) Dedicated Flash: This peculiarly named type of flash unit takes automatic strobe equipment its one last step into the sphere of totally automated photography. Until recently, the union of automatic flash units and automatic cameras had yet to be consummated. By means of the ingenious internal circuitry of dedicated flash units, the strobe actually takes charge of setting the camera's shutter speed and aperture for correct exposure. While photographic purists might object to the existence of such a fully automated system, dedicated flash must nonetheless be regarded as a harbinger of photography's future technological development.

The extreme power output of electronic flash is a profound asset for close-ups, where depth of field and subject movement are major obstacles.

Spontaneity in human
action and expression
is probably the
most sought-after
quarry of the
photographer armed
with an electronic
flash unit. Candid
portraiture like this is
greatly simplified by
by the unobstrusive
quality characteristic
of electronic flash.

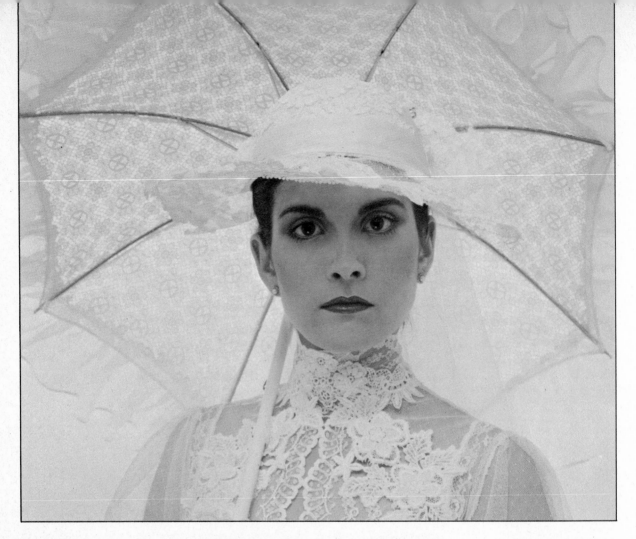

Thanks to its extreme versatility in the studio, electronic flash is perfectly suited for all kinds of portraiture from the formal to the bizarre.

Electronic flash can freeze and call attention to subtle action that the eye might overlook. The short duration of lighting burst also makes it the ideal tool for creative experimentation.

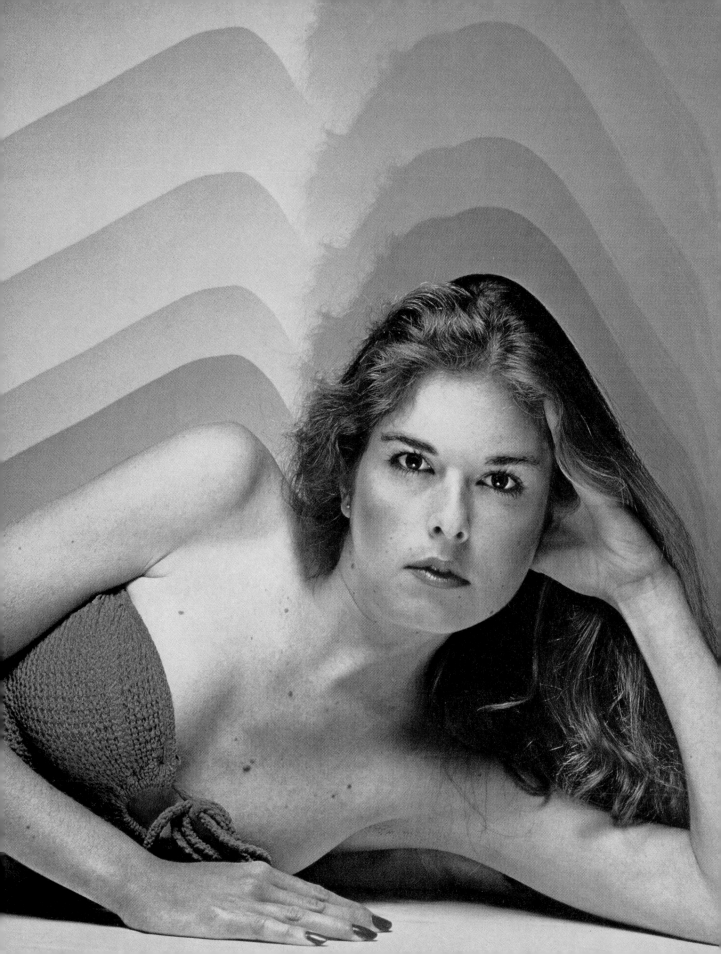

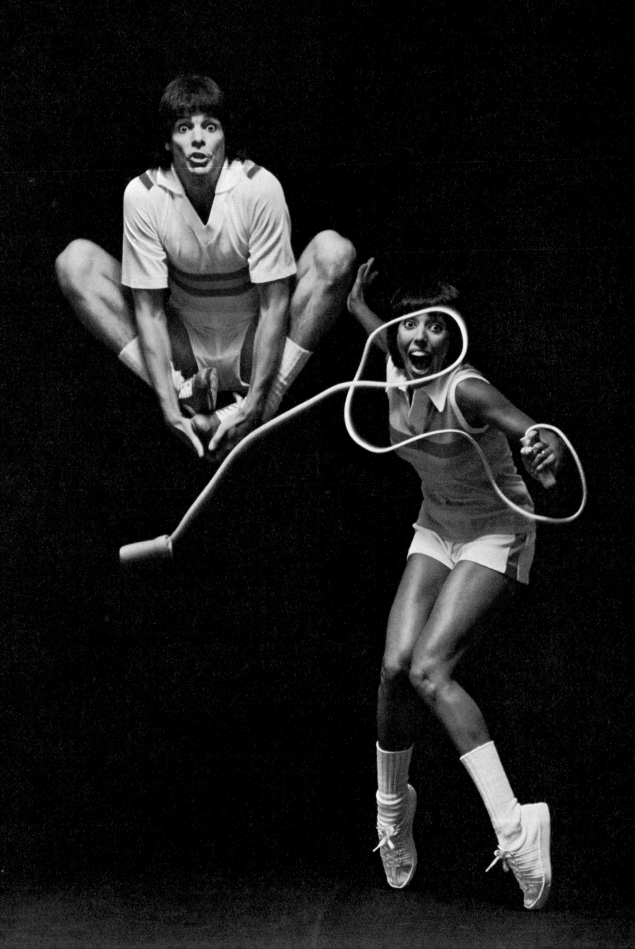

For serious action-stopping with really kinetic subject matter, electronic flash is indispensable. Its very brief but powerful pulse of light makes it able to isolate the dramatic moments of an action sequence like this one.

Product and food photography requires lighting equipment that is adaptable to any number of light control accessories, as well as powerful enough to satisfy the need for good depth of field. Electronic flash is the perfect tool for this type of photography, and, in the case of shooting food, has the added advantage of producing negligible heat to alter or spoil perishable items.

Portable electronic flash units are a great boon to the photographer on location shooting. They can simulate institutional overhead lighting in a data processing center, or through their power, light up a scene in a mine hundreds of feet underground.

Group shots need not require exotic lighting setups; here a single strobe bounced from an umbrella at camera right provided illumination.

(Below, left) Careful
positioning of light,
using modeling lamps
to preview effect,
placed emphasis on
necklace.
(Below) Diffusion filter
over camera lens
produced soft effect,
and flash unit was
aimed directly at model
to add some punch to
the image.
(Right) Single flash
unit bounced from large
umbrella to model's
left lit subject here.

These photos of Masquers at the New Orleans Mardi Gras were made with a single strobe head in an umbrella reflector. Electronic flash is the best lighting source when dealing with non-professional models who are not used to prolonged posing.

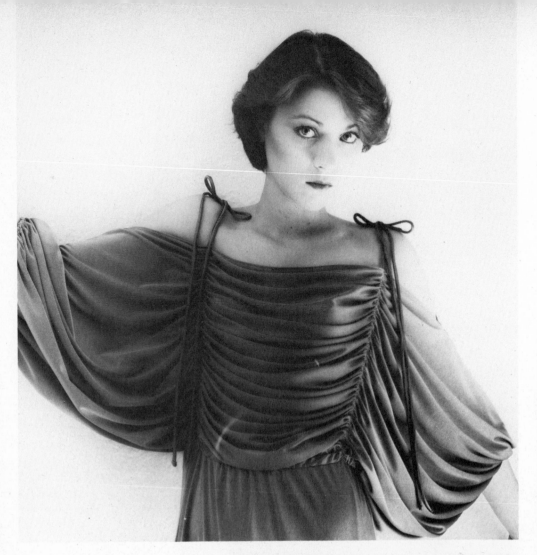

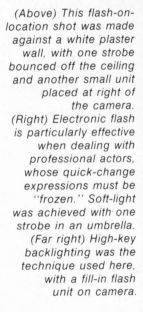

(Above) This flash-on-location shot was made against a white plaster wall, with one strobe bounced off the ceiling and another small unit placed at right of the camera.

(Right) Electronic flash is particularly effective when dealing with professional actors, whose quick-change expressions must be "frozen." Soft-light was achieved with one strobe in an umbrella.

(Far right) High-key backlighting was the technique used here, with a fill-in flash unit on camera.

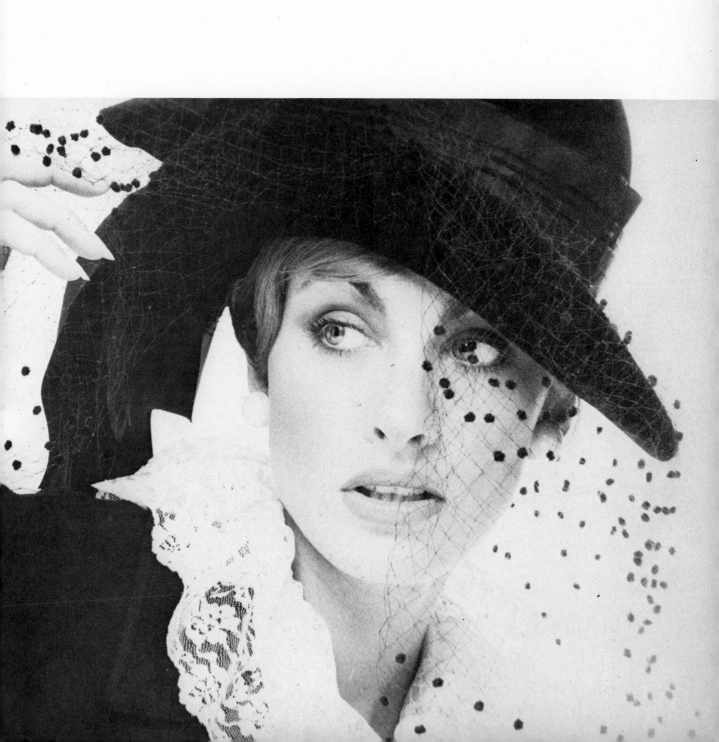

How to Use Electronic Flash--
Basic Techniques and Troubleshooting

The broad scope of flash equipment design and application permits a wide range of usage, according to the photographer's desired effects in posing and lighting. Knowing what these variations are and how best to employ them for maximum benefit is vital for achieving the optimum artistic result. So let's consider the various different camera/light setups, with their respective advantages and limitations.

Electronic Flash On-Camera

One of photography's most venerable popular images is that of a press photographer furiously snapping away with a flash unit attached to his camera. The image is justifiable simply because the most common and convenient method of using electronic flash is simply to mount the unit directly on the camera. In this conformation, camera and strobe combine to become a single easy-to-handle unit. And, thanks to the efforts of manufacturers toward miniaturization, the combination rarely has to be much larger or heavier than the camera itself.

The utility of on-camera flash is obvious for any number of common picture-taking situations—especially candid shots. Exposure calculations, of course, are extremely simple in this particular mode of flash photography since camera-to-subject and flash-to-subject distance are always the same. Whether you use guide number calculations or simply refer to the exposure dial on the back of the strobe unit, the all-important distance figure that you need to know for correct exposure is never farther away than the footage scale on your lens barrel.

The simplicity of on-camera flash technique makes it ideal for a rather eclectic variety of picture-taking opportunities. The same camera and strobe combination that a part-time snapshooter might use at a children's birthday party can just as easily find its way into the hands of a wire-service photographer at a Presidential news conference, or a *paparazzo* lying in wait for movie stars outside a fashionable discotheque. The uniquely candid look of on-camera flash photos has even lately become a popular style among fashion photographers who use it to add the illusion of spontaneity to photos of elegant garments.

Despite the relative ease of on-camera flash technique, it does present several pitfalls that can hamper your best efforts unless you know how to prevent them from occurring. The following are some techniques for dealing with such problems and helping you get the most out of your on-camera strobe pictures.

1) *Preventing "Red-Eye":* One of the most common problems when you're shooting color film with flash on-camera is the "red-eye effect" which causes the pupils of your subject's eyes to take on an eerie red glow. (It also appears as a white glow in black-and-white photos.) The glow is the reflection of the retina, and it is a very common nuisance in shots where the subject is looking squarely into the camera lens. Red-eye is caused by the flash reflector being very close to the lens, and it tends to be more of a problem to photographers who use small portable strobes, since larger flash heads usually keep the reflector a safe distance from the lens.

The obvious cure for the red-eye effect is to have your subject turn his head slightly away from the camera, so that he's not looking straight into the lens. If that's not always possible, the next best solution—particularly if you're continually plagued by the problem—is to elevate the strobe unit to a higher position. This can be done, without removing the unit from the camera, by means of an extension device, several varieties of which are generally in ample supply in camera stores. These extension devices usually attach to the hot-shoe mount on your camera, and will give the strobe the extra margin of elevation required to eliminate red-eye. Frequently, they feature a ball-and-socket joint that can be useful in several other ways, as we'll see later on.

2) *Preventing Glare from Reflective Surfaces:* If your subject happens to be positioned in front of a reflective surface, naturally some of the strobe light will spill onto the background, and that means a distracting background highlight will appear in your photo. One way to deal with this problem is to

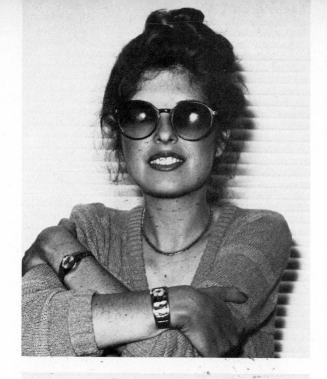

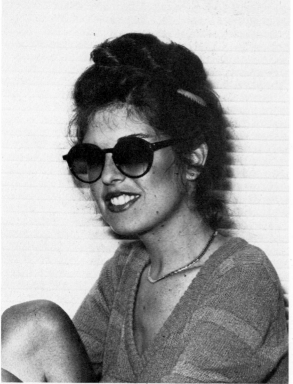

In most good portraits, the subject usually looks directly into the camera lens, but if the sitter is wearing eyeglasses, on-camera flash is guaranteed to create a nuisance of strong reflections in the glasses. This undesirable effect can be prevented by angling the subject's head slightly away from the camera-to-subject axis, or as a less preferable option, angling the eyeglass frames slightly down on the subject's nose.

Annoying lens flare and unwanted reflections are common liabilities when using on-camera flash with the subject posed in front of a reflective surface. To circumvent the problem, place the subject and the camera/flash unit at an angle to the offending background.

move your camera position so the lens axis is on an angle to the background surface.

The same technique can also be extended to other troublesome reflective surfaces. Eyeglasses, for one, can pose a major problem. If you can't convince a subject to remove them, you must turn his head to an angle, or angle the frames slightly downward to prevent getting two disastrous highlights where the subject's eyes should be. Similarly, if you're shooting a scene that contains polished objects like silver or mirrors, be sure to position them (or reposition your subject) so they won't be in direct line with your strobe light.

You must always bear in mind that portable strobe does not allow you the luxury of accurately previewing the effects your lighting will have on the final picture. When you compose your shots, don't think in terms of the natural illumination already present in the room. Try to predict what effect the light from your flash unit will have.

3) *Preventing Hard Background Shadows:* A standard feature of most on-camera flash pictures is the hard, dark shadow that often appears directly behind the subject. Since hard shadows are a common liability of direct lighting anyway, why ask for trouble by placing your subject close to the background? Move him away from it, to soften and minimize the shadow.

Hard shadows can also present another kind of problem when you're shooting a group of people or objects using flash on-camera. Try to ensure that your subjects overlap as little as possible. Anything behind one subject and directly in line with your strobe will be partially obscured by a shadow.

4) *Keeping Your Subjects in the Same Plane:* For reasons other than simply eliminating shadow problems, it's always wise with on-camera flash to keep several subjects as close to the same plane as possible, and that plane should be as nearly perpendicular to the lens axis as you can make it. The reason for this should be fairly obvious. Your expo-

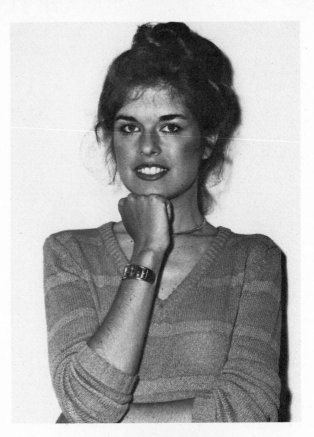

When the subject is close to a background surface, irritating dark hard-edged shadows become an inevitable problem, since flash mounted on-camera is slightly off the camera-to-subject axis. The remedy is to move the subject far enough away from the background surface that the shadow will become appreciably softer or better yet fall beneath the subject, out of sight of the camera lens.

sure calculation, as you've seen, is based on flash-to-subject distance. Any thing or person included in the picture and standing nearer to the camera than your measured flash-to-subject distance will be overexposed. Conversely, subjects farther away than the measured distance will be underexposed. That's why it's also important to ensure that unwanted objects close to the camera have been cropped out of your viewfinder. Again, preview your shot with the ultimate effect of the strobe in mind, and you'll avoid having your picture ruined by distracting, overexposed foreground elements.

5) *Other Drawbacks:* Despite the fact that most of the above-mentioned liabilities of on-camera flash can be minimized or reduced, this particular mode of lighting is still far from ideal. Part of the distinctive look of such pictures derives from the fact that flash positioned right at the camera produces a very flat "washed-out" appearance. This is caused by the fact that the direction of the light very nearly matches the camera-to-subject axis, creating an almost complete absence of shadows on the side of the subject facing the camera. Since shadows help to "model" a subject, giving it depth, people and objects illuminated by on-camera flash usually appear to be rather shapeless and two-dimensional. Owing to the popularity of this mode of lighting and its use over the years in popular media like newspapers and magazines, we've all grown accustomed to its more unpleasant characteristics. However, in those shooting situations where the sheer convenience of flash-on-camera is not an overriding necessity, your strobe unit can be used in a variety of creative ways to produce far more interesting and attractive lighting effects.

"Bounced" Flash for Soft Lighting

Like any type of light source used directly on a subject, on-camera flash is very hard

Overexposed foreground detail is a perpetual nuisance in on-camera shots flash. Assuming that exposure calculations are based on correct exposure for the subject, any object or person appearing in the shot that is closer to the camera than the subject will be overexposed. The easiest remedy is to crop extra detail out when composing the picture, but if detail is important to retain, the camera/flash combination must be repositioned so that all subjects are in roughly the same plane and thus receive equal amounts of illumination from the flash.

Despite its convenience, the on-camera flash technique produces a characteristically flat, two-dimensional effect, with harsh highlights and washed-out skin tones as typical side-effects. As noted in the text, this is sometimes desirable as a special effect but is seldom the only strobe lighting technique in the repertoire of a serious photographer.

These companion photos illustrate the difference between illumination from on-camera flash used directly on subject and on-camera flash bounced off a light-colored ceiling or wall. Though special accessories are available for allowing portable flash units to be tilted or rotated while mounted on the camera, many of the more elaborate portable units now feature built-in capability to change the angle of the flash reflector without special gadgetry.

and usually unflattering lighting for human subjects. Since, as we noted in the last section, the light from an on-camera flash unit falls off very quickly in back of the subject, the overall effect in most shots made with this particular mode of lighting is customarily about as flattering as the light from a car headlight, and it tends to produce the same ghostly, unnatural look.

To get around this liability, many photographers would rather "bounce" the illumination from their strobe units, by reflecting it off the surface of a light-colored wall or ceiling to simulate the quality of lighting usually associated with mildly overcast skies out of doors. To understand why this alternative is more attractive—particularly for portraiture—you should quickly review another couple of basic facts about lighting in general.

Direct light, meaning the kind of light that travels from light source to subject without being impeded, is easily recognized in a photograph, since the contrast between highlight and shadow is very pronounced. It is the same kind of light that on-camera flash produces, and it is the same kind of light that falls on a subject on a cloudless, sunny day.

Light waves travel in a single direction and strike the surface of a subject at millions of individual points in that surface. They will not bend around into shadow areas (which would reduce that shadow/highlight contrast) as long as they are coming directly from their source. If, however, a series of obstacles, or deflectors, is introduced between the light source and the subject surface, many, if not all, of the waves will change direction. These direction changes are quite random, and can have the important effect of causing the light waves to strike the subject from many different directions, instead of just one.

That is roughly what occurs when a layer of clouds is introduced between the sun and a subject below. The obstacles, in this case, are tiny individual droplets of water that form the overcast. With the sunlight now approaching the subject from many directions at once, the boundaries between highlight and shadow be-

One simple technique for reducing the patent liabilities of on-camera flash used directly is to elevate the flash unit an arm's length over the camera-to-subject axis. This adds important modeling and depth to the subject's features, maintaining a three-dimensional illusion that is lost with flat, on-camera lighting.

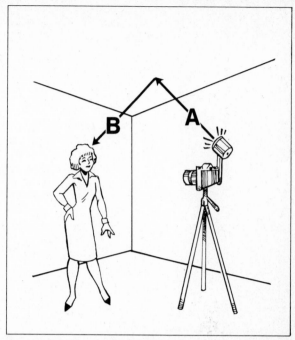

As in all indirect-lighting situations, strobe illumination bounced off wall or ceiling entails an appreciable deficit in the light level on the subject. Exposure calculation must compensate for this loss to produce a properly exposed picture. One fairly reliable technique is to compute flash-to-subject distance as the sum of distance between the flash unit and the bounce surface (A) and the distance between the bounce surface and the subject. (B) An important variable here is the actual reflectivity of the bounce surface, which ideally is a white or very light-colored wall or ceiling.

come considerably softened, and the contrast is substantially reduced. In other words, the light is spread out more evenly—and that's principally what the bounced flash technique is intended for.

With the flash reflector pointed away from the subject and upward at a light-colored ceiling or back at a wall, the individual light waves are again scattered in random directions. Examine the difference between the shots on pages 72 and 73 and you'll see how dramatic this difference can be. Not only is the light from the bounced strobe softer and more flattering to the subject, it is also spread out more evenly to all parts of the photograph, producing a far more natural look, and illuminating more of the details around the subject.

In an on-camera flash situation, of course, you can come *close* to achieving this softer

effect simply by interposing some type of diffusion material between flash reflector and the subject. A layer of white handkerchief is usually suggested as a suitable material, but it rarely does the job very well, and you're still stuck with the flat, two-dimensional look that we observed earlier as the fundamental characteristic of on-camera flash. Not only does the bounce technique soften the lighting, it also provides your picture with the illusion of depth, since the soft shadows created add modeling and dimensionality to your subject.

Many of the latest portable strobes on the market have some built-in provision that allows you to use the unit in the bounce mode

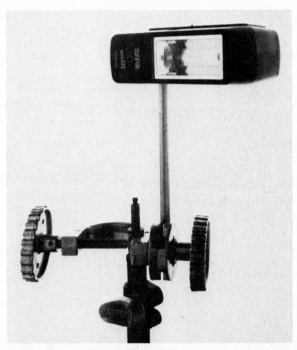

Many off-camera flash techniques can be accomplished perfectly well with portable strobe units designed principally for use on-camera. Accessories like this C-clamp made by Larson Enterprises offer a simple method of mounting a portable strobe unit on a light stand with a full range of positions for tilting and adjusting the height and direction of the strobe's illumination.

A basic inventory of accessories for using off-camera flash should include: a lightweight aluminum stand, an extension sync cord, at least one umbrella reflector and a large sheet of white cardboard or poster board for use as fill-in reflector. For added versatility, a second light stand is advisable for positioning the reflector.

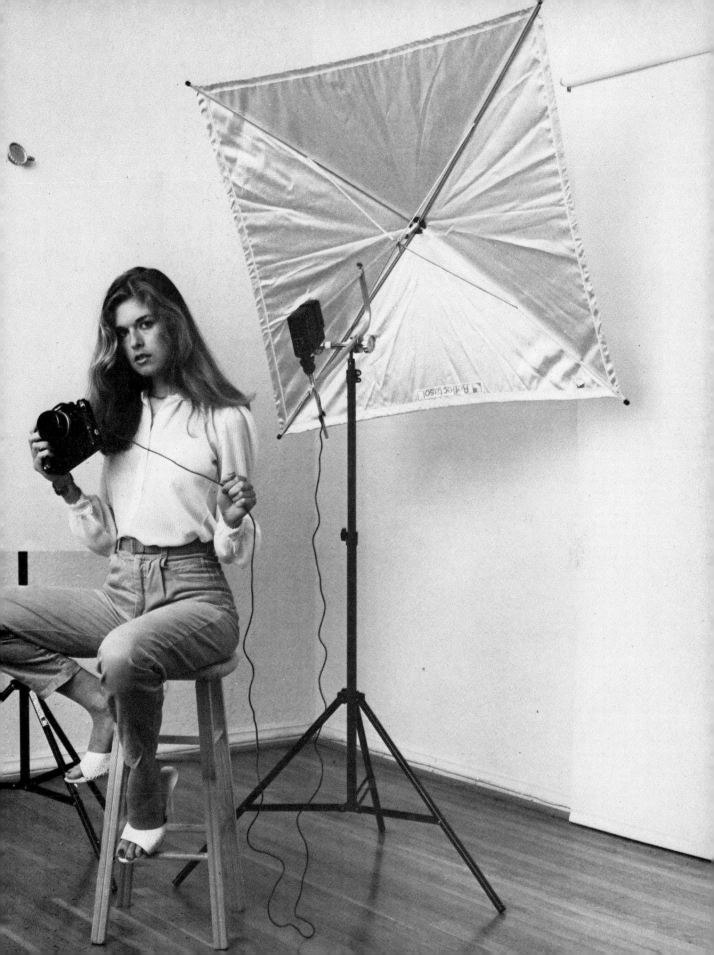

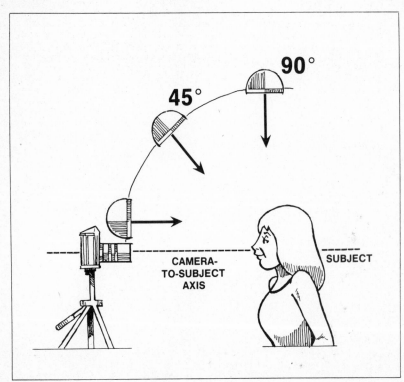

Effects of strobe illumination at different elevations in the vertical axis are shown here. The unit positioned close to the camera-to-subject axis produces flat, two-dimensional look of on-camera flash. At an elevation of about 45 degrees above the camera-to-subject axis, the effects of highlights and shadows produce illusion of depth and three-dimensionality. Note that at higher elevations, shadows lengthen to emphasize texture and exaggerate features out of natural proportion.

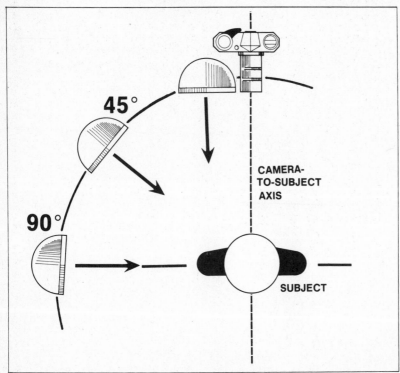

As the flash unit is moved from the camera-to-subject axis in the horizontal plane, changes are similar to those in the vertical axis. Again the 45-degree position provides a revealing amount of modeling, but at a 90-degree ''split-light'' angle half of the subject is obscured by shadow.

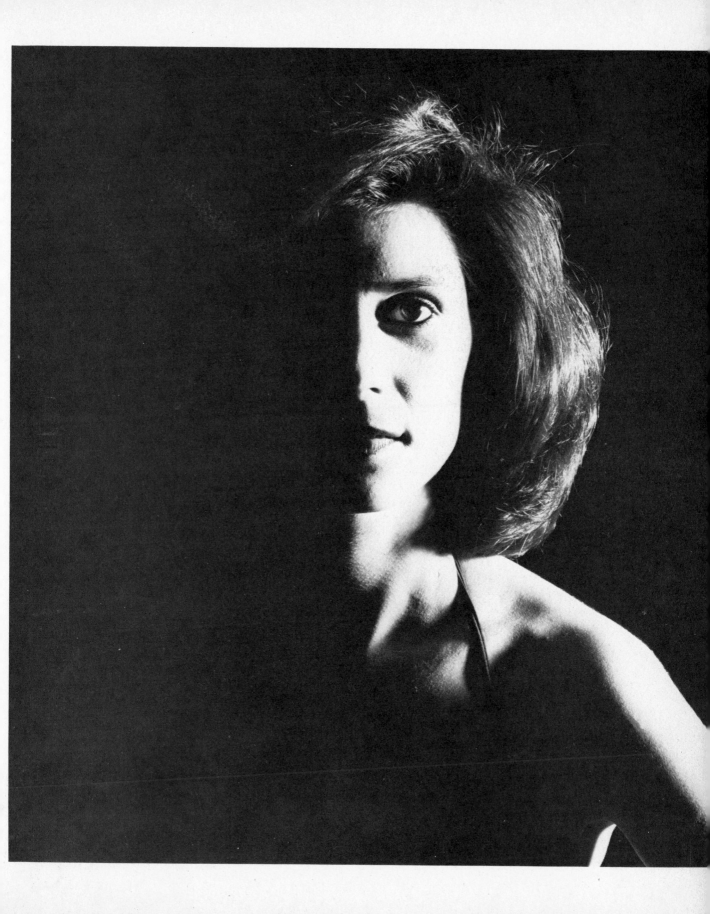

without removing it from the camera. You can simply tilt the flash head back, so the light will reflect from the ceiling, or you can rotate it around to the side or the rear, making a wall your bounce surface. If you own one of the older model flash units where the flash head remains in one fixed position, you can still adapt it for bounced lighting by purchasing one of those jointed extenders we mentioned earlier in the section on red-eye effect. Either way, bounce-light capability can extend the versatility of your camera-mounted strobe unit.

Naturally, since exposure calculation with strobe is so highly dependent on flash-to-subject distance, the bounce-light technique poses some tricky exposure problems. Not the least of these is a substantial reduction of the strobe's effective guide number. What you are doing, in effect, by directing your strobe unit away from the subject toward a wall or ceiling, is simply increasing the flash-to-subject distance.

The standard way for computing this increase is to measure the distance from flash head to reflecting surface, then add to that the distance between the reflecting surface and the subject. Before we discuss the best methods for uncomplicating that particular situation, we should first note that the increased distances which bounce flash entails usually make a more powerful strobe unit highly desirable for use with this technique. In lieu of that, however, you can also opt for faster film emulsions, which will help to compensate for the overall loss of speed you encounter when using bounced flash.

How you deal with the problem of correct exposure in the bounced flash mode depends a lot on the type of reflecting surfaces in the environments where you most often shoot. Most average rooms in homes, apartments and business offices can usually be counted on to have light-colored walls and ceilings, with the ceilings ordinarily eight to ten feet above the floor. You can prepare yourself for working in these typical conditions by running some simple exposure tests similar to the guide number tests you learned about in the chapter on flash basics. Carefully measure off the distance between your flash and the reflecting surface, add to that the distance from surface-to-subject, and shoot a roll of transparency film, changing f-stops for each picture to find the one that gives the optimum exposure.

Kodachrome 25 might not be the ideal film to choose for this series of tests, since it is a comparatively slow emulsion and, unless your portable strobe is very powerful, the results of your test are likely to be inconclusive. A better film choice in this case would be Kodak's new Kodachrome 64 emulsion, which is faster but still offers the same rigid processing procedures that will help to control the accuracy of your results.

Once you've examined the film and determined the best test exposure, you can apply to it the same computations you used for determining your guide number, in order to give you a new guide number for your unit in a bounced light situation. Say your measured flash-to-ceiling distance was five feet and the distance from the point where the strobe beam hits the ceiling to the subject was another five feet. If your best exposure was obtained at f/4, the bounce light guide number is 40 (distance X aperture = guide number). Under average conditions, the bounce light guide number will usually be about one-half the unit's guide number when used direct. So, as a general rule of thumb, you can ordinarily get pretty good exposure results by dividing your regular guide number in half when using the bounced light technique or by simply opening up your diaphragm by two f-stops after computing exposure according to *flash-to-ceiling-to-subject distance.*

Needless to say, bounced flash can have severe limitations if you're working in an area that has unusually high ceilings or darkly painted walls. Experience will generally acquaint you with the kinds of situations in which you can successfully apply this technique and, as you grow more familiar with the limitations of your equipment, your results will soon become fairly standardized. Obviously, if you like to use bounced flash in a variety of different situations, a flash meter could be a very wise investment indeed. It can take a lot of the exposure anxieties out of what is otherwise an extremely effective lighting technique.

Off-Camera Flash

Bounced lighting with the flash unit on-camera is principally a technique for improving the quality of the illumination on your subject without sacrificing the convenience of a single-unit camera-strobe combination. As we mentioned earlier, on-camera flash is perfectly adequate for any number of shooting situations where your primary concerns are speed and the ease with which you can handle your

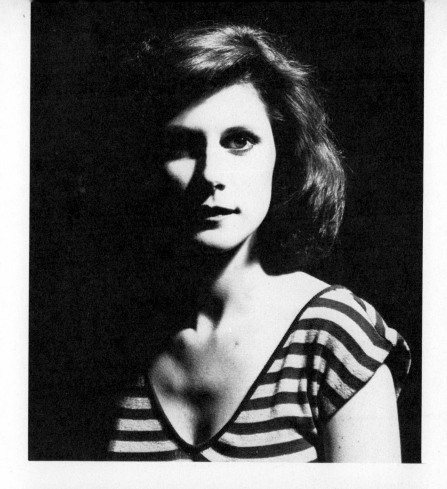

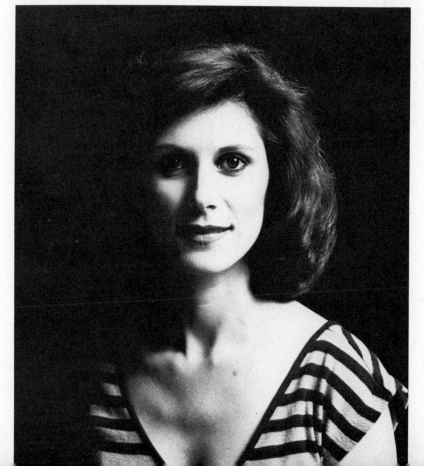

Two similar photos of the same subject demonstrate the differences between direct light using a flash unit alone and indirect lighting using flash in combination with an umbrella reflector. Take careful note of the fact that while the strobe/umbrella combination does not necessarily lessen the contrast between highlight and shadow values (as is often claimed by manufacturers of such accessories), it does noticeably soften the boundaries between light and dark areas, creating a much more natural look—especially for a portrait—and de-emphasizing textural details that the hard shadows of direct lighting have the irritating tendency to accentuate.

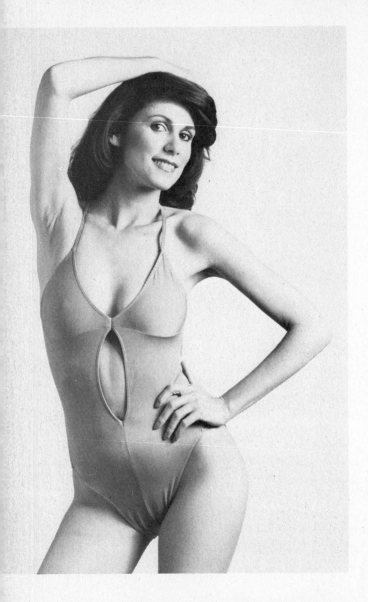

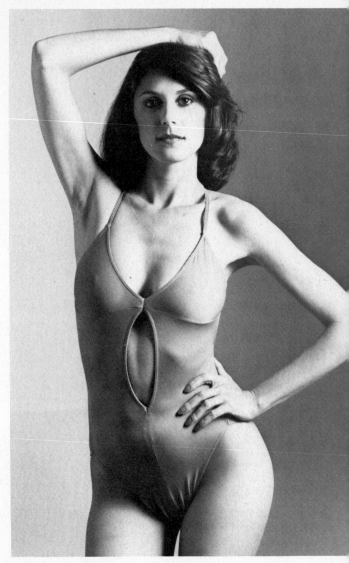

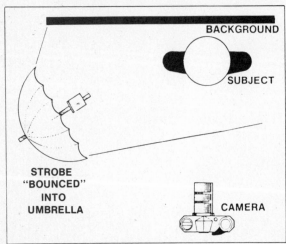

STROBE
"BOUNCED"
INTO
UMBRELLA

BACKGROUND

SUBJECT

CAMERA

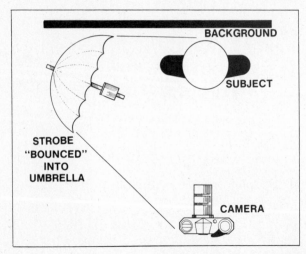

STROBE
"BOUNCED"
INTO
UMBRELLA

BACKGROUND

SUBJECT

CAMERA

camera and strobe unit. You can really begin to see the versatility of your electronic flash, however, when you free it from its mounting bracket and take it out into the world of off-camera lighting techniques.

Even when it's pointed directly at a subject, your electronic flash unit, simply hand-held at arm's length above the camera, can add significant depth and pictorial quality that flat, on-camera illumination lacks. Held slightly around to one side of the subject, or positioned on a light stand 90 degrees from the lens axis, the off-camera strobe becomes a true creative tool for dramatizing a subject, emphasizing important details and texture, and minimizing undesirable features. It is only with the strobe off-camera that you can really begin to explore the remarkable versatility of electronic flash photography.

1) *Off-Camera Strobe Accessories:* In order to exploit the entire range of lighting effects possible with a single portable strobe unit, you'll need a few accessories to minimize the inherent difficulties and in some cases to dramatically help extend the range of the strobe's basic capabilities. The following list represents my own recommendations for accessories that are useful with a single portable strobe and will retain their utility when you get into the setups we'll look at later involving more than one flash unit:

(A) Extension sync cord: This is a must, particularly for portraiture or any other application that involves using lenses of longer than normal focal length. Extension sync cords are available in several useful lengths, and are usually packaged with a plastic spool that simplifies handling and storage.

An important item to mention here if you're using an automatic strobe unit is an extension cord for your flash unit's remote light sensor. Since the sensor can only accurately measure lighting striking your subject from the camera position, your strobe unit must have the capability of placing the sensor remote from the flash unit. Most of the top-of-the-line automatic units on the market today feature this provision and it is definitely a must for using your auto-strobe off-camera.

(B) Light stand: Unlike large studio strobe gear and heavy tungsten lighting units, your portable strobe requires little more than a lightweight telescoping aluminum stand. There are several different accessories for mounting the unit to such a stand, and choosing the type that is compatible with your particular strobe is a matter between you and your camera dealer.

(C) Umbrella reflector: This is the standard implement for getting controlled bounce-lighting effects, and there are several types available. The size of the umbrella will depend on the power and covering angle of your flash unit, so be sure to consult the available literature (as well as your camera dealer) to find the size that is appropriate for your strobe. Of course, you'll also need some sort of clamp for mounting the umbrella, so again, check with the dealer to determine what's available. By far, the most efficient of these clamps is the kind that allows you to alter the angle of the strobe and the umbrella simultaneously, and ideally, the clamp should hold the umbrella shaft as close as possible to the central axis of the strobe's built-in reflector.

(D) "Bounceboard" reflector: This can sim-

The umbrella reflector adds great versatility to a single electronic flash unit. Since the "beam" of illumination from the umbrella is fairly uniform across its diameter, it can be angled to alter the tone of a background without significantly modifying the lighting on the subject. With the umbrella "feathered" to allow some light to spill on the background, as shown by the diagram, a bright high-key effect is obtained. But by simply feathering the edge of the umbrella away from the background, a totally different effect is created behind the subject, while the illumination on her is substantially the same in both shots.

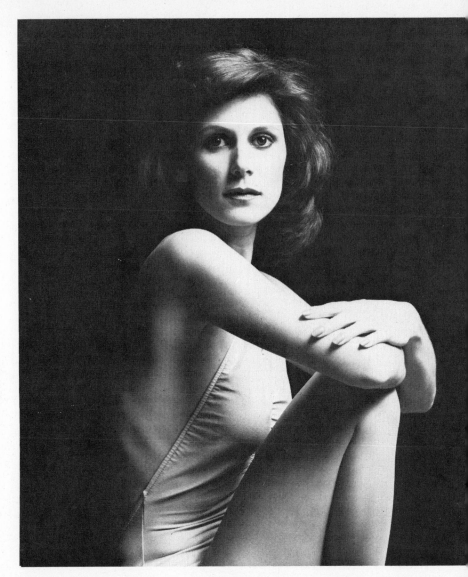

While more sophisticated "studio" strobe units usually allow several flash heads to operate from a single power pack, conventional portable units with self-contained power can be used in multiple-lighting setups with the aid of photoelectric triggering devices. Usually referred to as "slaves," such devices attach to most strobe units by adaptors like the one shown here, which can be plugged into the flash unit's sync terminal. On the command of the light pulse from another strobe unit—usually the one connected to the camera—the slave will fire the unit to which it is attached so that both units effectively fire simultaneously. By this method, any number of slaved strobes can be fired together. Although multiple-headed extension cords are available for the same purpose, the use of slaves is more convenient and reliable.

ply be a sheet of stiff white or silvered cardboard, and its size will depend on the type of subject matter you shoot. For full-length portraiture, you might want something that's four or five feet long by two or three feet wide. Smaller subjects will naturally not require anything quite so imposing. Once you've gotten the hang of working with some of the techniques we'll look at soon, you might also want to invest in one of the large, free-standing fabric reflectors that fold up for easy storage and portability. In the meantime, however, cardboard should prove perfectly adequate.

2) *Positioning Your Off-Camera Flash:* With electronic flash, as with any other light source, the single most important phase of

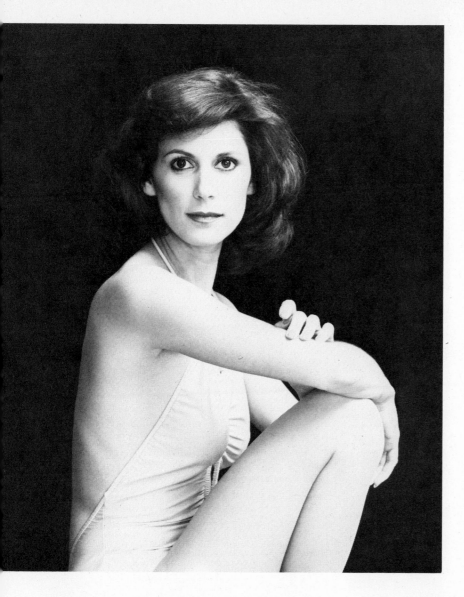

One application of multiple-flash technique is shown by these two portraits. The first was shot using a single light source consisting of a strobe unit-umbrella combination. For the second, another strobe was added on-camera to provide fill-in illumination for the shadows. Since the on-camera unit can be synced directly to the shutter via hot-shoe or short length of cord, the "main light" umbrella unit, more distant from the camera, was fired by a slave.

lighting your subject is proper placement of the strobe in relation to the subject. Remember that we use artificial lighting of any type for one of three reasons:

(a) To reveal or emphasize certain details of the subject.

(b) To create a certain mood or impression of the subject.

(c) To do both (a) and (b) simultaneously.

Both the quality of the light and the direction from which it strikes the subject provide the tools by which we can accomplish any of these ends, and lighting placement is the basic mode for using those tools.

To talk about placement of a light source, we usually think in terms of two axes—hori-

zontal and vertical, as illustrated by the accompanying diagrams. In each axis, the "neutral position" is the radius formed by the line from camera to subject, and we usually refer to the position of the light source as deviations from that neutral position. For example, a strobe unit placed at the camera position both vertically and horizontally, will give us effects that are equivalent to the flat illumination we observed with the strobe mounted on-camera.

As we raise the unit upward in the vertical axis, however, we begin to see marked changes in the subject's appearance. In a portrait, for instance, we can expect the strobe, in a higher position, to reveal more

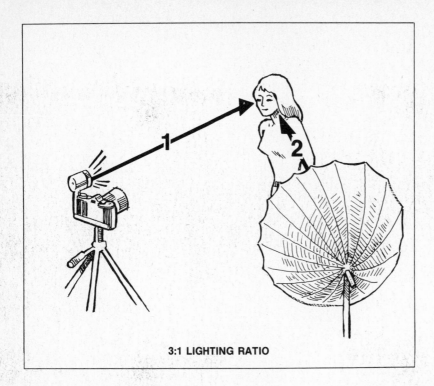

3:1 LIGHTING RATIO

The notion of "lighting ratios" provides a simple scheme for establishing the relationships between main light and fill light illumination. As shown by this diagram, the terminology of lighting ratios is based on units of light. Here the main light exposure (from the unit mounted with the umbrella) has been calculated to be one stop stronger than the exposure for the fill light mounted on-camera. It therefore provides twice the illumination of the fill, or two light units to the fill's one light unit. Since the fill-in strobe adds light to the highlights already illuminated by the main light, we can see that the total light falling on the highlight areas of the subject is three light units. The shadow areas, on the other hand, receive only one light unit, so the ratio for this setup is characterized as 3:1.

about the subject surface than we saw in the flat, on-camera position. Shadows cast by such details as nose, mouth, cheekbones and eyebrows grow progressively longer as the unit is elevated upward from its neutral position. Placed about 45 degrees above the camera-to-subject axis, it will create small shadows that emphasize the depth of these features, as you can see in the pictures on page 78. Again, this effect is referred to as *modeling* and the degree to which you use it depends on whether you're trying to create a mood effect, or to reveal the shape of the subject's face, or both. This 45-degree elevation is considered a standard vertical placement for portraits, since it reveals the depth of facial features without creating inordinately long shadows that obscure other details. At a full 90-degree elevation, of course, the longer shadows will exaggerate these features considerably—an effect that might not be pleasant for conventional portraiture, but might be perfectly valid if you wanted to make a subject look a little threatening.

Lighting placement in the horizontal axis subscribes to the same fundamental principles. The further we deviate from the neutral, flat-lighted position, the more modeling we can expect with facial features. In a candid situation that requires hand-holding both cam-

era and strobe unit, a good rule of thumb is simply to hold the strobe above the camera at about arm's length, with the arm held out slightly to the side. This higher elevation will, in all cases, provide much more natural illumination than the on-camera placement, since the two most common light sources by which we *see*—sunlight and indoor lighting fixtures—are nearly always higher than eye level.

You should, of course, take careful note that as you continue to move your light source away from the neutral position in either the horizontal or the vertical axis, you eventually reach a point where the light no longer reveals any frontal detail at all. With the light behind the subject, frontal features are almost entirely in shadow, and the light creates only thin highlights along the top or side of the subject's head. We'll see how this type of lighting is useful, when we look at setups using more than one strobe unit.

Despite the fact that off-camera strobe increases the versatility of the effects you can achieve, it still suffers from the same liability we observed with undiffused on-camera strobe: It is a direct source, and thus can be counted on to produce the same hard, contrasty illumination. This is why I recommend an umbrella reflector for an off-camera lighting using just one strobe unit.

The umbrella offers you many of the same advantages that come with bounced flash, since the umbrella is nothing more than a reflective surface itself. But, unlike a wall or ceiling, it is a reflective surface that you can control quite precisely. While a flash used directly in the 45-degree elevation creates hard, dark shadows, an umbrella-strobe combination in the same position creates a very soft, pleasing effect—particularly for a portrait. Again, refer to our previous discussion of the differences between direct and bounced light to see why the umbrella works in this way. Since the lines between highlight and shadow are softened with the umbrella-strobe combination, it becomes a perfectly valid tool for creating natural lighting effects using just a single flash unit. And, since you can carefully control the direction of the broad light beam, the combination also offers you far more lighting versatility than you can achieve with either direct or conventional bounced flash.

The level of illumination on your background, for instance, can be altered by adjusting the umbrella position to allow more or less light to "spill" behind the subject. For a light

This diagram undertakes to illustrate the several optional methods for adjusting the lighting ratio in a typical portrait setup using two strobe units—a main light and a fill light at camera: (1) In many cases, the simplest technique is to reposition the main light to provide more or less illumination as desired for your lighting ratio. This is particularly useful when the fill source consists of an on-camera flash unit, which itself cannot be moved without altering the composition of your picture. (2) If the fill can be mounted off-camera on a light stand, its illumination level can be simply adjusted by repositioning it closer to or further from the subject. Remember that to provide pleasing fill-in lighting, this unit must be kept as close as possible to the camera-to-subject axis. (3) Since fore-and-aft movement of on-camera strobe must alter the crop of your picture, bear in mind the other alternative for at least reducing the fill level by placing a handkerchief, a sheet of neutral density filtration gelatin or a scrap of tissue paper over the flash unit. This will effectively reduce the unit's output by one to two stops. (4) If composition is not a problem, of course, you can move the on-camera strobe to adjust fill level, or (5) to prevent changing composition with this method, a change in camera lens (or better yet the use of a variable-focal-length or zoom lens) can be used to compensate for the modified camera-to-subject distance.

background, you might position the unit so that the central shaft of the umbrella points directly at your subject, placing him (or it) in the very center of the entire beam, and permitting light toward the rear edge of the beam to fall on the background. If, on the other hand, you want to minimize background detail (and this is especially useful if you're working in an area that won't allow you to move the subject away from the background), you can reduce background illumination by pointing the umbrella shaft *away* from the subject more in the direction of the camera position. This technique, called "feathering," puts your subject on the edge of the light beam, with light spillage occurring in front of him, and usually outside the picture area defined by your frame.

Even though the umbrella reflector will soften the edges of shadow areas, it will not significantly reduce the actual contrast between shadow and highlight values. The obvious method to reduce contrast would be to lighten the shadows by adding another strobe unit for "fill-in" illumination. We'll look at that technique shortly. Meanwhile, you can still obtain a wide range of fill-in effects, from very subtly lightened shadows to almost nonexistent shadows, by using your single strobe-umbrella unit in combination with the flat bounceboard reflector in our list of off-camera strobe ac-

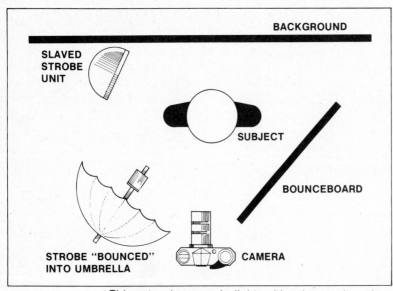

This setup has a main light, with a bounceboard as fill, and a second, slaved strobe unit as an accent light to "separate" the subject from the background. (See text for details.)

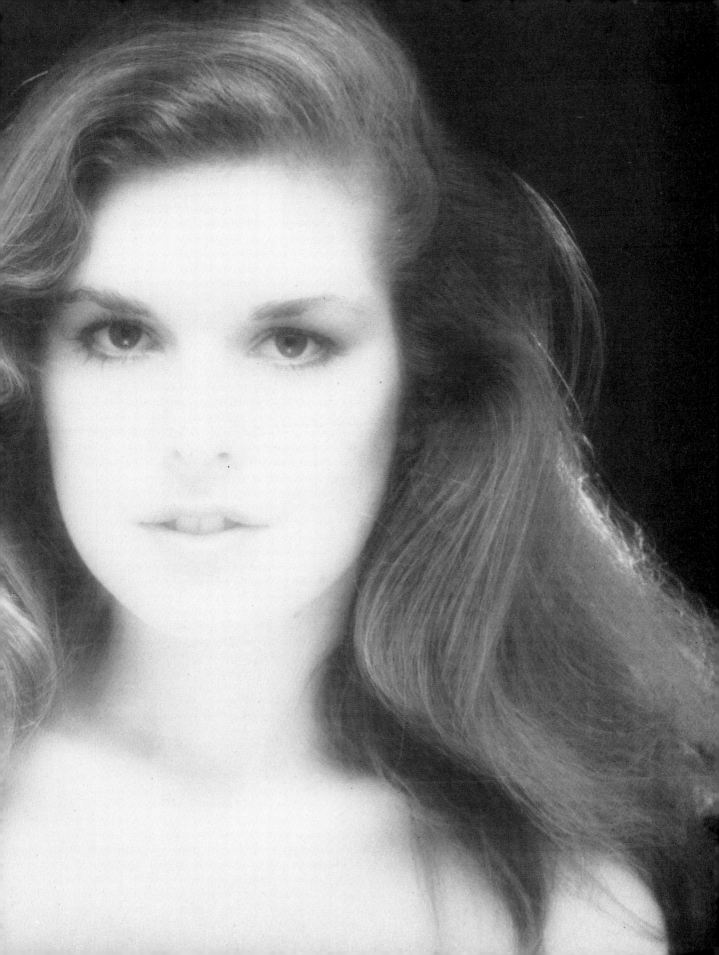

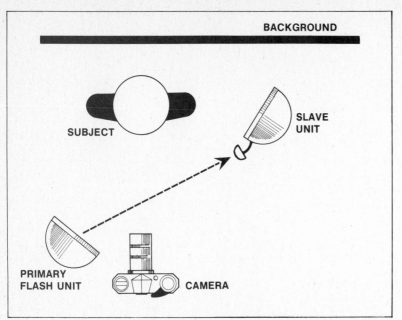

BACKGROUND

SLAVE UNIT

SUBJECT

PRIMARY FLASH UNIT

CAMERA

In order to be effective, the slave unit responsible for firing a second or third strobe must be positioned to "read" the light pulse from the primary flash unit. Obstacles like umbrellas or reflectors can sometimes obscure the line of sight between slave and primary flash. If your setup precludes altering the positions of such obstacles, a good solution is to attach the slave to its strobe unit via an extension cord. This will permit the placement of the slave in a better line with the triggering flash unit, without having to move the secondary strobe.

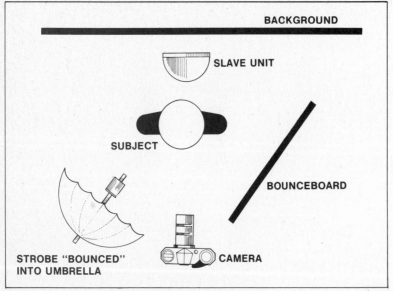

BACKGROUND

SLAVE UNIT

SUBJECT

BOUNCEBOARD

STROBE "BOUNCED" INTO UMBRELLA

CAMERA

Here, a main light again has a bounceboard as fill and the slaved strobe unit used to illuminate the background. (See text for details.)

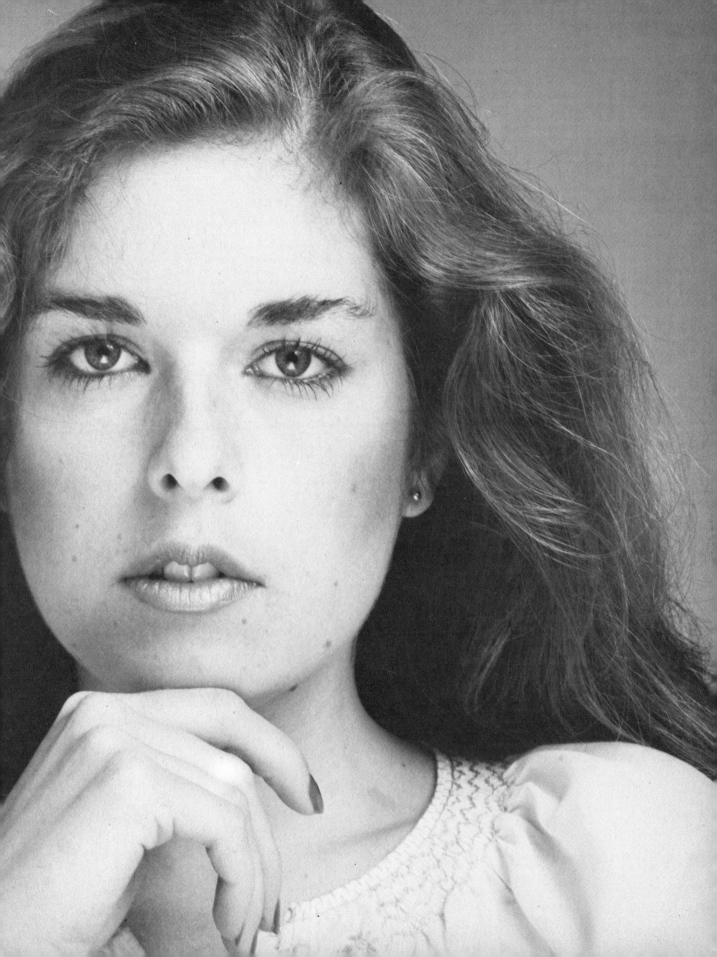

cessories. As diagrams on pages 90-94 illustrate, the bounceboard is simply placed on the shadow side of the subject in such a way that it will reflect light from the source back into the shadow areas. The closer the reflector is to the subject, the lighter the shadows.

In this way, the bounceboard, along with the umbrella reflector, converts your single portable strobe unit into an extremely versatile lighting tool that, unlike strobe on-camera, allows you all the advantages inherent to electronic flash, without sacrificing the attractiveness and overall quality of your results.

3) *Exposure Calculation with Off-Camera Flash:* Exposure for off-camera flash is calculated just the same as exposure with on-camera flash. The important exception is simply that flash-to-subject distance is no longer the same as camera-to-subject distance. We've already discussed the convenient method for measuring this distance, using your lens's distance scale, but there are a couple of other procedures you should also know.

The first of these relates again to your unit's guide number. As we mentioned in Chapter 3, guide numbers must be recalculated for all different "conformations" in which you use your strobe unit. The umbrella reflector represents one such conformation, and merely knowing the correct guide number for your flash alone will not ensure you accurate exposures when the unit is used in combination with an umbrella. Since umbrellas of different sizes and materials vary a great deal in the amount of light they reflect, you should conduct a new series of guide number tests with each kind of umbrella you own. First, establish a standard distance between the strobe itself and the umbrella, marking the umbrella shaft so that this distance will remain constant whenever you shoot. After you've arrived at a guide number, be sure to measure all your subsequent flash-to-subject distances from the same point on the umbrella shaft, to further ensure consistency. A good trick for standardizing flash-to-subject distance is to affix a length of string or ribbon to your light stand, and mark it with a pencil or by tying knots at intervals of, say, one foot. This gives you a method for quickly figuring flash-to-subject distance, and it's also a way of positioning your unit quickly at those distances which experience tells you provide the best results. You might find, for example, that at 10 feet, with a certain film, you get optimum exposure for portraits, since the correct aperture for your unit (with that film and at that distance) minimizes background detail by reducing depth of field. A 10-foot mark on your measuring string will simplify portrait setups.

On the other hand, you might find that for close-ups or tabletop shots, a smaller aperture gives you better results. If that smaller aperture is indicated at, say, a three-foot flash-to-subject distance, you would mark the string accordingly.

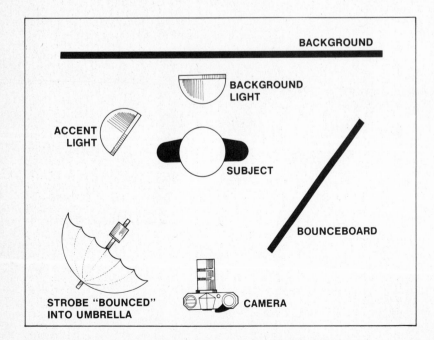

A three-strobe setup this time incorporates both a background light and an accent light, each fired by slave units. The fill light in this case is still a bounceboard reflector. (See text.)

BACKGROUND

BACKGROUND LIGHT

ACCENT LIGHT

SUBJECT

BOUNCEBOARD

STROBE "BOUNCED" INTO UMBRELLA

CAMERA

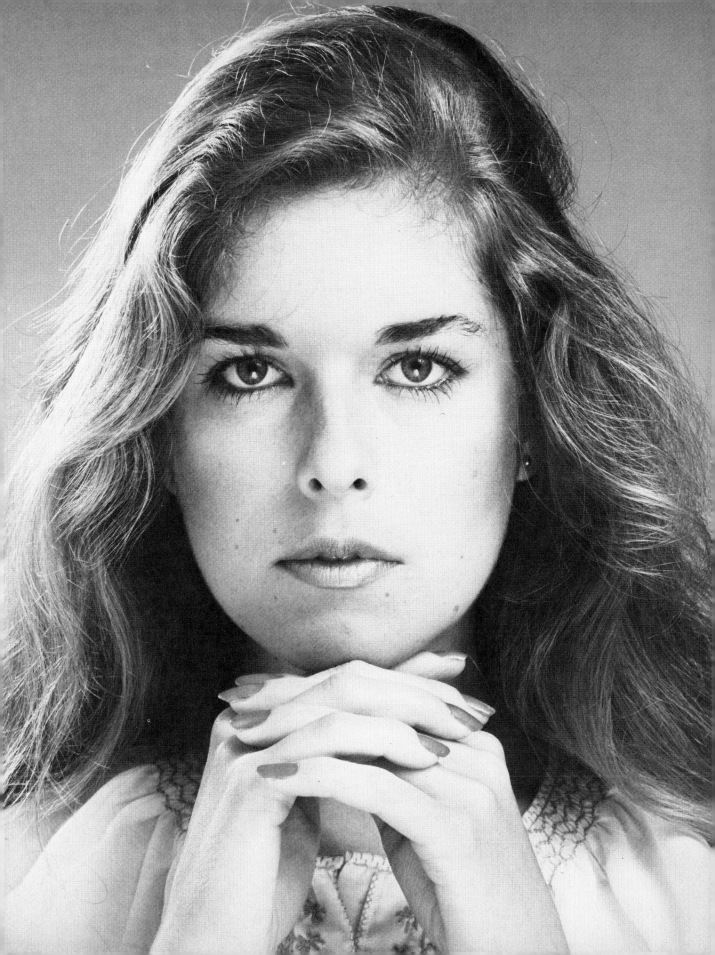

Previewing Your Lighting

Like exposure calculation, the technique of positioning your strobe unit for best results is hampered by the difficulties inherent in a light source that can be turned on for only a fleeting fraction of a second. With a continuous artificial light source, this obviously poses no problem, since you can see the effect of your lighting before you make an exposure. Experience with your electronic flash will eventually allow you to predict with a fair amount of accuracy what will happen to a given subject with the strobe in a certain position. But some subjects require very precise lighting that entails experimenting with different positions until the desired effect is achieved. Rather than make hundreds of separate exposures, each with the light in a different position, you can modify your strobe unit so its ultimate effect can be previewed before you shoot. This modification simply involves adding a "modeling light" or "pilot light" to your flash setup.

A modeling light usually consists of little more than a weak continuous light source, such as a photoflood bulb or household fixture, mounted near the strobe unit, so its effect on your subject simulates the effect your strobe will have when you make an exposure. For flash used in the direct mode, your modeling light should point directly at your subject

A high-key lighting scheme favored by glamour photographers, this incorporates two background units, both slaved, which provide a broad uniform highlight behind the model and are fired by a third fill-in unit close to the camera-to-subject axis. (See text for details.)

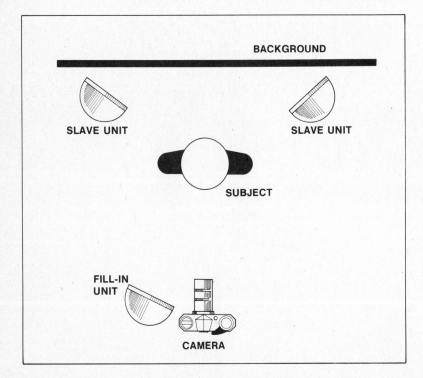

BACKGROUND

SLAVE UNIT

SLAVE UNIT

SUBJECT

FILL-IN UNIT

CAMERA

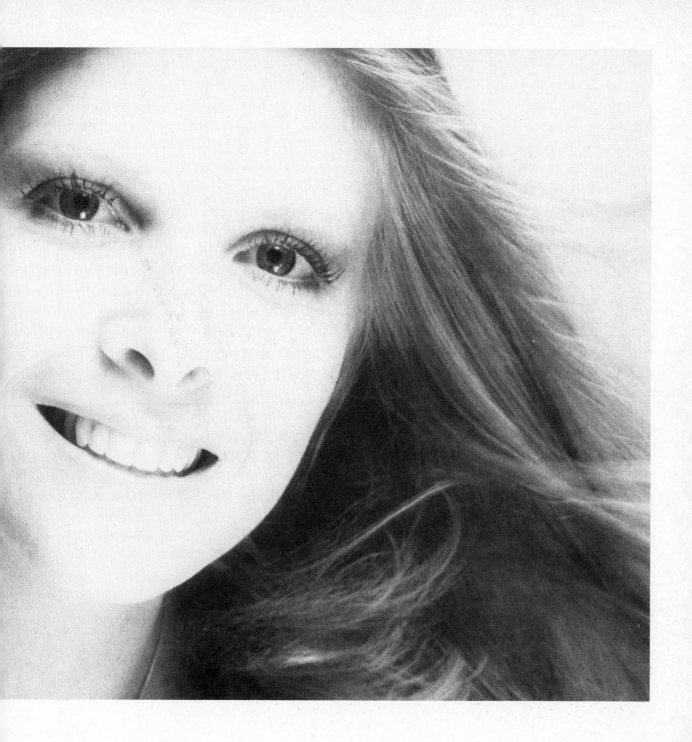

from the same position as the flash. For indirect lighting, bounced off a wall, or an umbrella, the modeling light should face the reflecting surface, again from the same position as the strobe.

There are many different ways to rig a modeling light to your flash setup, but probably the easiest is with a clamp-type light fixture, of the kind available in most hardware stores. With a relatively weak household light bulb, the clamp fixture—fastened to your light stand or umbrella bracket—will provide you with an accurate preview of your lighting effects. As a precaution, be sure that your modeling light is not so powerful that it will record on film when you make your flash exposure. If your portable strobe is one of the small, low-power models, this is a very real danger, and one that you should avoid at all costs, especially when you're using color film, since the color temperatures of incandescent bulbs and electronic flashtubes are dramatically different. (See Chapter 1.) Naturally, if you prefer a powerful modeling light, you can take the extra precaution of extinguishing the light before you make a flash picture. But, with many sub-jects, some continuous light source is usually needed as an aid to focusing, so it's always a good idea to have a modeling light that can be kept on throughout your shooting session. A few test shots with bulbs of different wattage will tell you what kind of modeling light is "safe" for use with your particular strobe unit.

Multiple Lighting with Portable Electronic Flash

Once you've explored all the lighting possibilities you can achieve with a single portable strobe unit and the basic accessories we talked about in the last section, you might want to move up into the more sophisticated techniques of multiple flash. With the addition of one to two portable units and accessories to your complement of gear, you enter a realm of technique in which it's possible to create nearly any lighting effect you could possibly want.

In addition to extra light stands for mounting your additional strobe units, a vital accessory for multiple electronic flash setups is the remote trigger, or "slave" unit. This is a small light-sensing device combined with a firing

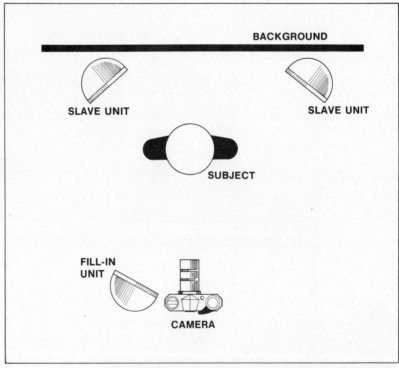

This low-key backlighting setup also employs three strobe units. The two slaved units behind model are fired by the fill-in unit in the camera position. (See text for details.)

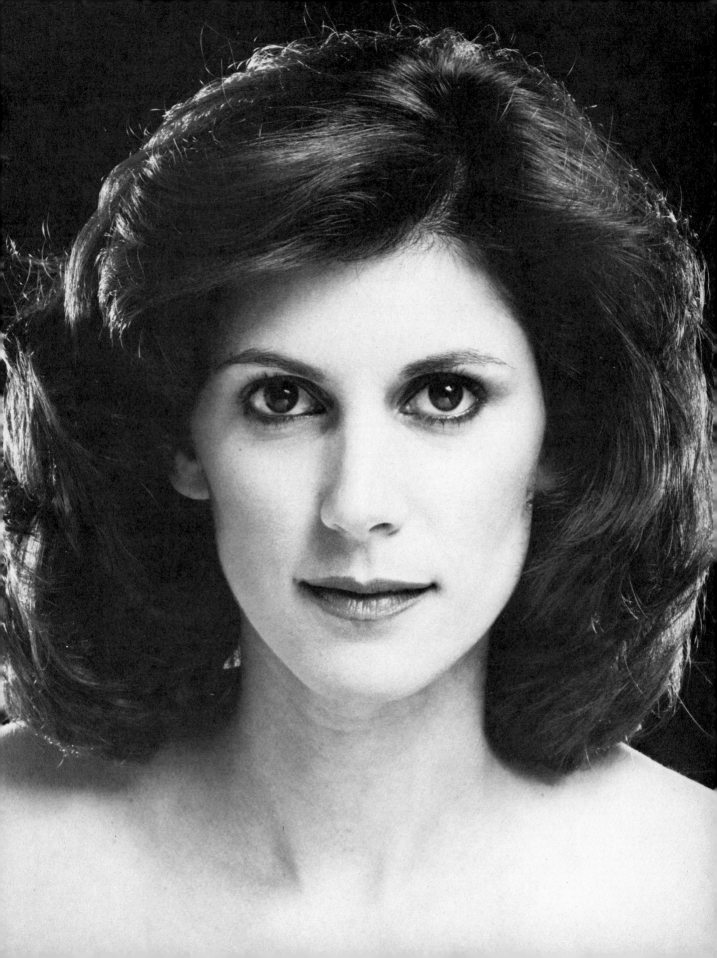

circuit that triggers a strobe unit after detecting the pulse of light from another flash. Most slaves attach easily to the strobe's sync terminal, providing you added luxury of remote operation without the need for extra entension cords. (Such extension cords are available, with multiple socket connectors that fire several strobes at once. They're omitted here simply because they offer a far less convenient method than provided by relatively inexpensive slave units.)

With a single strobe unit connected to your camera's sync terminal you can fire hundreds of other strobes, providing each is equipped with its own slave. This will give you an idea of the range of lighting effects the slave unit allows you. You'll probably never want to use more than three or four portable units together at the same time, but the slave unit permits you an almost unlimited range of options if you need them.

The following are some of the basic multiple lighting techniques you can achieve with electronic flash and slave units.

1) *Main Light Plus Fill Light:* This is a standard scheme for lighting a broad variety of different subjects. You've already seen one way to accomplish it, using a single strobe unit in conjunction with a bounceboard reflector. It can also be achieved with two strobes—one mounted on-camera as the fill light and the other equipped with a slave unit and mounted off-camera as the main light.

We usually discuss the relationship between the effect of the main light and the effect of the fill light in terms of "lighting ratios." A high lighting ratio indicates a lighting scheme in which the main light is considerably "stronger" than the fill light. In a low lighting ratio, the fill light strength is relatively close to that of the main light. Thus, a high lighting ratio means relatively high contrast between shadows and highlights, and a low lighting ratio means lighter shadows that approach the brightness level of the highlights.

Lighting ratios are computed on the basis of exposure data, and it's important for you to understand how to establish the proper lighting ratio in order to get the effects you're after. If the main light provides twice the illumination of the fill light—or, in other words, if the main is "one stop brighter" than the fill—then the lighting ratio is 3:1. It's not called a 2:1 ratio, as you might expect, simply because the fill light and main light do not act independently on the subject. Since the fill

light increases the illumination level in the highlights (which are principally illuminated by the main light) as well as in the shadows, the effects of main and fill are considered cumulatively when computing the lighting ratio. Thus, when the main is one stop brighter (or twice as bright) as the fill, we say that the main is responsible for "two units" of light, in relation to the fill, which is responsible for "one unit" of light. The total effect on the subject, then, is "three units," giving us our 3:1 lighting ratio.

If the main light is two stops brighter than the fill, that of course means it is providing *four times* the amount of illumination. Again, in terms of "units of light," we compute the ratio as four units from the main light vs. one unit from the fill light. Four plus one is five, making the ratio 5:1.

What makes one lighting ratio preferable to another depends a lot on the nature of your subject matter. In a head-and-shoulders portrait situation, for instance, the "roundness" of the subject's face will dictate whether a 3:1 or a 5:1 ratio will yield a more flattering result. If the subject's face is average, or narrow, you'd probably choose as 3:1 ratio simply because it provides a pleasing balance between highlight and shadow, and reveals good detail in both. A person with a round face, however, might call for a higher ratio, 5:1 or even 9:1, since the darker shadow areas that come with these higher ratios would help to minimize the roundness by confining highlights to a narrower area of the face. Aesthetic judgments such as these, of course, are made easier by experience in shooting portraits or whatever your favorite type of picture is.

In any case, let's look at an example of how we apply our knowledge of flash exposure to establishing a typical lighting ratio. Assume that our main light is a flash unit with a guide number of 80 and we place it five feet from the subject. We know that our correct exposure for that unit at five feet is f/16 (80 divided by 5 = 16). That unit is equipped with a slave, and will be fired by our fill light, which, we'll assume, is a flash with the same guide number mounted on-camera. In order to establish a 3:1 ratio between main and fill, we must now determine the distance from fill-to-subject that will give us fill-in illumination that is one stop less than the main illumination. That means we must find the fill-light-to-subject distance which will require one stop more exposure, or an aperture of f/11. Again, re-

arranging the guide number formula we have:

Guide Number/Distance = f-stop

to calculate correct distance:

Distance = Guide Number/f-stop

we can determine the correct fill-light-to-subject distance:

Distance = 80 ÷ f/11 (or approx. 7.5 ft.)

Thus, to give us our 3:1 lighting ratio, the fill light must be placed 7.5 feet from the subject. Since, in this example, our fill light is mounted on camera, we are restricted to shooting the picture at the distance of 7.5 feet. But, suppose that focusing distance did not allow for composing the picture the way we had intended? The obvious answer would simply be to employ another light stand for mounting the fill-in strobe unit, freeing the camera from having to be positioned according to your exposure calculations. We would also have the option of repositioning the main light, or reducing the power of the fill-in flash manually, if the unit comes equipped with a provision for power control. A "half power" setting, for instance, would allow us to shoot this particular portrait from five feet away, since at that setting, the fill-in strobe output would be one stop less than the main.

Another alternative for controlling the output of an on-camera fill-in strobe is to cover the flash head with several thicknesses of handkerchief material or tissue paper. You'll have to run tests beforehand, of course, to determine what kind of material and how much of it is needed to precisely reduce the illumination level. Some of the newer portable strobes now feature clip-on diffusing attachments that perform the same function.

A fourth alternative, which would again allow us to keep the fill-in flash mounted on-camera, would be to use a variable focal length or zoom lens. With this type of lens, we would compose the picture however we wanted, without the necessity of changing our camera-to-subject distance. It should go without saying here that if you shoot a lot of pictures that require precise control over lighting ratios, you'd be very wise to choose a fill-in strobe that has a lower guide number than the one you use for main light illumination. Lacking this, you'll constantly find yourself in the position of trying to reduce the output of your fill-in unit.

As in most multiple lighting setups with any kind of artificial light source, your correct exposure setting should be based on the effect of the main light alone. In the above example, our proper aperture setting would be f/16—the f-number dictated bx the main-light-to-subject distance—no matter what lighting ratio we were trying to establish with the fill light.

2) *Main Light Plus Fill Light Plus Accent Light:* Although this is a three-light setup, you can still accomplish it using just two strobe units. One of these will act as your main light, and will connect to the camera directly via an extension sync cord. Your bounceboard reflector acts as the fill light, and your second strobe unit, equipped with a slave, can be positioned behind the subject to act as an "accent light" or a "hair light." Accent lights are especially useful when the shade of the background is either darker than, or close to, the tone of your subject. The accent light gives depth to your picture by defining the separation between subject and background. Another scheme accomplishing the same end follows.

3) *Main Light Plus Fill Plus Background Light:* Here's another three-light set up you can create with just two strobe units. Again, one strobe acts as your main light, with the bounceboard providing fill-in light. The second, slaved flash unit is again positioned behind the subject but this time directed toward the background surface, rather than toward the back of the subject as the accent light must be. The illuminated background, providing that its brightness level is higher than that of the subject, will also provide apparent separation between the planes of the subject and backdrop.

4) *Main Plus Fill Plus Background Plus Accent:* By adding an additional strobe to your lighting inventory, you can combine both of the above lighting schemes for a variety of applications. The most common of these is the standard four-light portrait that uses both an accent light and a background light to give added depth to your subject. Here again, the strobe unit nearest the camera—your main light—is fired directly by a sync cord, and the two accessory units are fired by their slaves.

5) *High-Key Backlighting Plus Fill:* This particular scheme is useful for shots that call for a more stylized approach to lighting. It's frequently used by fashion and glamour photographers to create an airy, lyrical feeling and it can also be useful for tabletop "product

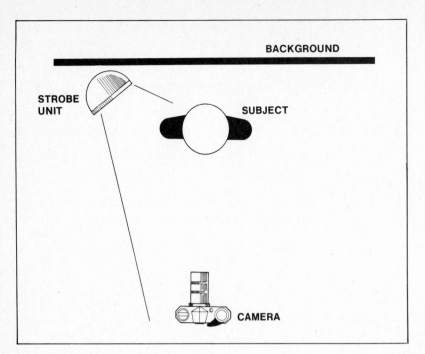

Since many setups require that background strobes be pointed in the general direction of the camera lens, a common danger with such setups is lens flare. As shown by the diagrams here, a "gobo" placed near the offending background flash unit, or if you prefer, close to the camera lens, will neatly circumvent the problem. (See Chapter 7 for more on positioning gobos.)

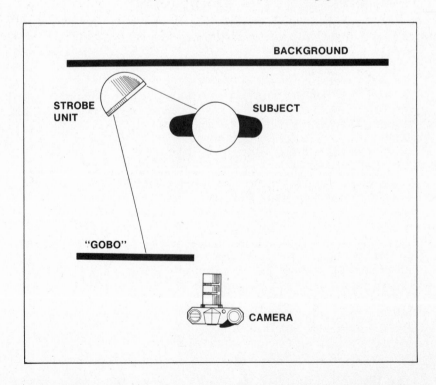

shots'' where you want to define the subject's contours dramatically, without sacrificing important frontal detail. In this scheme, two strobes are positioned behind the subject (and naturally out of your lens's ''sight''). They should both point back toward a white background and be equipped with slave units so they can be fired by the fill-in strobe in front. The fill light can be mounted either on- or off-camera to be fired by your sync cord. Depending on the output and quality you want from the fill light, you can mount it with an umbrella reflector, or simply eliminate the strobe altogether and use a large white bounceboard for fill. (In the latter case, of course, you'll have to connect one of your background units to your sync cord.)

Exposure calculation for this kind of setup can be as tricky as it looks, and if you use this scheme a lot, you'll find a flash meter to be of enormous help. If you're using a strobe unit for fill-in illumination, the problem is considerably reduced, since you can base your calculation on the fill-light-to-subject distance. Determine the f-stop you would use if the fill-in strobe were your only light source (on the basis of flash-to-subject distance), then stop your lens down one stop from that calculation. Now position the two background units at a distance from the white backdrop that corresponds to the f-stop you arrived at in your first calculation for the fill-in unit. This technique should give you a starting point for determining correct lighting balance in this type of shot, but you should shoot a few tests first to determine what modifications are necessary for the result you're after.

6) *Low-Key Backlighting Plus Fill:* As a simple variation on the high-key technique, turn the two slaved units toward the subject, rather than the background. If you use a fairly dark background surface, you should get a dramatic ''rim-lighted'' effect. Correct exposure here also depends on the degree of fill-in illumination you want. As a starting point for your tests, calculate the correct exposure on the basis of the distance between one of the background units and the subject. Then, position your fill-in strobe so that it will provide one stop less illumination than the backlights. Again, you can create very similar effects using your bounceboard as the fill and running one of the backlights off a sync cord, the other off a slave unit.

7) *Some Extra Precautions:* Whenever you're using slave-equipped strobes behind your subject, you always run the risk of the subject obscuring the pulse of light from the frontal unit attached to the camera. If the slave cannot ''see'' the burst of the primary strobe unit, it will not fire the unit to which it's attached. You can usually avoid this problem by carefully positioning the slaved unit until you're sure it has an unobstructed view of the primary unit. Then fire the primary unit manually to make sure your slaved units are operating before you attempt any exposures on film. In some cases, you might have to connect the slave to the strobe unit with an extension cord that will allow the slave to be placed out to the side of the subject, where it will have a clear ''view'' of the primary unit's flash.

An additional risk when you're using strobe units behind the subject, as either accent or background lights, is the danger of light spilling onto the camera lens. This is a common cause of lens flare, and can wreak havoc with your results. Even if you've fitted your strobes with modeling lights, as suggested in the last section, you may still be unable to detect the lens flare that might occur when the strobes are fired for an exposure. One simple precaution against the possibility lens flare is to use a lens shade or matte box to shield the glass from extraneous light. And, if you still fear that your background strobes might spill light onto your lens, add a couple of ''gobos'' to your setup as well. Gobos (short for ''go-betweens'') can consist of small sheets of black cardboard, mounted on light stands and positioned between the strobe unit and camera, to shield the lens from direct light.

Using Flash with Available Light

Most of the flash techniques we've been looking at so far are for use in "studio" situations—those in which the only illumination in the photo comes from our strobe unit or units. There are, however, a great many other situations in which electronic flash is used not as the sole light source but rather as a means of augmenting available light. For at least one such situation, when the available light is daylight, electronic flash is perfectly suited and very simple to apply. But daylight is only one type of available light that a photographer might encounter, and

The exposure calculator dial of most portable strobe units can be extremely handy for solving the problems of balancing flash fill with sunlight. For the sample problem described in the text, the sunlight illumination indicated an exposure of 1/60 second at f/22. With the calculator dial shown here as our guide, following is the procedure for establishing a pleasing flash-fill lighting ratio:

1. First locate the required aperture setting on the calculator dial. Our conventional exposure meter indicated that this setting was f/22. On the dial, f/22 corresponds to a flash-to-subject distance of six feet, and that would be our shooting distance if the strobe unit was the sole light source in our picture. For a flash-fill situation, however, the flash-to-subject distance must be adjusted. If we want a 3:1 lighting ratio, for example, the correct exposure for fill-in illumination must be reduced to one stop under the correct exposure for the sunlight illumination. This requires calculating the proper distance to achieve the reduction.

2. To determine the distance required for a one-stop decrease in light level, we first locate the next larger f-stop on the calculator dial—f/16. (Remember that we are trying to de-power the strobe's output, so we need a distance that would entail using a larger f-stop to compensate for the reduction in output). Since f/16 corresponds to a flash-to-subject distance of about 8½ feet on the calculator, that is the distance at which our flash unit must be placed to achieve a 3:1 lighting ratio.

3. Suppose the same shot calls for a 5:1 ratio instead, meaning that we now want a two-stop difference between sunlight and flash exposures. This reduction of two f-stops from f/22 gives us a new aperture setting of f/11. Referring to the calculator dial, we find that f/11 corresponds to a distance of about 12 feet—our new flash-to-subject distance for a 5:1 ratio.

we'll explore some of those contingent situations as well. First, however, let's have a look at the most commonplace application of strobe with available light.

Electronic Flash Outdoors

Thanks to its relative portability and the fact that electronic flash illumination has the same color temperature as average daylight, it is an ideal tool for use in augmenting or modifying lighting conditions outdoors. On exceptionally dark, overcast days, it can add contrast and brilliance to a shot, minimizing the drab look that usually prevails in bad-weather photos. At sunset, or with some spectacular cloud formation in the sky, your strobe can become a beautiful main light source to isolate your subject against a breathtaking natural backdrop. And its role in night photography barely even requires mention. But probably the single most important application to which you can put your electronic flash unit out-of-doors is as a fill-in source on sunny days.

We've already observed the reasons why lightly overcast weather conditions are considered ideal for many photographic applications outdoors—so ideal, in fact, that much of the effort that goes into illuminating indoor subjects is aimed at duplicating the soft, diffused light of the sun through a thin veil of cloud

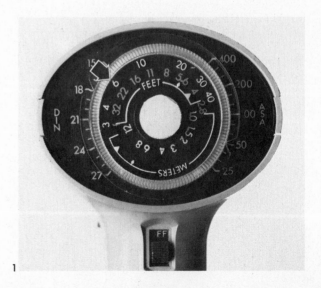

1

cover. But photographers are not always fortunate enough to be shooting outdoors under perfect climatic conditions. And oddly enough, one of the most difficult climatic conditions to work under—especially when you're shooting pictures of people—is when the sun is glaring down directly on your subject through a clear, cloudless sky.

As you saw earlier, direct light from *any* light source has certain characteristic drawbacks. In portraiture, the worst of these drawbacks is the harsh contrast between highlights and shadows. On a clear sunny day, the direct light of the sun provides you with a textbook model of everything that's bad about direct lighting. You see the effects all the time in outdoor snapshots—when the sun is at an angle to the subject, there are hard, dark shadows near the nose, the mouth and the eyebrows. Pores and skin blemishes are emphasized all out of proportion, and skin—if it's not properly covered with make-up—takes on a very unpleasant oily appearance. If, on the other hand, the subject has been turned so he's facing into the sun (to simulate the flat, shadowless lighting position which we also achieve with on-camera flash), many of the hard shadows disappear, but the subject is unable to open his eyes in the direction of the camera without squinting from the glare.

So those are your basic alternatives for making a portrait in bright sunlight: a face marred by hard, distracting shadows, or one scrunched up beyond recognition. Fortunately, there is yet another alternative: fill-in flash.

No matter what other outdoor creative effects you'll find for your strobe unit, the place to begin is flash fill, since it puts you through all the basic lessons involved in learning to balance flash illumination with the continuous light of the sun. And, because strobe light is already color-balanced to match sunlight, the only real balancing you're responsible for is balanced intensity.

Balanced lighting with flash fill is fundamentally a matter of applying the basic techniques for determining flash exposure to a situation in which strobe light is being mixed with light from a continuous source. Many guidebooks, charts, and various other aids are available to help you unravel the so-called mysteries of flash fill. But they're really not necessary if you understand the principles involved. Stated simply, those principles are as follows:

1) There are (as you've already seen) two ways to control exposure with strobe: by manipulating flash-to-subject distance, or by adjusting lens aperture.

2) Exposure for continuous light sources, like the sun, is controlled by aperture and shutter speed.

Since the common denominator of these two principles is aperture, the whole technique of balancing strobe exposure with sunlight exposure becomes a simple matter of adjusting either shutter speed or flash-to-subject distance. We use the shutter speed to control the sunlight exposure; we use dis-

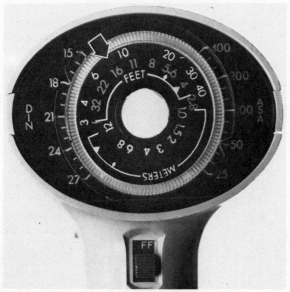

2

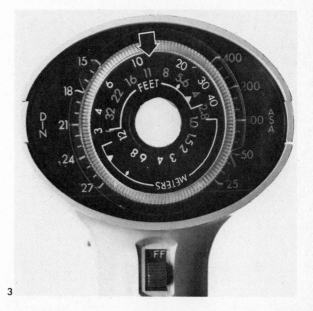

3

tance to control strobe exposure. Let's see how this technique works in a practical shooting situation.

Say you're shooting a portrait in bright, undiffused sunlight, and you decide that the conditions call for reducing contrast by opening up the hard shadows on your subject's face. Since the sun, in this case, is acting as your main light, you would first calculate the correct sunlight exposure by taking an incident or reflected light reading with a conventional exposure meter. Let's suppose that the exposure data recommended by the meter for the film you are using calls for a shutter speed setting of 1/60 second and an aperture of f/22. All you've got to do now is to find the flash-to-subject distance that will give you correct flash exposure at f/22.

Remember that "correct flash exposure" in this instance means the correct exposure for a fill light, not for a main light source. As you read in the last chapter, the illumination level for a fill light in a 3:1 lighting ratio is one stop below the illumination level created by the main light. Fill lighting outdoors subscribes to the same general rule for fill lighting with a multiple strobe setup indoors: The fill-in flash should lighten the shadows, but not completely eliminate them. So, for a 3:1 ratio in the example at hand, you must position your strobe at a distance that requires one stop more exposure than f/22. (Or, put another way, at a distance that provides one stop *less* illumination than the sun.) One stop over f/22 is f/16, which is the f-number you now use to compute flash-to-subject distance. Divide your guide number by f/16, and you have the correct flash-to-subject distance for creating a 3:1 lighting ratio for your portrait.

Let's suppose that your unit has a guide number of 140, making the correct distance for 3:1 fill approximately nine feet (140/16 = 9). If you now want to reshoot the same picture using flash fill in the ratio of 5:1 with the sun, you will have to move your flash unit even farther away from the subject. In a 5:1 lighting ratio, the difference between main and fill illumination is two stops, which, in this case, calls for a distance that will now correspond to an aperture of f/11. Again, you divide your guide number by the f-number, to compute the adjusted flash-to-subject distance for a 5:1 lighting ratio. Your new flash-to-subject distance comes to 13 feet (140/11 = 13).

Obviously, if this were all there was to flash-

fill technique, it would never have become as immersed in mystery as it is. There are built-in complications, but dealing with those is purely a matter of applying common sense to your knowledge of strobe exposure. Let's have a look at one such complication, as it might arise in the example we just considered.

Assume that in that example you are using your flash mounted on-camera—as it often is for use outdoors. Given your correct distance, nine feet, for 3:1 fill lighting, you must obviously place your camera at that same distance. But suppose, with the lens you are using, a focusing distance of nine feet does not allow you to compose your portrait exactly as you'd planned. Since nine feet is the only distance at which you'll get proper lighting balance for your 3:1 ratio, does that mean that you're hopelessly pinned down to shooting from that distance?

The answer to that question depends on several factors. Bearing in mind, again, that we control sun exposure with shutter speed, and strobe exposure with distance, let's suppose that you select a camera position that is 13 feet from your subject. You'll recall that, at 13 feet, with the camera still set for 1/60 at f/22, your strobe will only give you a 5:1 fill-in ratio. To shorten this ratio back to your desired 3:1, you could simply open the camera lens one stop to f/16. Since your strobe, at 13 feet, calls for a setting of f/11 to give 3:1 fill, your aperture is now properly set to establish the necessary one-stop difference between sun and strobe. But what have you done to the sunlight exposure? By opening one stop, you're obviously going to overexpose those areas of your subject illuminated by sunlight. So, to compensate for the extra amount of light you're now letting into the lens, you "stop down" your *shutter speed* by one full increment—from 1/60 to 1/125 second. Since 1/125 second at f/16 is equivalent to 1/60 at f/22, your sunlight exposure remains correct. You've merely altered shutter speed to accommodate the change in flash-to-subject distance.

Unfortunately, not all cameras will allow you to make this particular adjustment. Why? Because, as we saw in the chapter on the basics, many modern cameras—those with focal-plane shutters—will not synchronize an electronic flash unit at shutter speeds faster than 1/60 second. This means that in flash-fill situations, you can use shutter speed to control sunlight exposure only at speeds of 1/60

(1/80 in some newer cameras) or slower.

So, if your camera limits you this way in flashfill situations, what options do you have? One alternative, in cases like this, where the limitations of your shutter restrict the range within which you can move your camera-mounted strobe, is just to remove the strobe from the camera. Mounted on a light stand, the strobe can be easily placed at any distance from the subject, independent of your chosen camera-to-subject distance. This method is especially desirable when you want to "cover" your subject from many different angles and distances, without altering the lighting balance.

Unfortunately, a light stand (or even an assistant to hold the off-camera strobe for you) is not always a practical accessory outdoors. So, as another option, you might consider leaving your strobe on-camera, and adjusting camera-to-subject distance by using a variable focal length or zoom lens. What you're really doing with this particular technique is changing the composition of your picture without moving. Your camera position—*and* flash-to-subject distance—remain the same. In an age when improvements in optical engineering are nearly on a par with the technological developments in electronic flash engineering, the zoom lens for flash-fill photography has at last become a serious alternative. It's definitely worthy of your consideration if your outdoor strobe picture might be tyrannized by your strobe's distance requirements.

Because correct sunlight exposure under typically bright, flash-fill situations usually calls for small apertures and relatively fast shutter speeds, there is one important precaution the user of a focal-plane shutter can take to minimize the complications he'll have to face: Use slow films. If, in the example we've just considered, you were using a film that was just one stop slower, there would have been no difficulty in changing the flash-to-subject distance to accommodate your new composition. The original sunlight exposure would have been 1/30 at f/22, allowing you to open up your lens one stop, and increase the shutter speed commensurately, still within the range of your shutter's synchronziation capabilities. For this reason, color films like Kodachrome (ASA 25 or 64) or Ektachrome (ASA 64) and black-and-white emulsions such as Kodak's Panatomic-X (ASA 32) or Ilford's Pan F (ASA 50) are preferable for use with focal-plane shutters under situations that characteristical-ly call for the use of flash fill illumination.

If you have the advantage of being able to select the strobe unit that will give you the best flash-fill results, you can make that selection according to the lenses with which you shoot most of your portraits. For example, a "normal" lens for a 35mm camera, having a focal length around 50-55mm, has a useful range of working distances from about four feet, for a head-and-bust shot, up to 10 or 11 feet for full-length portraits for small groups. (Shooting human subjects at closer than four feet with such a lens is not recommended, since it distorts facial features at minimum focusing distances.)

As a general rule, strobe units rated between 2000 and 4000 BCPS provide optimum output for either 3:1 or 5:1 ratios at the normal lens's conventional focusing distances for portraiture. Units of lower power, say 1200 or 1000 BCPS, while they might be adequate for closer focusing distances, simply do not provide sufficient fill for more distant pictures. With lenses that are more optically suited to portraiture—usually within the 85mm—135mm focal-length range, you'll want a strobe in the neighborhood of 3000-8000 BCPS, to accommodate the longer focusing distances that are possible with these semi-telephotos. A 135mm lens, for example, can be used for portraits from a focusing distance of 5½ feet for a tight head shot, and up to 21 or 22 feet for a full-length study. Even a powerful 8000 BCPS unit will barely provide adequate fill for a 5:1 lighting ratio at this lens's maximum distance. But, for the more common camera-to-subject distances at which such lenses are used, the 3000-8000 BCPS power range is ideal.

Step-by-Step Procedure for Flash Fill

Now that you've looked at a couple of typical flash-fill problems and understand their causes, let's establish some practical procedures for optimizing your flash-fill results.

First of all, as you've probably guessed, you can circumvent the need for making distance or aperture calculations to determine your ratios of sunlight to fill light. This is where your unit's built-in calculator comes in handy. After you've determined your correct sunlight exposure (aperture and shutter speed), refer immediately to the calculator dial. Set the dial for the ASA of the film you're using, and find the "sunlight aperture" on the dial. Locate that aperture's corresponding distance figure on the footage scale, and you now have the

As we saw in Chapter 5, lighting ratios between main and fill-in illumination do not correspond numerically to the ratios between actual exposure settings. The same is true of the lighting ratios obtained using fill-in flash outdoors. For example, in a 3:1 ratio, correct exposure for the fill-in illumination is really 50 percent (or one stop) less than the correct exposure for the sunlight illumination.

Translated into schematic terms, this means that two units of light on the subject are provided by the sun, while only one-half of that amount—one unit of light—is provided by the strobe unit. Since the position of the flash adds fill lighting to the highlights as well as the shadows, the cumulative illumination from sun and strobe is three light units, making the true ratio of sunlight to flash fill 3:1.

Similarly, a 5:1 lighting ratio calls for a difference of two stops between sunlight and flash fill. That means that the sunlight is four times as bright as the strobe illumination, so we can think of it as providing four light units to the one light unit of flash fill. Total of five light units yields 5:1 ratio.

It is important to remember that the main objective of fill-in flash is to lighten shadows but not totally eliminate them. This photo shows the result of applying too much strobe fill to an outdoor portrait.

Using too powerful a flash unit or placing it too close to the subject can easily produce the artificial, ''pasty'' look that can ruin an otherwise natural-looking portrait.

Electronic flash is the perfect tool for softening these harsh, unflattering effects of direct sunlight on a portrait subject. By ''opening up'' the dark shadows that result from undiffused illumination characteristic of bright sunny days, fill-in flash minimizes textural features of the subject's skin.

113

proper flash-to-subject distance for *eliminating the shadows* on your subject.

But, as we've observed, the purpose of flash fill is to *lighten,* but not eliminate, shadows. So, you must now decide to what extent you want to lighten those shadows in relation to the highlights created by the sun. The relationship is your lighting ratio, and the most natural-looking results outdoors are obtained when that ratio is somewhere around 3:1 or 5:1. As a rule, 3:1 is appropriate for a subject whose face is two-thirds or more in shadow, with the remainder receiving direct sunlight. A 5:1 ratio is better for filling in smaller areas.

Having selected the lighting ratio you want, consult the calculator dial again to determine the proper flash-to-subject distance for that ratio. For 3:1, locate on your aperture dial the f-number that is *one stop larger* than your sunlight f-number. (If the sunlight f-number was f/16, one stop larger would be f/11.) Again referring to the distance scale, find the footage that corresponds to the new aperture. Set your strobe at that distance for a 3:1 lighting ratio.

If you want a 5:1 ratio, count *two stops larger* than the sunlight aperture and locate the correct footage for the f-stop. (Two stops larger than f/16 would be f/8.) Place your strobe unit at the indicated distance, and you will now have a 5:1 lighting ratio.

If your strobe is mounted on-camera and you change camera-to-subject distance to modify cropping and composition, you must also change exposure settings to maintain your desired lighting ratio. To compute the necessary f-stop changes, use your calculator dial in reverse. Find the new distance on the footage scale, read the corresponding aperture, and set your lens one stop under that aperture (for a 3:1 ratio) or two stops (for a 5:1 ratio). Now readjust your shutter speed setting to give you correct sunlight exposure with the new f-stop. If you move closer to your subject, you must stop down the lens, so you'll have to use a commensurately slower shutter speed. If you move farther away from your subject, you must open the aperture, which means using a faster shutter speed. If the new shutter speed is beyond the synchronization range of your camera, return to the original distance and reduce the strobe output by placing a layer of handkerchief or white tissue over the head of the flash unit.

Additional Contingencies

Under the bright conditions for which fill-in flash is most appropriate, you'll usually find that your exposure readings for sunlight call for relatively small apertures. Such aperture settings are not always ideal for portraits, since the increased depth-of-field they provide prevents you from de-emphasizing background detail—as you often do in a portrait study—by allowing distracting elements behind the subject to record out of focus.

With flash on-camera, the distance requirements (as well as the shutter speed limitations of a focal-plane shutter) for correct fill-light exposure restrict you from adjusting the f-stop and shutter speed controls by which you ordinarily manipulate depth-of-field. One obvious alternative for dealing with this problem is to pose your subject carefully so there will be as little distraction behind him as possible. If you still need larger working apertures for shallower depth-of-field. One you must use neutral density filters. These filters simply reduce the amount of light transmitted by the lens, and they represent an effective means of "stopping down" without increasing depth-of-field. An equivalent setting of f/16, for example, can be obtained by adjusting your aperture to f/8 (for shallower depth-of-field) and adding a "4X" (two-stop) ND filter over your lens. A 2X filter would stop down one f-stop, and an 8X would stop down three stops.

An added precaution should also be taken in your selection of shutter speeds with certain types of subjects. Since your shutter speeds in flash-fill situations—especially with a focal-plane shutter—tend to fall in the slower range (1/30 second, 1/60 second), you might find that some of your flash-fill shots contain "ghost" images. These usually appear in shots of moving subjects, but they can also be a danger on windy days, when long exposure times record hair or clothing billowing in the wind as blurred images. An even more common cause of ghost images is camera movement. If you can't hold your camera steady at shutter speeds of 1/60 second or slower, don't attempt to do so with flash fill. Use a tripod. The parts of your subject illuminated by the strobe unit will not be affected by such movement, but the area illuminated by sunlight—a continuous light source—probably will.

Balancing with Other Continuous Light Sources

1) *Electronic Flash with Window Light:* Without a doubt, one of the most beautiful ways to light a photograph, portraits in particular, is with soft, indirect illumination filtering through a window. Unfortunately, the level of this type of illumination is not always sufficient to provide pleasing light, especially on the shadow side of the subject. The simple use of a reflector, of course, is an obvious way around this problem. But frequently a photographer might want to resort to a more dramatic means of supplementing his window light. Since window light is the same color as daylight, electronic flash is once again the perfect fill-in tool.

In the environs of a room, fill-in flash can be used in the same way as it is used outdoors, with the additional advantage that the room provides a good opportunity for even more creative effects. Using the fill-in indirectly, for instance, with the light bounced into an umbrella, is a simple matter in the confines of a room where there is no breeze or other *al fresco* conditions to contend with. The beautiful quality of bounced light lends itself perfectly to producing attractive and convincing effects in conjunction with window light. In addition, the photographer should not overlook the possibilities of using the room's walls or ceiling as tools for creating indirect illumination. As we saw earlier, the darker such surfaces are, the less useful they become as bounce surfaces. And, you must also be careful that the hues of the room do not significantly alter the result of a color photograph.

2) *Electronic Flash with Fluorescent Light:* Color balance becomes a really significant nuisance in another fairly common shooting situation which many modern photographers encounter all of the time. Since many industrial and residential interiors are lit by fluorescent fixtures, a predictable and frequent problem is combining electronic flash with fluorescent illumination, whose extremely high color temperatures tend to record as very greenish on daylight color emulsions. Obviously, the problem is insignificant in a black-and-white photograph, but color balance between flash and fluorescent can be quite a maddening exercise which we'll have a brief look at here.

A photograph illuminated solely by fluorescent lighting can usually be rendered accurately on daylight color film with the aid of special filters manufactured for that purpose. One such filter, the FLD, produces color that is quite natural indeed, and there are even available some fluorescent lighting fixtures whose color balance is already quite close to that of electronic flash or daylight, and thus require no filtration whatsoever. The problem, of course, is that the general level of fluorescent lighting, no matter how bright it might appear to the eye, usually is inadequate for making sharp photographs on slow, fine-grained emulsions. Electronic flash is, therefore, a useful tool in such a situation providing we first solve the inherent color balancing difficulties.

One obvious but rather cumbersome solution is to cover the fluorescent fixtures with filtration gelatins that will cause the fluorescent illumination to record naturally on daylight film. Gelatins of this type are manufac-

To add to the popular "candid" look, this photo was made with flash on camera, augmenting the natural and fluorescent lighting at the location site.

When using strobe to produce a convincing effect with window light, care must be taken to ensure that the interior illumination from the flash unit not overwhelm the natural window light illumination or the light on background details that might be visible through the window. For the first of these photos here, a meter reading was taken of the outdoor illumination at the same f-stop called for by the natural light. This technique is similar to the one discussed for using fill-in flash outdoors. For the second photo, the flash unit was deliberately placed too near the subject to demonstrate the artificial effect that results from overwhelming the exterior light with interior strobe illumination.

tured in large rolls or sheets and sold by many theatrical and motion picture supply companies. In all too many cases, however, they are extremely time-consuming and unwieldy to use. They're also far more expensive than their general utility ever justifies.

A much better option for color-balancing flash and fluorescent is to filter the strobe illumination so that it matches the color temperature of the fluorescent tube. The Rosco company of Portchester, New York, manufactures a gelatin filter, #88, in 20x24-inch sheets which can be cut down to mount very conveniently over several flash heads. With this filtration material in place, strobe illumina-tion is now balanced to match the fluorescent color temperature. Since there is no color film specially balanced for this color temperature, daylight film can now be used in combination with an FLD filter over the lens to correct the colors of both the fluorescent and the filtered strobe lighting.

Strobe is ideal for use in conjunction with window light. In this shot, it provides soft fill lighting for the shadow side of the subject. The relative ease of using bounce umbrellas and interior wall surfaces, as well as the daylight color balance of electronic flash, makes it perfect for augmenting window light without creating an artificial effect.

The optimum technique for combining strobe and florescent illumination is shown here in typical application of an office interior portrait. Rosco #88 gels are placed over flash heads to match strobe color temperature to that of existing florescents. An FLD filter over the camera lens corrects for both light sources to render natural colors on daylight-balanced film.

Electronic Flash in the Studio

Among all of the creative arts, commercial or otherwise, there is probably no single type of physical plant for the production of graphic images that is as elaborate and expensive as a well-equipped photo studio. Today even the most modest studios, like the kind used for the production of school portraits or passport photos, can be counted on to contain equipment and accessories of the highest sophistication. Obviously, for a professional photographer, competition demands that his studio be capable of producing the highest possible quality photographs in the shortest possible time and with the least hassle. Though there's no guarantee that expensive equipment will accomplish this for him, a serious professional would be unwise indeed to attempt making a name for himself without the best tools available.

Nowhere in the entire world of photography are these tools more impressively arrayed than in a large commercial studio—particularly of the type used for taking advertising, industrial and magazine pictures. Novice photographers, professional and amateur alike, are usually quite astounded on their first visit to such a studio. The broad expanses of floor space, the high ceilings, the forests of light stands and hardware, are nothing short of intimidating to someone whose own "studio" may consist of a garage, or extra bedroom.

We've already mentioned the role of electronic flash in the studio and we've briefly seen the type of flash equipment designed for this type of photography. Many of the lighting techniques we looked at in Chapter 5—though they can be accomplished with with any type of electronic flash equipment—were developed by and designed for the serious studio photographer. By virtue of the much grander power capabilities and versatility of studio strobe equipment, these simple techniques can be expanded and combined in a well-equipped studio to produce a variety of pictorial effects that is, at its best, limitless. In other words, the studio offers the photographer the opportunity for *complete control* over his lighting.

The Studio Strobe Unit: A Closer Look

Before we explore the variety of support equipment that provides the studio photographer with so much versatility, we should first take a closer look at a typical studio grade electronic flash unit. In most modern studios, this piece of equipment is the real cornerstone of artificial lighting technique.

Power Pack: As we have observed in an earlier chapter, the complex circuitry and large components required to produce the light levels necessary in the studio are usually housed in a power pack like the one shown here. The power source for this unit is a 110- or 220-volt AC electrical main to which the power pack attaches via conventionally grounded power cord and plug. Since the unit provides power not only for the flashtubes, but for the modeling lights as well, packs like the one shown here usually have separate circuitry for each of these functions. In this particular unit, the modeling light can be extinguished independently for those cases where, owing to extremely fast film or long exposures, the modeling light might adversely affect the outcome of the photo. Most recent units, like this one, also feature continuously variable power adjustment for the modeling lights. The rheostats shown here allow the photographer to adjust the level of his modeling lights to match the relative power of the flash heads when more than one is in use.

Nearly all studio strobe power packs are capable of operating in conjunction with several flash heads simultaneously. In the case of this one, a photographer could place six heads around his subject using only one power pack. In addition, nearly every such unit provides the option of varying the light output of each head according to the needs of the picture. The switches shown adjacent to the lamphead terminals provide that kind of control in our sample unit. With the switches in the position shown here, the head connected to the cord on the right would receive 1200 watt-seconds of power and the one on the left 800 watt-seconds of power. By varying the number of flash heads and their respective power allotments, the photographer could achieve any number of lighting combinations.

Like its smaller portable relatives, the studio strobe unit features a lighted signal to tell the operator that the capacitors have returned to

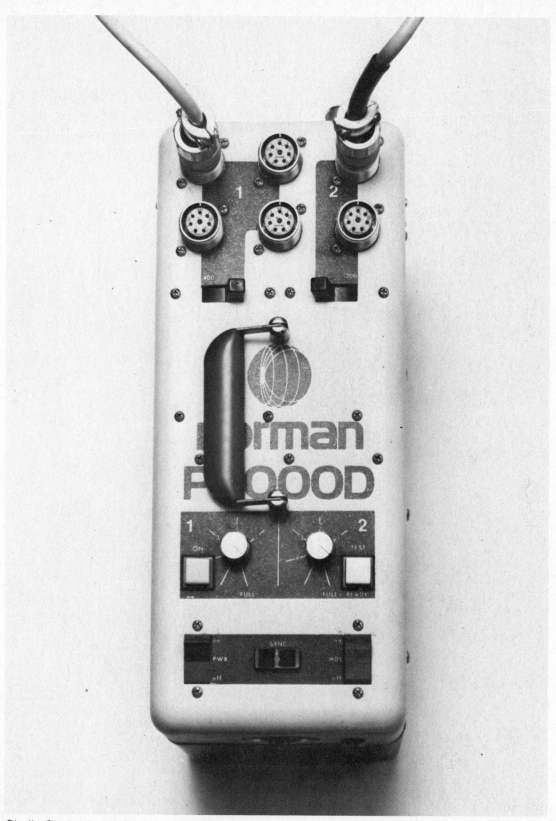

Studio Strobe Power Pack

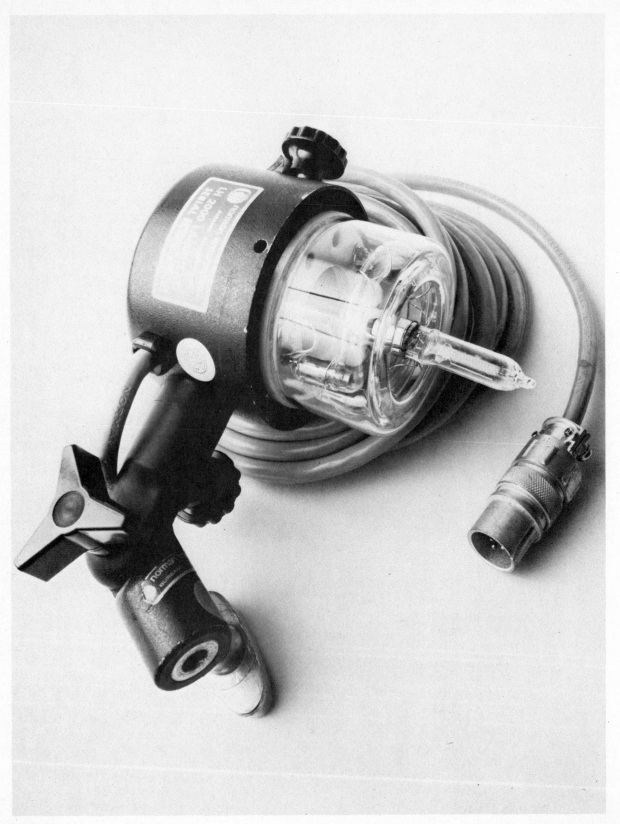

Flash Head

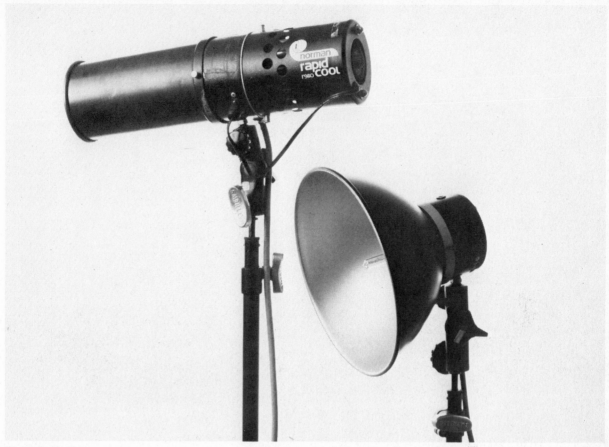

Metal Reflectors

full charge following an exposure. In the unit shown here this signal is the lamp on the lower right. In this case, the ready light is combined with a "test" button for manually firing the unit.

The capability for manual firing has special importance in a studio unit where guide number calculations are rarely used for determining proper exposure. This function is usually assumed by flash meters similar to the type we saw in Chapter 3. Manual firing is handy for providing an extra burst of light for a photograph requiring the use of very small apertures to achieve extreme depth of field. If a single flash is insufficient for the required aperture, the photographer leaves his camera shutter open and manually fires the unit a second time, in effect doubling the light output of the initial flash burst.

In the studio, electronic flash shutter-to-flash synchronization is accomplished with a synchronization cord. Unlike most portable strobe units, however, this cord lacks the familiar PC terminals at both ends. The standard PC cord must be adapted to a power cord that features a heavier terminal at the end which connects to the strobe unit. In the case of the unit shown here, that connection is made at the two-slot receptacle marked "sync" at the bottom-center on the power pack shown here.

The Flash Head

The other half of a studio strobe unit naturally consists of a flash head like the one shown here.

The circular flashtube is obviously quite a bit larger than the type you're accustomed to seeing in portable units. The tube is mounted on a ceramic base and surrounded by a Pyrex housing to protect it from external damage. The placement of the tungsten-halogen modeling lamp in the center of the ring is obviously done to ensure the accuracy of the lamp's illumination. In most studio units, this proximity is maintained in a similar fashion to the

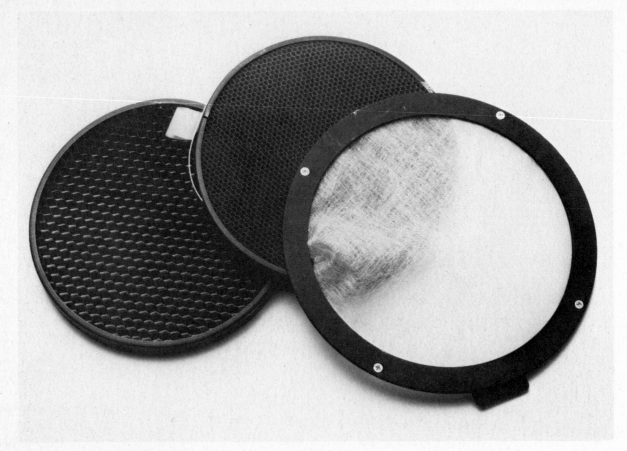

Diffusers and Light Reducers

unit shown here. The bare wire coiled around the flashtube conducts the current which actually causes the gas within the tube to conduct electricity when the unit is fired. Because of the high voltages required in studio-grade flash units, the gas within the flashtube must be maintained at just slightly higher volume than that which would allow the capacitors to discharge. When the unit is fired, current through the coiled wire causes the gas to be slightly ionized and thus capable of conducting electricity.

Depending upon the manufacturer, strobe heads are always attached on some type of assembly which allows them to be mounted on light stands or booms where they can be fitted and adjusted to whatever angle a photographer requires. All flash heads like the one shown here can be mounted with metal reflectors of various sizes and in the case of our sample there's also a special hole that allows the unit to be fitted with an umbrella reflector for bounce lighting.

Diffusers and Light Reducers

The convenience afforded to the photographer by the modeling light makes possible very precise controls over his lighting effects in electronic flash pictures. For this reason, a number of manufacturers now make available various screens and diffusers which clip on easily over a flashhead and whose effects can be previewed with the modeling light. Not only do such accessories alter the softness of illumination, but they also serve, as do metal reflectors, to make precise adjustments in illumination angle.

Colored Gels

Since it is not a heat-producing, continuous light source, electronic flash lends itself well to use with heat-sensitive gelatin filters. These materials can be used in a variety of ways in the studio from providing theatrical color effects to simply correcting an inherent color shift in the flashtube. Naturally, the heat of a

Colored Gels

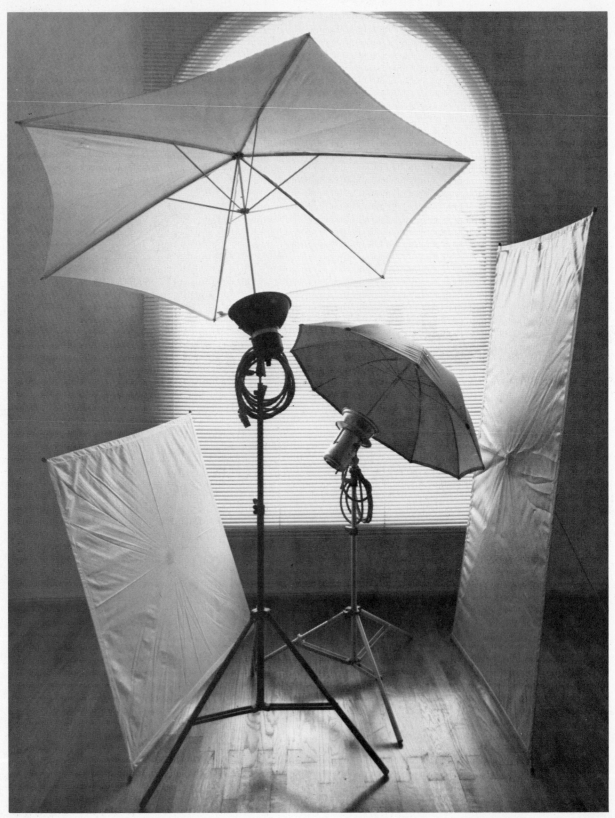

Umbrellas

modeling lamp limits the use of gelatins somewhat, but several manufacturers now provide a range of filtration materials that are impervious to high temperatures. When using the more temperature-liable filtration materials, the use of modeling lights is prohibitive.

Metal Reflectors

The angle of electronic flash illumination from a single head is controlled by metallic reflectors such as those shown here. The standard parabolic reflector, like the one on the right in this photo, creates an illumination angle of from 40-60 degrees. More elaborate metal reflectors are available for producing greater angles of illumination, some of which feature a small metal cap that partially covers the flashtube and bounces light back from the reflector and toward the subject. As we'll see, the use of this type of reflector for indirect lighting is rare, since there are other accessories that do the job far more efficiently.

To create a narrow angle of illumination, spot reflectors like the one shown on the left of the photo are used. This type of reflector is necessary when a photographer wishes to create small highlights or accents for which the beam from a standard reflector would be far too broad. Note that the flash head shown on page 123, when used with a spot reflector, must be augmented by the cylindrical cooling fan which extends from the back of the flash head. In the confined space of the narrow spot reflector the heat of the modeling tube builds up very quickly, creating the potential for damage to the unit. All studio flash heads that accept narrow reflectors have some cooling provision built in.

Umbrellas

Among the photographer's most important light control accessories for use with electronic flash are umbrella-style reflectors like the ones shown here. For reasons that we have discussed earlier, the use of soft, indirect lighting in all its various incarnations is a major theme in nearly all studio photography from portraiture to tabletop shots. The ingenious design of the umbrella reflector still represents the most convenient method of controlling and manipulating indirect light.

There are any number of different varieties of umbrella available to today's photographer. Many electronic flash manufacturers supply umbrella reflectors specifically designed to be compatible with their flash heads, and at least one firm, Larson Enterprises, of Fountain Valley, California, is devoted exclusively to the production of fold-up studio reflectors.

The photographer's principal considerations in selecting the type of umbrella for any given shooting situation can vary considerably depending upon his creative intent for that particular shot. For this reason, a well-equipped studio usually contains several umbrellas of different sizes and different surface characteristics. Since today's umbrellas are available in a wide range of sizes, it's very simple for the photographer to match the size of his flash heads to the proper size umbrella. Obviously, smaller strobes of lower output should be paired with smaller umbrellas simply because the large spread of light which the umbrella shape creates tends to reduce the lamp's illumination level appreciably.

In order to minimize this reduction of output, many popular umbrellas are constructed with high-reflective metallic fabrics. The surface of this type of umbrella, naturally, has a tendency to produce slightly harder illumination than the more conventional umbrellas which feature soft white fabric. The individual requirements of a photograph will determine whether the photographer wants to opt for one type of surface over the other. When maximizing the light output of the flash head is the primary consideration, obviously the metallic fabric is preferable. Some umbrellas are even manufactured with alternating panels of metallic and matte surface fabrics in an attempted compromise between the features of both.

Since the umbrella reflector represents an intermediary between the light source and subject, it can, like filtration gels, function to correct or alter the color of the light emitted by the flash head. Many strobe tubes, for instance, despite built-in color correction features, emit light that has an annoyingly high ultraviolet content which daylight-balanced color films record as excessively bluish. A neat way of compensating for this color shift in a bounced lighting situation is to use one of the metallic umbrella fabrics containing a gold-colored thread. The gold tint of the fabric acts on the colors of the photograph in a similar fashion to an 81A series filter. It "warms" the tones of the photo slightly and eliminates unnatural bluishness.

Since the beam of light from a flash head is naturally circular, the familiar near-round umbrella shape is perfect for maximizing the use of the flash-head's full light output. The

square and rectangular Reflectasols ® shown here, while less efficient in this capacity, have a special advantage that's not shared by their umbrella-shaped counterparts. Both the square and the rectangle can be spread perfectly flat to create extremely efficient bounce-board surfaces. Unlike bulkier sheets of cardboard, these umbrellas fold up conveniently for storage, their fabrics can be interchanged for a variety of effects, and their hinged shafts allow them to be positioned at a variety of angles to the subject. By replacing their reflective fabrics with black material, they instantly convert for use as "gobos" by which stray light or lens flare can be blocked.

Light Boxes

Bounce lighting is one way of achieving the soft, pleasing effects of indirect lighting. The other technique is to diffuse the light through a material which scatters and spreads it out uniformly. While a diffusion technique like a thickness of handkerchief over the strobe re-

Light Boxes

flector might suffice in a pinch when you're shooting with a small portable flash unit, handkerchiefs just won't cut it in the studio. So, for that reason, "light boxes" like those shown here are manufactured for use as diffusion devices in conjunction with heavy-duty studio strobe units.

Now, bear in mind that the effects of diffused lighting on a subject are closely similar if not identical to the effects of bounced lighting from an umbrella reflector. For certain types of subject matter, however, the umbrella is less than an ideal lighting tool. Any highly polished subject—for example, a glossy tabletop, a chrome or silver teapot or eating utensil—will reflect the shape of the light source used to illuminate it. The incongruous shape of an umbrella reflected in the surface of such an object can severely hamper an otherwise attractively lit photo. On the other hand, the uniform rectangular highlight created by a light box has a very natural appearance and, in many cases, adds significant beauty to a tabletop photograph. To achieve this uniform quality, most better light boxes operate on the principle of double-indirect lighting. This is accomplished by means of a reflective interior surface into which light from the flash heads is bounced, and a white diffusion material which further softens the light as well as eliminating distracting shapes that might reflect in the subject.

Obviously, the double-indirect-light principle entails a significantly increased loss of light output which reduces the light box's effectiveness with anything other than very powerful electronic flash units. Nonetheless, it is particularly useful to commercial product photographers for whom its advantages far outweigh this liability.

Bounceboards and "Gobos"

The "fine-tuning" of any studio lighting set-up often requires tools like these which are capable of precisely adding or subtracting subtle amounts of the illumination on a subject. We've already seen how effective square Reflectasols ® can be in such applications. But for many types of subject matter, the degree of control required demands a broader range of capabilities than the square Reflectasols ® alone can provide.

This is why a well-equipped studio usually has on hand a supply of lightweight cardboard in varying size and varying degrees of reflectivity. Materials of this kind can often be

Bounceboards and "Gobos"

Light Stands and Booms

130

purchased from an art supply store and are also available from studio equipment suppliers. Although there is no rule about what constitutes the ideal inventory of bounceboards, it's wise for the photographer to keep on hand at least a couple of sheets each of board with highly reflective, medium reflective and flat white surfaces. These boards should be purchased in the largest size a photographer might need to accommodate the type of subject matter he shoots. They can also be cut down to smaller sizes and different shapes as needs dictate. The material that has recently become popular for use as bounceboards is a stiff, porous material known as foam-core. Foam-core is available in very large sizes; it is very easy to cut with an X-Acto or matte knife and it is astoundingly lightweight but still very rigid.

Beyond reflectors, "gobos" (a contraction of the phrase "go-between") comprise an important part of a studio's cardboard inventory. Black posterboard with the dullest possible finish offers an accessible and inexpensive option for cutting stray reflections or highlights out of a lighting setup. For very large "gobos" foam-core is again a satisfactory alternative if it's covered with black paper, or better yet, a lightweight black fabric. Actually, black fabric "gobos" consisting of material stretched across a wire frame are commercially available. The one shown here features an extension rod that allows it to be positioned using special clamps. To position reflectors and "gobos" of the cardboard type securely is usually a simple matter of clamping or taping the cardboard to a light stand, using accessories we'll look at in the next section.

Light Stands and Booms

If control is the ultimate point of studio lighting, its guiding principle is certainly precision. The minutest adjustments of light sources or control devices often represent the key to the success of a given setup, and, for this reason, a well-equipped studio can be counted on to be fairly well supplied with a healthy inventory of accessories designed to allow the photographer maximum freedom in the placement of light sources and control devices.

The stands shown here are typical of the kind of equipment contained in most studios for supporting electronic flash gear. The basic telescoping light stand is the keystone of a studio's support inventory, and this device is

manufactured in a dazzling variety of sizes and styles to accommodate practically any piece of lighting equipment. Thanks to the relative compactness of the modern electronic flash head, most photographers are permitted the option of choosing fairly lightweight stands for the majority of studio applications. These usually consist of hollow aluminum "risers" fitted together telescope fashion. Tightening knobs located between the sections of the light stand allow for an infinite range of adjustment in the height of each riser. On less expensive stands, such knobs often do little more than put the pressure of a flat heavy screw directly against the riser to keep it from sliding down under the weight of the flash head. In more sophisticated light stands, this function is accomplished with an

Heavy-Duty Stand

internal pressure brake of plastic or aluminum, which provides a more positive grip on the riser and makes for less metal fatigue over a prolonged period than does the simpler screw-type locking system.

Although there is no official rule of thumb for matching the proper light stand to a given flash unit, the size and weight of the flash head usually provide pretty obvious guidelines for making the right selection. A modest lightweight stand of around ½-inch diameter is often perfectly adequate for supporting a single head and metal reflector at the moderate heights needed for many studio applications. The extreme heights sometimes required for special techniques (particularly adding hairlights or accent lights) obviously call for higher stands, which are proportionately heavier and broader in diameter.

As you've already seen, the need for supporting an individual flash head alone is, today, more the exception than the rule. Serious lighting technique more often calls for the head to be augmented by any number of light control accessories, some of which are many times heavier and more cumbersome than the head itself. The umbrella reflector, as a good example, mounted properly to a flash head atop a light stand, and raised seven or eight feet above the floor, is the very picture of an accident waiting to happen. To mount such an ungainly rig on a cheap amateur quality stand would simply be to invite disaster. (Remember that both a flashtube and tungsten-halogen modeling lamp are extemely fragile. A fall to the hard floor of a studio from even a moderate height can be an expensive—to say nothing of dangerous—proposition.) It is for applications like this that heavy-duty stands like the one shown here are intended. Weight, of course, provides only a partial solution to the balance problem in such situations. The breadth of support at the base of the stand provides the real stability, usually in the form of long legs held tight by a positive locking mechanism.

Some studio setups, of course, require the use of flash heads in configurations that, while they might not defy gravity, do at least give it a run for its money. Such configurations go well beyond the support capabilities of a single telescoping light stand. Consider, for example, those occasions when the photographer might want to position a light source very close to his subject, or at least very close to the camera-to-subject axis, but he obviously needs to do so without the light stand appearing in his picture. For this purpose, we have another familiar piece of studio equipment—the boom stand.

While there are a few lightweight boom stands commercially available for use with small strobe units, the kind required for more rigorous studio applications with large strobes are usually more like the one shown here. Stands like this characteristically feature telescoping risers within the boom itself and a very positive locking mechanism at the top of the stand for maintaining the entire unit's center of gravity. With its ability to position the light source in any of a limitless number of axes, the boom is obviously an ideal studio tool for use with heads in every conceivable configuration. A single spot or accent light, for example, can be positioned directly above a subject without having to conceal the light stand. The same goes for complicated soft-lighting configurations like the one shown here. But, needless to say, balance becomes a crucial issue when the head is augmented by elaborate accessories for indirect lighting. For this reason, heavy, clamp-on counterweights are important accessories to have on hand when working with large boom stands. Many photographers use canvas or vinyl sandbags for this purpose as well, and there is at least one firm that manufactures a water-filled counterweight system to accomplish the same end.

In terms of bulk and ungainliness, accessories like bounceboards and "gobos" rarely present the same problems the photographer encounters in the placement of light sources themselves. Nevertheless, serious studio work generally requires the same flexibility and precision in the positioning of this important tool. To this end, there is available quite a broad variety of gadgetry designed for use with cardboard and fabric accessories.

For most simple applications, obviously, the basic light stand and a roll of tape can perform yeoman service in conjuction with many different types and sizes of cardboard reflectors or "gobos." For more exotic requirements, however, when the positioning of such a light control accessory at an odd or difficult angle is crucial to the shot, you often have to turn to one of the special devices manufactured specifically for this purpose. By far, the grandest of these is the odd-looking "Century Stand" or "grip stand" shown here. This type of stand has been a familiar sight in photo

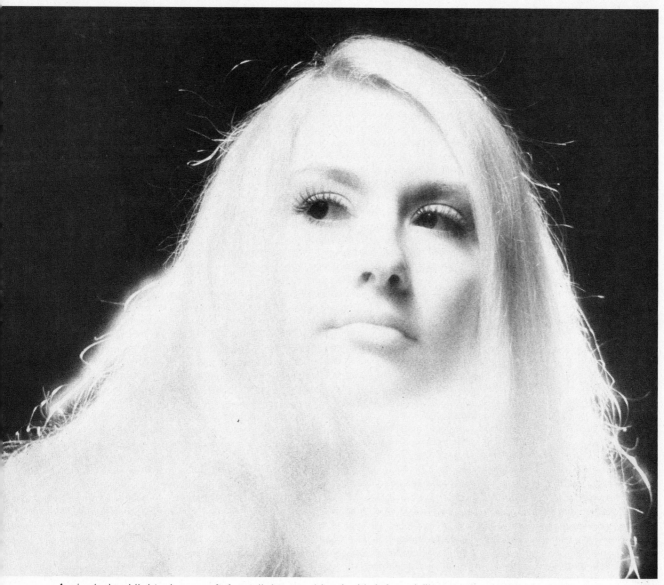

A single backlight plus a soft front light, combined with infrared film, produced this dramatic shot.

studios and motion picture sound stages for years, thanks to its limitless range capabilities for supporting almost any kind of light control accessory at any angle a photographer might need. An ingenious system of double clamps and extruded aluminum arms are the heart of the Century Stand system, allowing a reflector or "gobo" to be turned through an infinite range of axes for positioning. Since it's definitely the *ne plus ultra* of such equipment, the Century Stand system is rarely carried by conventional camera stores, and, to say the least, is not exactly for the budget-conscious photographer. Motion picture supply firms (like Matthews Studio Equipment or Gordon Enterprises, both in Los Angeles) are the best, if not the only, source for Century Stands.

For a more economical approach to equipping a studio with the same flexibility in controlling light, we can turn again to Larson Enterprises, whose Reflectasol® line of reflectors and "gobos" is held together by a lightweight clamp that is a sort of hybrid between the Century Stand clamp and the familiar "C-clamp" sold in hardware stores. Although it's designed for use with the aluminum shafts of Reflectasols®, the Larson clamp also works well with common cardboard or foam-core.

Putting Electronic Flash to Work in the Studio

If the foregoing information illustrates nothing else, one point should be very clear: To a photographer afflicted with gadget mania, the studio represents something pretty close to paradise. However, in commercial studio photography, there is a reason for all that extravagant gadgetry. To show it all in use, in every incarnation of lighting setup, is, of course, not possible. We can, however, have a look at some typical studio situations that illustrate at least some fundamental applications of electronic flash equipment and its myriad accessories. What follows is a compendium of such situations, all of them dealt with as part of some commercial assignment, and each demonstrating in a different way how studio strobe and its collateral equipment were used to solve the problem posed by that specific assignment.

Special Effect, "Electronic Flash" Book Cover

The cover shot for this book offers a good, immediate object lesson in the use of studio electronic flash equipment to solve a creative problem. The nature of the problem was simply to illustrate, in a graphic form, the notion of electronic flash photography. The only real restriction was posed by the necessity of including a strobe unit in the shot. To show a flash unit that was not firing, of course, as in a technical or catalogue photo, would reduce the picture's impact considerably, which boiled the problem down simply to one of synchronizing the subject flash unit with the background illumination and, secondarily, to controlling the subject strobe's output.

A possible solution was to fix the background strobe unit with a slave and use the flash on the model's camera as the primary firing unit. When the model pressed the shutter release, the background strobes would fire simultaneously with the unit on her camera. To capture all that on film, of course, would have required leaving the shutter open or at least timing rather precisely the opening of the camera shutter used to record the picture and the model's releasing of the shutter on her camera. Either of these options carried with it the liability of having the model change her position slightly every time she recocked the shutter between exposures. Since the graphic simplicity of the shot dictated very precise positioning of the model's hands, this approach was quickly abandoned.

The units were fired, instead, by the camera shutter used to record the picture. This could have been accomplished by synchronizing the small subject strobe to the main camera shutter via an extension cord running behind the model and up, along her arm, to the back of the little unit. The subject strobe would then remain as the primary firing unit, but the difficulties in concealing the extension cord made this option unsatisfactory.

The actual setup for the shot is shown by the diagram. The model was positioned in front of a large sheet of frosted Plexiglas that was covered with a thickness of transparent colored theatrical gel material. Two flash heads from a 2000-watt-second power pack were located behind and directed toward the rear surface of the Plexiglas, whose matte surface serves to diffuse the direct illumination from the heads into a single, broad, uniform highlight.

Since the two rear flash heads were the primary light source and were positioned behind the model, the task of concealing the slave unit for the secondary, on-camera strobe that appears in the shot was fairly simple. The slave was attached to the little unit's sync terminal and taped to the rear surface of the model's camera where it was out of sight of the taking lens, but could successfully "read" the burst of the primary strobe unit behind the Plexiglas.

At this point, a lesser but significant problem still existed—that of how to prevent the burst from the small strobe unit from "flaring" when it was fired directly into the taking lens. Since the unit selected for the shot featured a wide range of power adjustments, its output was first minimized by using the lowest possible power setting. Test shots with Polaroid film revealed that, even at this setting, the small unit was too powerful to prevent lens flare. Rather than switch to a smaller, less powerful unit, an alternative way was chosen for reducing the little strobe's output. A small piece of neutral density filtration gelatin was cut to fit the shape and size of the subject flash unit's reflector. The gel was then positioned over the reflector with transparent tape, effectively reducing the unit's output by yet another f-stop. A subsequent final test shot on Polaroid revealed a near-perfect balance between background illumination and the burst from the little strobe unit, with the lens flare problem completely eliminated.

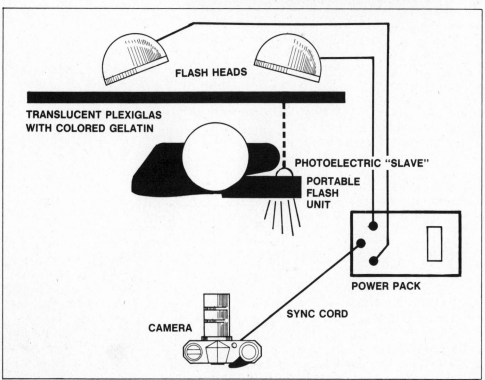

FLASH HEADS

TRANSLUCENT PLEXIGLAS
WITH COLORED GELATIN

PHOTOELECTRIC "SLAVE"

PORTABLE
FLASH
UNIT

POWER PACK

CAMERA SYNC CORD

Conventional Wedding Portrait

Accompanying examples of electronic flash at work in commercial studio situations demonstrate the remarkable range of creative options possible with powerful strobe units. But not all studio photography takes place within the rarefied world of stylized product shots or magazine illustration.

Conventional portraits like this wedding shot are more the rule than the exception among commercial photographers, so it stands to reason that any survey of studio strobe applications should properly include at least one example of a typical commercial situation.

Although this couple are not actually man and wife (they are professional models posing here for demonstration purposes), the shot provides us with the chance to address the problems common to assignments like this.

Most commercial portraiture, unlike photography of people for advertising or magazines, bears the significant liability of dealing with subjects who are not accustomed to appearing regularly in front of a camera. Actors, models and most public personalities, in or out of show business, share a common familiarity with the peculiarities of looking natural and unruffled while surrounded by cameras and lighting equipment. It's part of their job to be at ease in such a situation. For the average layman, however, the experience of sitting for a formal portrait can embrace a lot of negative emotions ranging from simple nervousness to sheer terror. Even individuals as attractive as this couple are often ill-at-ease in the strange environs of a photographer's studio. In addition, the occasions for which much formal portraiture is done—weddings, graduations, religious ceremonies—usually compound the sitters' general discomfort in front of the camera by giving them much more to think about than just the experience of posing for a picture. Nevertheless, they still expect the outcome to be flattering, which represents only one of the pressures which the photographer must deal with.

Most competent photographers, given enough film and enough time, can usually put the subject at ease for at least a couple of exposures that will please their client. But people making their living shooting this type of portrait must usually be a little more mindful of cost accounting than someone shooting more commercial types of assignments. Time

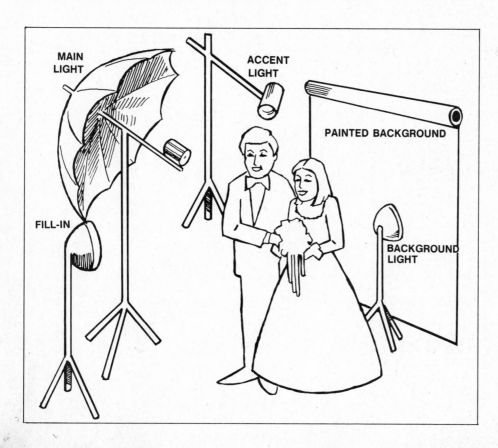

MAIN LIGHT

ACCENT LIGHT

PAINTED BACKGROUND

FILL-IN

BACKGROUND LIGHT

and film represent money, and anything that helps to ease and speed up the process of relaxing a nonprofessional portrait subject is a welcome addition to the studio.

A powerful studio strobe unit is one such addition and a fairly common feature of any busy portrait studio. We've already reviewed at length the fundamental advantages of electronic flash over other forms of light production. Now let's look at how the formal portrait situation underscores those advantages. As shown by the diagram, a portrait like our sample here requires a now-classic lighting scheme that includes at least four separate light sources, and sometimes more. Since so many people have come to associate this type of lighting with high-quality portraiture, it's rare that a photographer diverts to a more spartan "editorial" look with a routine client. However, four bright light sources surrounding a sitter can become highly intimidating to a nonprofessional subject. Fortunately, strobe is not a continuous light source, which means that the subject is spared from sitting under hot, uncomfortable lights during the course of his sitting. With modeling lights reduced to their lowest useful power setting, the overall level of light in a photographer's studio needn't be much more powerful or unfamiliar than the subject's living room. Nor is the subject required to hold still for the long exposures often required by continuous light sources. The brief pulse of electronic flash illumination permits the photographer to capture the subtle nuances of expression that a relaxed subject will produce when not told to hold perfectly still. And the short recycling interval of most modern studio flash units allows him to quickly record the variety of changing, natural expressions.

Long breaks for adjusting the position of light sources can also become intimidating to a portrait subject, who usually wants to terminate the whole experience just as quickly as the photographer does. With the capability of making quick adjustments in the power of individual flash heads that has become a common feature of modern studio strobes, the process of fiddling about with four or five individual lamps has been significantly shortened and simplified. And finally, the sheer power advantage of strobe over other light sources brings with it the capability of using slow, high-resolution films that are easily retouched and produce the kind of crisp, clean image a portrait client expects.

High-Key Product Shot, Fruit and Drinks

The photo on page 142 was to illustrate an article for a national men's magazine. The article described a broad range of fruit-flavored liqueurs and brandies, and the photograph that accompanied the text was intended to associate the visual notion of certain specific fruits with the beverages that are distilled from those fruits. In addition, the photograph had to create an association in the viewer's eye with the delicacy of flavor for which such drinks are known—thus the use of elegant glassware and subtle colors in the beverages and fruits chosen for the shot.

Before we delve into the specific lighting problems of this particular assignment, we should first point out that electronic flash is a natural choice for use with this type of subject matter. First, and most obviously, is the basic fact that most food does not withstand prolonged exposure to high temperatures. Curling, melting and discoloration are all very real dangers when perishable subject matter must be exposed to hot lights for the intervals usually required to arrange and photograph such a setup. So, the use of tungsten-halogen lighting for this shot would have been out of the question. Strobe, on the other hand, with its minimal operating temperature—and that created by the relatively weak modeling lights—was thus the perfect choice. Secondly, the persistent problems of depth of field and color balance we looked at in the first chapter further reinforced the need for electronic flash as the only sensible option for lighting this picture.

The fundamental lighting problem here is typical of most situations involving glassware: To show off transparent shapes and colors with backlighting, while, at the same time, preserving foreground detail in subjects which cannot be transilluminated—in this case, the fruit slices.

A common solution for such a problem is the use of frosted Plexiglas as both a background and tabletop surface. The advantage of this material is that light can be passed through it from behind, eliminating the need for frontal light sources that would create distracting reflections in the glassware. To achieve this effect without the intrusion of a horizon line through the center of the picture, required the use of the table shown in the diagram on page 142. The table's curved acrylic surface overlayed with a sheet of

translucent vellum provides a uniform, seamless backdrop through which light can be passed from flash heads mounted behind and below the Plexiglas, as shown. This setup, alone, of course, provides ideal illumination for the glassware, since it is transparent. The solid pieces of fruit, however, would record as meaningless silhouettes without some provision being made to light their front surfaces. This was achieved with the simple addition of a white cardboard reflector positioned above the subject by means of a Century Stand and small boom to which the reflector was clamped. The amount of frontal illumination created this way was sufficient to highlight the surface of the solid objects, without producing unwanted reflections in the glass surfaces.

Although they are not inexpensive, product tables like the one used for this shot are extremely useful for the the photographer who does a lot of this kind of work. There are several firms which supply the tables, among the best of which is Easton Studio Products of Los Angeles, whose table also includes an overhead frame for hanging reflectors, and a percale fabric "tent" for photographing highly reflective tabletop subjects.

To show off objects with diffused backlighting and no frontal illumination, this type of table is ideal. It features a Plexiglas base and translucent vellum roll which provide a seamless backdrop that passes light from sources behind and beneath it.

Special-Effect Product Shot, Hot Drinks

This highly theatrical illustration was intended to dramatize another magazine story relating to cold-weather cocktails, which are customarily served hot. Despite the fiery effect, the subjects were actually cool when photographed, if for no other reason than to preserve the whipped cream "heads" for the period required to set up and photograph the arrangement. For the same reasons we observed with the preceding problem, electronic flash provided a far more suitable option than tungsten-halogen.

Although the subject here again involves glassware, the beverages are not transparent, so transillumination as used in the last shot was not called for. To create the effect of glowing coals, however, acrylic Plexiglas once more came to the rescue. As the accompanying setup sketch shows, the tabletop surface is a sheet of frosted Plexiglas, supported on leg stands at sufficient elevation to permit flash heads to be positioned underneath and directed toward the underside of the Plexiglas. (Note here that the proximity required between the heads and the glass would have automatically ruled out tungsten-halogen, whose high temperatures would surely have melted the acrylic material.) To create the illusion of glowing coals, sheets of yellow and red transparent theatrical gels were placed over the Plexiglas. The "coals" are actually decorative stones of the kind used in sauna baths. They were positioned around the glassware once it had been properly arranged for the shot. The flame in the background is real fire, produced by a "flame tube" consisting of a length of perforated pipe, sealed at one end and attached at its other end, via rubber hose and regulator, to a pressurized canister of propane gas. Special effects equipment like this can be rented from firms which specialize in motion picture gadgetry. Needless to say, when they involve such dangerous effects as fire, they must be very carefully handled, and should never be homemade or improvised.

Correct exposure for this shot was obviously a little trickly, since the flame itself required a longer-than-usual exposure time to record satisfactorily on film. The glasses, of course, were illuminated solely during the brief duration of the strobe burst. In order to achieve the proper balance between flash and firelight, the studio was darkened (to accommodate the possibility of very long exposure

times) and test exposures were made with Polaroid film at progressively slower shutter speeds. The shutter speeds did not affect the foreground lighting, merely the quality of the flame effect in the background. Once the fire appeared bright enough in the Polaroid print—in this case, at a shutter speed of about ½ second—that corresponding exposure time was selected as the one to be used for the final shot, and the picture was then recorded on conventional transparency film.

Special-Effect Portrait, Politician

This cover photo for a regional business magazine was intended to link the familiar face of this well-known politician with his abilities to forecast economic trends. Thus the device of a "crystal ball" and the choice of the rather exotic lighting commonly associated with seers and mystics.

The globe for the crystal ball was purchased from a household lighting fixture supply store and mounted atop a flash head from which the metal reflector had been removed.

As the diagram illustrates, this head was positioned in front of the subject with a small Century Stand fitted with a boom that allowed it to be placed in the picture without interfering with the subject's movement to any great degree. The strobe unit inside the ball served as the main source of illumination, while a white reflector card placed above the subject (again by means of a Century Stand) provided subtle fill-in for his forehead. As with many portraits against dark backgrounds, the problem of separating the subject's dark hair from the background had to be dealt with as well. For this purpose, a second flash head was called into service, positioned above and slightly behind the subject and used direct on a low power setting to create the strong highlight that follows the contour of his head. This second unit was, for reasons that should be obvious by now, boomed from the side. Both heads were connected to a single 2000-watt-second power pack, with 1200 watt-seconds being apportioned to the unit inside the ball and 800 to the head used for the accent light.

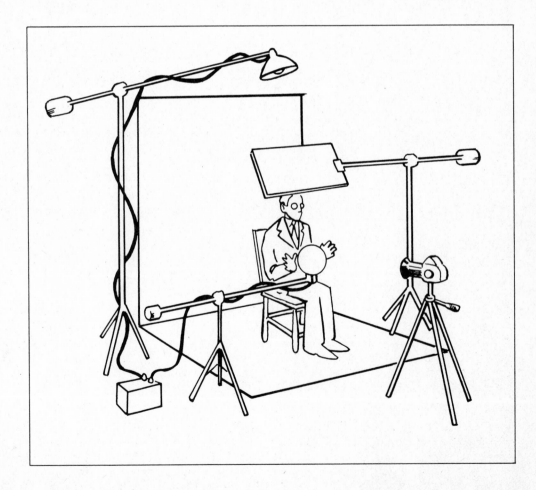

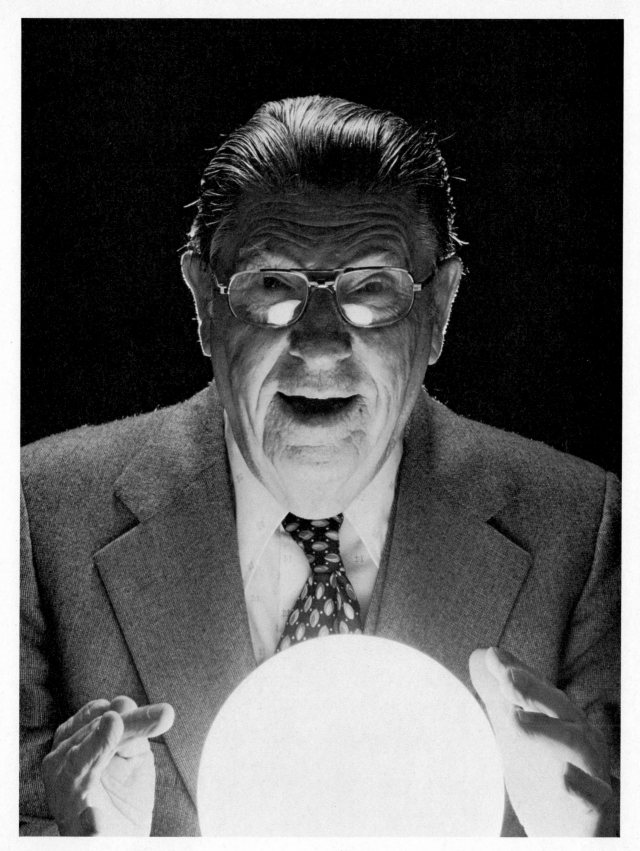

The lighting challenge in this set-up was to show the shapes of the transparent glassware as well as the subtle colors of the various fruits and corresponding beverages. The use of electronic flash, frosted Plexiglass, a special posing table and controlled reflected light made the shot possible—and effective. Further details can be found in the explanatory text on page 138.

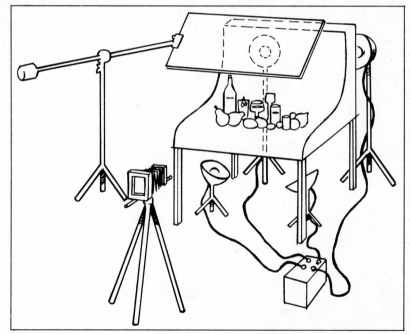

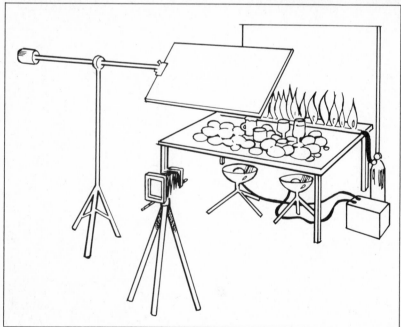

The photographer's assignment here was to glamorize cold-weather drinks, which are usually served hot but must be photographed while cool. Once again electronic flash lighting was employed because it could meet this illumination requirement. The ''glowing coals'' were make-believe, but the flames were real. For more information on the props and techniques used, see page 139.

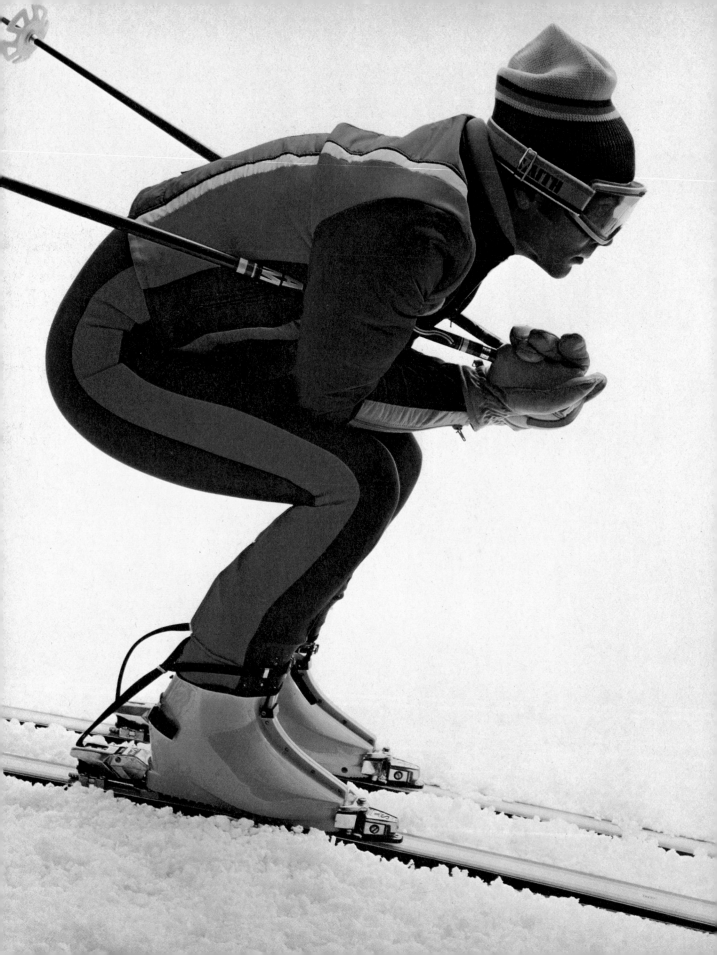

High-Key Illustration, Skier

This shot was made to adorn the cover of a travel magazine for an issue featuring winter sports. Since many publications work on individual editions many months in advance of their appearance on the newsstands, seasonal pictures like this often have to be "faked" in the studio in the absence of weather conditions that would allow them to be shot on location. To create the illusion of a skier on a snow-covered hillside, a broad, high-key lighting setup was chosen, using light from several flash heads bounced into large umbrella reflectors. The seamless background was of the type specifically designed to render as pure white with color film (some white background papers, being highly reflective, tend to produce a blue cast on color films that is extremely difficult to filter for. When you require an absolutely pure white, it's necessary to specify to your supplier that you want a paper designated for use with color emulsions.)

Despite the intense brightness required for the background effect in this shot, the importance of using bounced light on the background paper should not be overlooked. While heads pointed directly at the paper would surely produce a much higher illumination level, the broad uniformity of reflected light is vital in this case to prevent the hot spots that might accompany direct lighting and destroy the bright, airy effect of even lighting. To maximize the output from these two background sources, each head was used with a separate power pack of about 2000 watt-seconds each on full power. As the diagram shows, at least one of the heads required a "gobo" between the strobe and the camera to prevent lens flare—a persistent problem when backlighting is done with umbrellas, requiring the flashtube to face precariously in the camera direction.

A third head, also used in conjunction with a large umbrella, was positioned over the subject to act as a fill-in source and to reinforce the outdoor illusion by illuminating the foreground. The "snow" in the foreground, incidentally, is a plastic foam manufactured for this purpose and sold in large quantities, again, by motion picture and theatrical supply firms. Tilted camera requires no explanation.

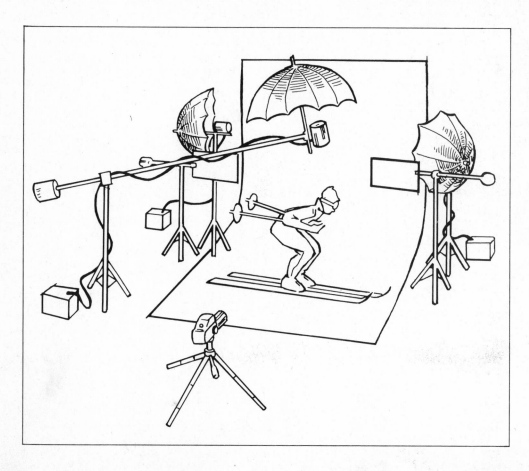

Change of Pace:
Electronic Flash for Special Effects

So far, you've observed electronic flash at work in any number of what are basically utilitarian applications. We've seen the strobe unit as a totally versatile workhorse of artificial lighting that is, in many cases, vastly superior to other modes of light production. In its most basic incarnation—flash-on-camera—it frees the photographer from the strictures imposed by low or nonexistent available light. Off-camera, the electronic flash unit begins to perform as a tool for achieving an unlimited range of creative lighting effects. In combination with other strobe units, it represents a vast arsenal of support equipment for the photographer's imagination, allowing him to manipulate light the way a painter manipulates his oils and watercolors, to heighten or to subdue elements of form and texture with impunity. It can freeze on film the subtlest nuances of movement and mood as a fashion model spins through her repertoire of poses. With its brief but powerful pulse of illumination it can insinuate itself into candid portrait situations unobtrusively, without the intimidating glare and heat of other modes of artificial illumination. Its remarkable power/size ratio allows for the production of enormous light output in product and tabletop photographs that require the use of the smallest possible apertures for the clean, etched look that comes with extreme depth of field. And its economy, portability and convenience make the electronic flash unit ideal for the photographer on a limited budget, the photographer who travels frequently to shoot on location, and especially the photographer who (and this is most of us) wants to minimize the hassles and technical problems that plague the art of picture-taking in so many other ways. In short, electronic flash—beyond just giving you light where there is none—gives you light you can take with you and light you can control.

For many photographers, of course, the notion of control goes well past the basic applications we've looked at so far. It's fine to know how to use your strobe unit to produce attractively lighted candids or formal portraits or tabletops, but to many of us, mastering fundamentals is just the beginning. Beyond that lies a world of creative options and experimentation that can be quite seductive in its attraction to anyone who thinks of himself as serious about photography. This is where we encounter that vast pantheon of creative electronic flash techniques that fall under the rubric of "special effects."

What Is "Special Effects"?

Before we look further, we would be well advised to first make a candid appraisal of the whole notion of special effects. In its purest definition, the phrase is really a child of the motion picture business, and its applications, while legion in number, are in most cases completely utilitarian. The background of a raging storm off Cape Horn is introduced behind actors on a pitching sailboat in the studio for very practical reasons: It is dangerous, difficult and time-consuming to film such a scene on location. Moses might cause the Red Sea to part, but that won't be done on location either. It will be accomplished by an ingenious combination of special effects. That famous shark is a special effect, and those now ubiquitous cinematic dogfights between oddly shaped little spacecraft—those, too, are done with special effects. The point is that, in motion pictures, the illusions produced by such effects are germane to a story line. The fabled legerdemain of Hollywood owes its reputation to the special effects department.

Still photography, on the other hand, has appropriated the term special effect and given it a meaning that is not quite as sound as the practical notion of motion picture special effects. That should be evident to anyone with a back-issue library of nearly any photography magazine. Flip through yours and try to find a

Among the special techniques for using strobe to produce the illusion of conventional lighting is the method used in this shot for recreating natural room lighting. To maintain the same mood in the environment as established by the lighting from the existing fixtures, small strobe units were concealed inside lampshades and behind the background doorway. (See text for details.)

single issue that doesn't feature at least one article on some way to alter or distort reality in an otherwise realistic photograph. Granted, there are probably a lot of good reasons for introducing things like solarization and line conversions and multiple exposures and zoom lens effects into the essential realism of photography. The inability, for instance, of the still photograph to always convey with complete fidelity a mood impression or an abstract idea provides ample rationale, in many cases, for the use of such effects. But this kind of use is, unfortunately, rare. More often, photogra-

Light modulation is useful for creating mood in a photo, as evidenced by this "antique" movie star portrait. Venetian blinds off-camera and a standard black "gobo" over the main light were the modulators used here to mimic the graphic devices characteristic of early Hollywood glamour portraits.

phers seize upon a special effect for the flimsy reason that it looks bizarre, and, all too frequently, it provides a mask for hiding what on its own is just simply a rotten photograph. Like expensive equipment, photographic special effects represent the kind of compulsion to which photographers inevitably and perennially fall prey. So, if for no other reason than to patronize that compulsion, any broad discussion of a major area of photographic technique—like electronic flash photography—has to include at least a perfunctory mention of that technique's special effect capabilities,

Fortunately, not all of the techniques that properly fall into the special effects category with electronic flash are totally exotic or designed to distort reality. In fact, there are several such techniques whose purpose is to create a *realistic* illusion with strobe units, in shots where some element of reality cannot

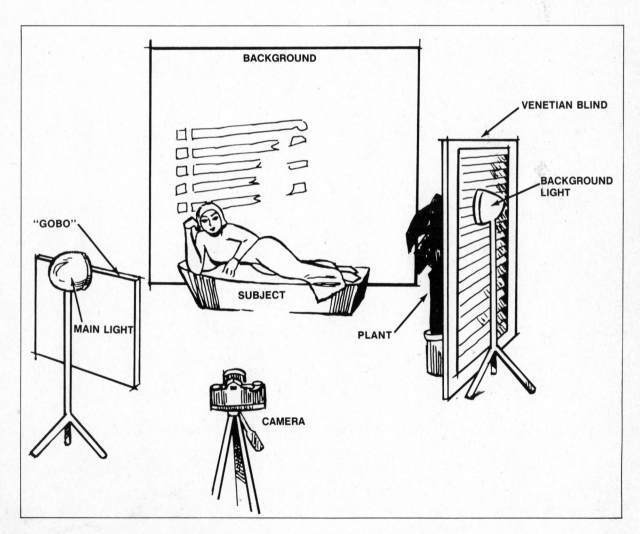

be otherwise retained. We'll look at a couple of realistic special effects first before getting into the area of effects that create illusions that are purely cosmetic.

Simulating Room Lighting

In the last chapter, we already considered a couple of illusions possible with electronic flash in the studio. As a matter of fact, many commercial photographic assignments involve doing nothing more or less than creating, in the studio, the impression of a setting or environment in a location too distant or impractical to be used for the production of the photograph. In this type of situation, the role of artificial lighting in commercial photography is analogous to what is done every day in motion picture studios. Even the simple use of indirect lighting for portraits and product shots has at its core the injunction to create the illusion of "natural" lighting, though indirect lighting on its own could hardly be termed a special effect.

Two other lighting techniques that do properly fall into the special effects area and are useful for creating realistic illusions should be included into every serious photographer's bag of tricks. The first of these provides the solution to a fairly common problem that can be encountered either in the studio or on location. Shots designed to show or create the illusion of a conventional room interior—office, living room, boudoir, etc.—often require, or can be helped by, the inclusion of ordinary lighting fixtures in the photo. The total "mood" of certain kinds of interiors—an elegant restaurant, for example, or a richly furnished study—often relies heavily on the subtle use of lighting throughout the room. Frequently the photographer's biggest challenge, when shooting such an environment, is to preserve the effect of the existing lighting, without sacrificing image sharpness, tonal range and depth of field—all the qualities that should be evident in any good photograph. Conventional lighting fixtures, unfortunately, while they might provide excellent illumination from the standpoint of an interior decorator or a maitre d', rarely provide the light levels necessary for producing a picture that features all the qualities we just listed. We've all seen, if not photographed, such interiors, relying solely on the available light offered by the room's existing fixtures. The results are predictably awful (though sometimes necessary consequences of having no other options): Fast film, "pushed" to accommodate the low light level, produces grainy, contrasty and overall dismal results. The obvious alternative, of course, is to use extremely long exposure times which, depending on the type of film you're using, can yield pretty acceptable results, but it's hardly a practical option if there are people or other animate subjects to be included in the shot. A much better solution would be to introduce electronic flash.

Now the question arises, *how* do you use flash to produce a sufficient light level in such a situation, without destroying the mood already created by the room's existing illumination? While a powerful strobe unit (or units) will surely raise the level to where you can produce an acceptable image, it will also introduce a totally different look to the setting unless used very judiciously.

A common technique for accomplishing this is to replace the incandescent light sources in the existing fixtures with electronic flash units that can be concealed by the fixtures' own globes or lampshades. The picture on page 147 shows this method in use to provide a convincing effect. Needless to say, it begins

A dual-level stone entryway in a hotel provided an unexpected light modulation device for a location fashion shot in Mexico. An undiffused electronic flash unit was placed on the floor above the model and directed down through the portal above her head to create an interesting pattern of shadows and highlights.

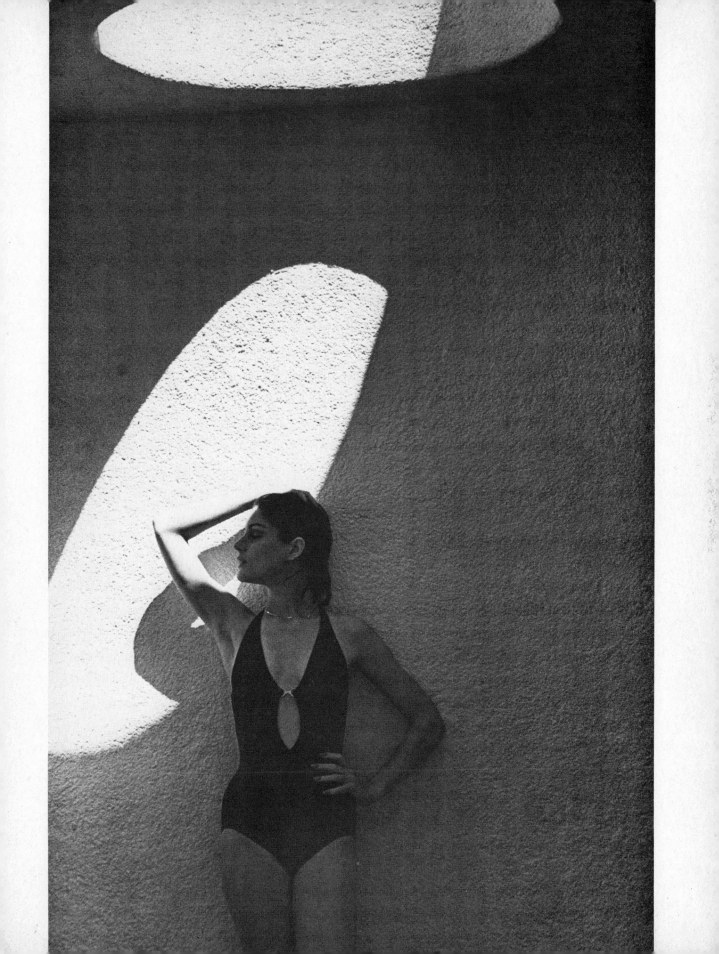

with first analyzing the room's available lighting scheme and asking a few pertinent questions of yourself, based on the result you're after: First, to minimize the hassle, are there any portable fixtures that can be removed from the shot? Second, which fixtures provide the most powerful illumination, which are of weaker output, and is it important to the shot to maintain the same balance between them using your strobe units? Third, are there any off-camera light fixtures that contribute significantly to the room's lighting scheme? The

Open flash, fired in a darkened room with the camera shutter open, provides a convenient method for creating multiple exposures of the same subject. As shown by the diagram, the camera angle is changed between exposures to place a second image on the other side of the frame. The first image is exposed when the camera shutter is opened, the second strobe burst is produced by manual firing of the unit using the "test button."

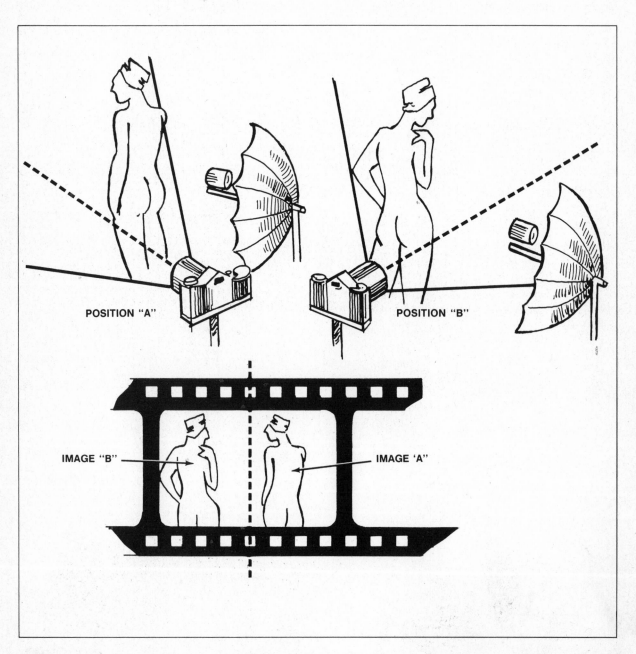

POSITION "A"

POSITION "B"

IMAGE "B"

IMAGE 'A'

next step is simply to assess your answers to those questions and set up your flash units accordingly.

Frequently, that's just a matter of rigging portable electronic flash units underneath lampshades or globes so that they are properly hidden from the camera's view, but will still provide lighting that convincingly mimics that of the existing fixtures. When several light sources are involved, photoelectric slaves are indispensable for this technique, and the placement of these slaves so that they will "read" the primary flash of another strobe unit can often become a maddening exercise. Your primary flash unit can easily consist of a weak portable mounted to your camera. If, however, you simply run a sync cord to one of the "faked" fixtures, so it will act as the primary strobe unit, there's generally no harm done, since the sight of an electric cord leading to a lamp is not out of place in such a photograph.

Bear in mind that mimicking the room's available light with strobe units can involve

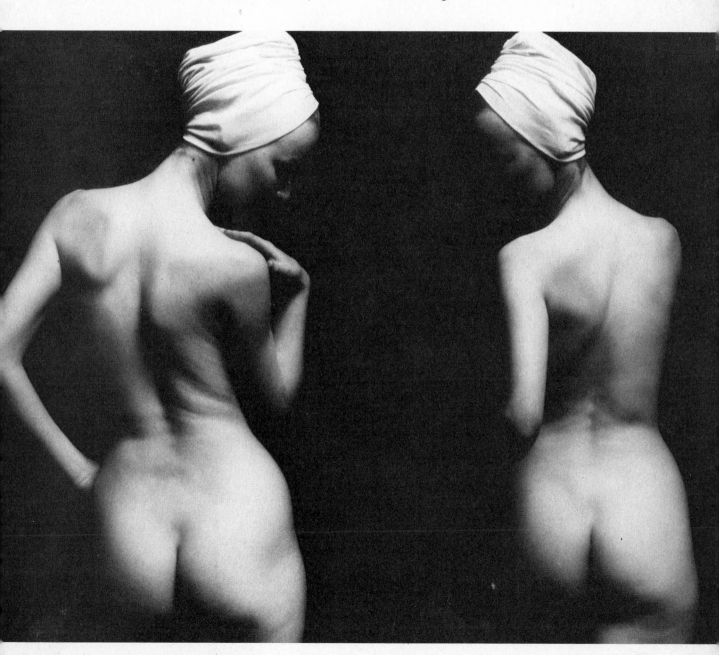

more than simply inserting strobe units under lampshades. Off-camera light sources—lamps in hallways, for instance—often add substantial depth and interest to such a shot, and can be simulated easily by using additional strobe units positioned in the appropriate areas behind walls, shutters or doorways.

"Modulating" Electronic Flash

A second popular special lighting effect with electronic flash is generally referred to as "modulation." This consists of interposing some object or shape between the flash head and the surface it illuminates in order to affect the illusion of something off-camera creating a shadow. A familiar example of light modulation used in this way is the Venetian blind shadow frequently used on motion picture sets to indicate time of day or create a certain mood within the set's interior. The picture on page 148 incorporates this distinctive pattern to mimic that cinematic effect. Although the shot is contemporary, it's intended to create the illusion of being an antique Hollywood portrait typical of the genre of portraiture popular during the 1930's. To produce the distinct shadow patterns in such a shot usually requires the use of flash heads aimed directly at the illuminated surface. Soft bounced or diffused light will not create the hard-edged shadow needed to establish this effect. For this particular photo, a length of Venetian blinds was positioned off-camera using a grip stand. A small potted palm was placed nearby to enhance the atmospheric effect of the shadows even further, and the light from a single flash head was directed through the props to the wall behind the model. The dramatic shadow over the lower half of the model's face is another graphic device typical of that genre of portrait. For this re-creation, it was accomplished by placing a black fabric "gobo" between the subject and the flash head used as the main light.

Obviously, light modulation with electronic flash is, to say the least, simplified a great deal by modeling lights which allow very precise placement of the modulating props. It's also a very neat technique for adding dramatic impact to a shot—particularly one in which the photographer wants to imply an ominous presence near the subject. The shadow of an unseen hand or gun or crouching figure makes a strong pictorial statement very economically. On a more abstract level, light

modulation can also make an interesting graphic statement on its own, as demonstrated by the photo on page 151. Here, an odd architectural detail above the model was incorporated as an important graphic device for a location fashion shot by positioning a direct flash head on the floor above so that it would create the startling highlights above and behind the girl.

In the category of special effects for creating realistic illusions, the two we've just looked at provide a good foundation for producing an enormous variety of visual sleight of hand using electronic flash units. The notion of simulated light sources using concealed strobe units, for instance, can be expanded to include creating ersatz illumination emitting from a fireplace, a television or motion picture screen—the list goes on and on, as it does for light modulation. Both these special effect techniques, alone or in combination, should give you a good start on some creative experimentation.

Electronic Flash for Cosmetic Illusions

Of course, as we observed earlier, when most photographers think of creative experimentation, it's usually in the form of startling exotic images that usually have little reason for existing but pure graphic interest. You could write volumes on the abstract special effects for which electronic flash can be used. For our purposes here, we'll just examine a few techniques for harnessing strobe to produce our second category of special effects—cosmetic illusions.

Power and color temperature aside, the main feature of electronic flash that makes it so well-suited for producing illusory effects is the simple fact of its brief, reusable light output. "Brief," as we've seen earlier, can, with most of today's strobe units, mean anything from 1/200 second on down to 1/10,000 second, and "reusable" simply means that most of the units available can recycle up to full

Open-flash technique is used here to produce the effect of multiple horizons. In this case, two strobe units were used, one to illuminate the model, the second for the background. With the shutter open on the "bulb" setting after the initial firing of the main light by the shutter release, the camera is directed gradually downward, as the background strobe unit is manually fired several times in succession. (See text for details.)

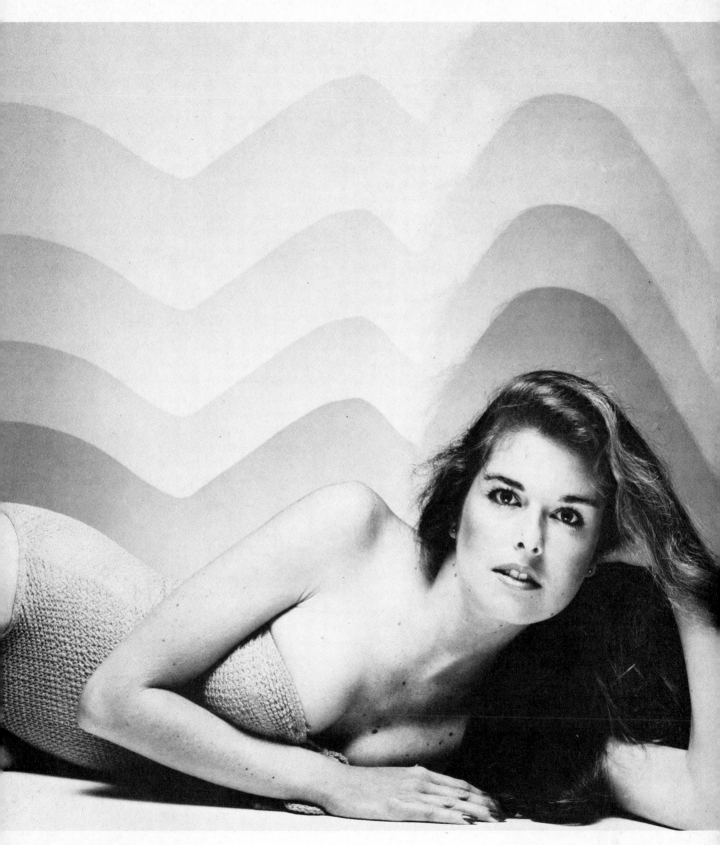

power in just a few seconds (and in many cases much faster) between light pulses. The most obvious application of these unique talents in the special effects arena is to produce several images of the same subject on a single frame or sheet of film. Ironically enough, this application, while it's considered photographic magic today, is also, you'll recall, the very reason for the birth of electronic flash in the first place. Dr. Edgerton's fast-recycling stroboscope was developed for the very purpose of recording several consecutive images of a moving person or object in a single photograph. Later on, we'll look at some techniques for using a direct modern descendant of that original stoboscope, but let's first look at the multi-image capability of its distant cousin, the conventional electronic flash unit.

Practically all flash units currently on the market have a provision for firing the unit manually, without the need of synchronizing with a camera shutter. This "open flash" or "test" button can be very handy when used in conjunction with the "bulb" setting on your camera's shutter speed dial to literally "paint" flash exposures cumulatively on film. In fact, many commercial photographers use this technique to compensate for power deficiencies in their studio strobe units. If the unit's maximum power setting doesn't provide sufficient light for a given shot, the camera shutter can be held open (or reopened, if it has a double-exposure capability) for manually adding a second, or even third, fourth or fifth pulse of light. The very same technique can also be used for lighting very large (but obviously, inanimate) subjects, with the photographer or an assistant firing a movable strobe unit at different positions on the subject while the shutter remains open. It goes without saying, of course, that these open flash techniques are limited to shooting outdoors at night, or indoors only in a room that can be totally darkened to prevent ambient illumination from recording on film along with light from the strobe unit.

Beyond these utilitiarian applications, the same technique can be used to create very interesting multiple-image shots ranging from simple double exposures to exotic studies of subjects in motion, à la Dr. Edgerton. Let's begin with the basic technique of shooting a double exposure using open flash.

Your camera, obviously, must be stationary for such a shot, so a tripod is a must. With the camera and your subject in place, first position the flash unit and calculate the correct exposure just as you would for a conventional strobe shot. Note that, since the flash unit alone will be providing the second image (as opposed to double-exposing the film via the camera shutter), your single exposure reading will suffice for both images, providing there will not be significant overlap of the images in the final picture. Needless to say, you must use a black, or very dark, background for such a shot to eliminate the possibility of illumination on the background "bleeding" through your subject's image when you make the second exposure.

With camera, subject, strobe unit and aperture dial ready, you must now "rehearse" the positioning of your second image.

Depending on the result you're after, it may take several run-throughs with the room lights on to ensure that the two images fall in the proper spot on your frame when you actually make the exposures. Placement of the second image, of course, can be accomplished either by having the subject move after the first exposure, or by moving the camera. Since the actual adjustment will be made in the dark, you have to develop some method for locating the correct subject position or camera angle without any visual reference. For simple double portraits, it's probably easiest to have your subject do the moving (very carefully, of course) from the initial position to some predetermined spot for the second exposure. Either way, it's important to remember that rehearsal of the movement, with you checking the image positions in your viewfinder, is a must to ensure good results. (Naturally, if your camera has a double-exposure capability, the task is highly simplified. You can merely use your finder screen for reference in setting up the second subject position.)

When you're ready, the final shot is done by setting your shutter speed dial to "bulb," turning off the room lights and opening the shutter. Your first exposure will be made by the shutter contacts, which fire the strobe unit as you press the shutter release. The second exposure must be done manually using the strobe unit's test firing button. Obviously, if

An exotic variation of open-flash technique combines strobe main light with penlight "painting," done while the shutter is still open. (See text for details.)

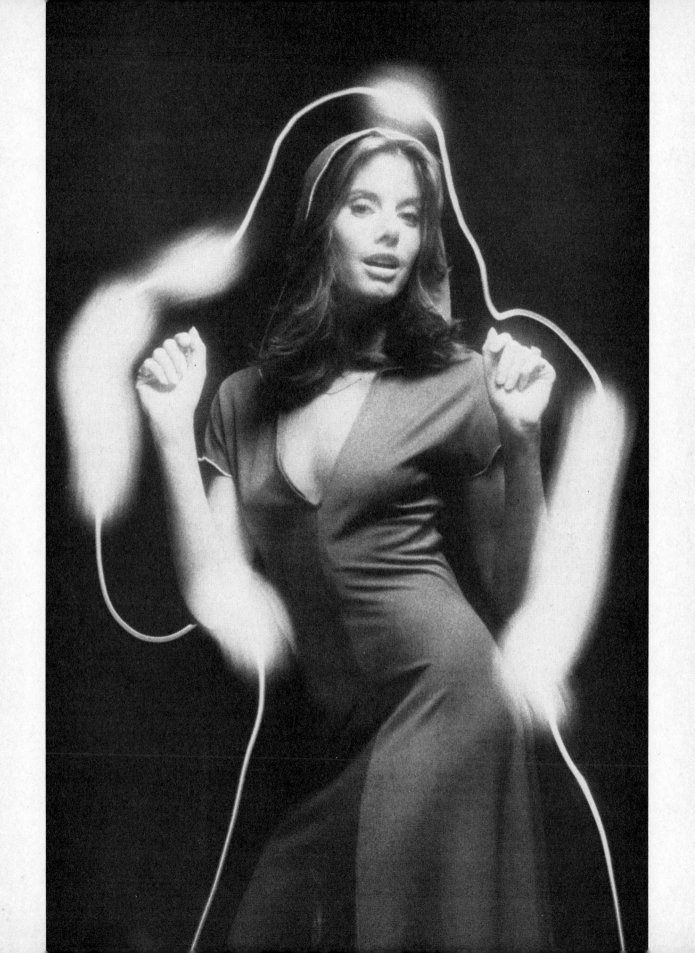

your flash unit is placed too far from your camera position to allow you to reach the button, an assistant will have to participate, firing the strobe unit on your command. After the second flash burst, you simply close the shutter, and you're ready to try again. Experimental techniques like this usually require a bit of repetition before you finally develop the ability to get predictable results, but don't be discouraged by a couple of initial failures or wasted frames of film.

Experiments for
the Imaginative

Once you've developed a feeling for the basic technique of multiple exposures with electronic flash, you'll probably want to get a little more adventurous and go beyond simple experiments like the one we just looked at. Here are a couple of the more obvious possibilities:

1) A double portrait in which the subject appears in close-up for one image, and in the distance for the other image. If you're using the open flash method, this shot requires some careful planning. The subject must be able to move to a new position in the dark, and you'll have to refocus without being able to see the focusing ring of your lens. A tiny penlight is your best bet here, as long as you're careful to keep its illumination off the subject while your camera lens is open for the exposures.

2) If you own a zoom lens, try changing the focal length for successive exposures while your shutter's open. Each time you alter focal length, fire your strobe with the open flash button to produce a series of radiating images that start at the center of the frame and expand outward toward the edges. This technique is most effective using the low-key backlighting setup we saw in Chapter 5. If, after the initial exposure is made of the entire subject, you then fire only the background strobe units as the lens is "zoomed," you'll have a head shot of your subject, with contours radiating out from his head like some kind of supernatural auras.

One interesting open flash technique involves making multiple exposures of the background to produce a series of silhouettes above your subject. The shot on page 155 is an example of this effect. It requires using two strobe units—one for the foreground illumination and a second, slaved unit behind and pointed toward the background. Again,

with the shutter on its "bulb" setting, both units are fired simultaneously. Then the background unit is fired manually as you slowly move the camera downward. At each position, the background illumination records a separate distinct silhouette of your subject. Obviously a black background is not called for here, but neither is a white nor light-colored one which will tend to overpower your multiple exposures. Instead, use gray or some medium shade of blue or red to get the best results. If you've got the patience, you might even try using different colored gels over the background strobe for each successive exposure. The effect will be garish, but interesting.

One variation of open flash experiment is not really open flash, but "open shutter." Instead of firing a second flash burst while the shutter is open, you can literally "paint" light onto the film using a small flashlight. This technique definitely requires an extra pair of hands, but the results can be spectacular and well worth the effort. As the shot on page 157 demonstrates, penlight painting is especially effective for adding an exotic accent to a fashion or glamour shot, and it usually requires some experimenting before you get results that you're pleased with. Again, the strobe unit is synchronized to the camera shutter as usual, and the initial exposure is made simply by releasing the shutter and firing the main strobe. Now, with the shutter still open, your assistant (preferably dressed in dark clothing and moving as quickly as possible) outlines the subject from behind with a penlight, angling the light toward the camera lens. If the penlight is directed straight toward the camera lens, the outline will record as a thick, diffused line; pointed slightly away from the lens, it becomes a thinner line with a harder edge. Needless to say, the variations on this bit of photographic whimsy are many.

So far, we've just been exploring multiple-image special effects that can be done with conventional electronic flash units. If you're really serious about such experiments, you might want to invest in a strobe unit specifically designed for these applications. There are several high-speed recycling "stroboscopes" available, ranging from the inexpen-

Multiple exposures with electronic flash need not entail camera movement. Here a high-speed "stroboscopic" flash unit, the Balcar Monobloc, automatically exposes several stages of subject motion during a ½ second exposure time.